The Transformation of the Avant-Garde

The Mathematics of the Gods and the Algorithms of Men

The Transformation *of the* Avant-Garde

THE NEW YORK
ART WORLD, 1940–1985

Diana Crane

THE UNIVERSITY OF CHICAGO PRESS

CHICAGO AND LONDON

Diana Crane is professor of sociology at the University of Pennsylvania. She is the author of *Invisible Colleges: Diffusion of Knowledge in Scientific Communities*, also published by the University of Chicago Press, and of *The Sanctity of Social Life: Physicians' Treatment of Critically Ill Patients*.

The University of Chicago Press, Chicago 60637
The University of Chicago Press, Ltd., London

© 1987 by The University of Chicago
All rights reserved. Published 1987
Printed in the United States of America

96 95 94 93 92 91 90 89 88 5 4 3 2

Library of Congress Cataloging-in-Publication Data

Crane, Diana, 1933–
 The transformation of the avant-garde.

 Bibliography: p.
 Includes index.
 1. Art and society—New York (N.Y.)—History—
20th century. 2. Avant-garde (Aesthetics)—New York
(N.Y.)—History—20th century. 3. Art, American—
New York (N.Y.) 4. Art, Modern—20th century—
New York (N.Y.) 5. New York (N.Y.)—Intellectual
life. 6. New York (N.Y.)—Popular culture.
I. Title.
N72.S6C73 1987 701′.03′097471 87-5013
ISBN 0-226-11789-8

TO MICHEL AND ADRIENNE
who shared their lives with this book

Contents

Illustrations

Following p. 118

Acknowledgments

The ideas for this book developed gradually over a period of several years. I first began to explore some of these issues while I held a Guggenheim Fellowship in 1974–75. While I was a fellow at the Institute for Advanced Studies in Princeton in 1976–77, I was able to conduct a number of interviews with artists and art dealers in New York City. The first draft of the book was written during a sabbatical year from the University of Pennsylvania in 1982–83. I am grateful to all of these organizations for their support.

I am also indebted to Ivar Berg for his support and encouragement, to Michel Hervé for advice and assistance, and to Sanna Deutsch for a critical reading of the manuscript. My students in seminars at the University of Pennsylvania provided a valuable sounding board for the development of my ideas.

I particularly appreciated the patient and gracious assistance provided by the staff of the Fine Arts Library at the University of Pennsylvania during the long and laborious process of collecting the documentary materials for the study. Anne Morrell, Aron Iyengar, and Marisa Velilla supplied valuable research assistance at various stages of the study.

Finally, I thank the artists themselves whose lives, careers, and creations provided the basis for this book.

Portions of chapters 6 and 7 appeared in "Avant-Garde Art and Social Change: The New York Art World and the Transformation of the Reward System, 1940–1980," in *Sociologie de l'Art* (Paris: La Documentation Française, 1986).

Introduction

The decades following World War II were unique in the history of American art. Prior to that time, there had been art movements and some notable artists in the United States, but the country had never before produced art styles that influenced artists in other countries, particularly those of Europe.[1] Beginning with Abstract Expressionism, New York City became the acknowledged center of the avant-garde art world, disseminating styles that were widely imitated by foreign artists and producing artworks that were purchased in substantial numbers by foreign collectors and museums.

While the beginning of this period marked the emergence of a true avant-garde for the first time in American art, in the form of Abstract Expressionism, the character of the avant-garde art produced in New York underwent a major transformation between 1940 and 1980. By the 1980s the work of younger artists defied the ambiguous classification of "high" culture and put into question the whole notion of an avant-garde.

The term "avant-garde" implies a cohesive group of artists who have a strong commitment to iconoclastic aesthetic values and who reject both popular culture and middle-class life-style. According to the prototype, these artists differ from artists who produce popular art in the content of their works, the social backgrounds of the audience that appreciates them, and the nature of the organizations in which these works are displayed and sold. Often esoteric, avant-garde art is purchased by a relatively small group of admirers who possess or have access to the expertise necessary to evaluate it. Such works are disseminated in a specialized network of organizations consisting of galleries, auction houses, museums, and more recently corporate collections. Many of the most prestigious organizations in the network are located in New York.

Between 1940 and 1985, this network expanded greatly in size, and in the process the number of artists grew, while the nature of the audience and of the various organizations that displayed and sold the artworks underwent significant changes. The growth of the plastic arts was part of a larger phenomenon which included the expansion

of other types of artistic activities in American society, including thea-
ter, dance, literature, and crafts, that flourished as a result of greatly
increased allocations of resources from other social institutions, pre-
sumably reflecting a redefinition of the importance or relevance of
these arts in American society. In this book I will analyze the effects
of these changes by examining the aesthetic and social content of seven
art styles that emerged at various times during this period and by
tracing the reception these styles received from galleries, museums,
corporations, and private collectors. I will also examine how concep-
tions of the avant-garde have evolved during this period. Does avant-
garde art appear in a situation that represents a particular constellation
of environmental and historical factors? Has the avant-garde disap-
peared, as some observers claim, or has it continued under a different
form?

For my study, I selected seven major styles that appeared during
the last forty years: Abstract Expressionism in the forties, Pop and
Minimalism in the early sixties, Figurative painting in the late sixties,
Photorealism and Pattern painting in the early seventies, and Neo-
Expressionism in the early eighties. More than four hundred artists
were identified as working in these styles. The abundance of docu-
mentary materials about these artists made it possible to reconstruct
the development of each art style from its beginnings to its eventual
decline, using interviews and reviews by art critics as well as state-
ments by the artists themselves and information from biographical
directories. Many of these materials were published during the period
when the style was emerging or at the peak of its success, thus
providing an indication of how these movements were perceived at
that time.[2]

The Expanding Art World: Growth and Its Causes

During the forties, the number of galleries specializing in the sale of
contemporary American art was probably around twenty. Observers
estimated that there were no more than a dozen collectors of con-
temporary avant-garde art. Visitors to Peggy Guggenheim's Art of
This Century Gallery, one of the first galleries to exhibit the work
of the Abstract Expressionists, were rare. Even in the fifties, Irving
Sandler recalled, during the three years in which he ran an influential
cooperative gallery, The Tanager, he sold only one work. (Sandler,
1984: 12). By contrast, in the late seventies, a critic, David Bourdon
(1977), described the necessity of visiting twenty-five to thirty gal-

leries *per day* in order to keep up with current developments in the art world. During this period, the number of galleries in New York City selling contemporary American art increased substantially. As table 1.1 shows, the number of galleries handling twentieth-century American art was more than three times as great in 1977 as in 1949. Among the 134 galleries that had exhibited two or more artists from the styles in the study, almost two-thirds were founded after 1960 (see table 1.2).[3] In the 1970s the number of serious collectors was estimated to be in the thousands (Kuhn, 1977: 113).[4]

Another significant development during this period was the emergence of an auction market for contemporary American art. Since negotiations between dealers and collectors are always confidential, auction sales have the effect of establishing a public price for an artist's work which can be used as a benchmark for future sales. Therefore, access to the auction market represents for the artist the possibility of economic success. Before 1970, contemporary avant-garde art was only occasionally auctioned. During the seventies auction sales of such works became much more frequent. Records of sales on the auction market provide an indication of the extent to which the prices of these painters increased over time. The auction prices of 26 percent of the Abstract Expressionists increased by more than 500 percent in about

TABLE 1.1

New York Avant-Garde Galleries by Decade, 1940–80

Originated Prior to	% Existing in				
	1949	1959	1965	1977	N
1949	★	41	40	26	90
1959	26	★	58	38	132
1965	19	40	★	30	197
1977	8	12	20	★	290

NOTE: Galleries are those handling twentieth-century American art only. Compilation of these figures was hampered by the absence of regularly published comprehensive lists of galleries. I have relied on the following sources which presented lists of galleries for certain years during this period: *The Art Collector's Almanac, No. 1, 1965; Fine Arts Marketplace, 1977–78,; Arts Yearbook* (1959); *Arts Yearbook 6* (1962); Motherwell and Reinhardt (1951); "Gallery Guide," *Art Now*, 8 (December 1977), and the New York telephone directory.

Figures above the diagonal line of asterisks represent the percentages of galleries founded in an earlier period still existing at a later period. Figures below the diagonal show the percentages of the galleries existing in a particular time period that had existed in an earlier time period. For example, of the 290 galleries existing in 1977, 8% were in existence in 1949.

TABLE 1.2

Decade of Origin of Galleries Representing Artists in the Study (in percentages)

Year Founded	All Galleries Representing Artists in the Study	Galleries Representing Two or More Artists
Before 1940	8	6
1940–49	8	12
1950–59	16	19
1960–69	27	28
1970–79	34	34
1980–83	5	2
NI	1	0
Total	99	101
N	287	134

twenty years (1960–82) in deflated currency. In the other styles, the auction data cover a shorter period (1970–82); the prices of almost two-thirds of the artists increased in real terms (see chap. 6, table 6.4). Prices were highest for Abstract Expressionists.[5] Between 1970 and 1982, 59 percent of these painters had had individual paintings sold at auction for over $100,000.

During this period, the number of artists exhibiting annually in New York more than doubled. Alloway (1977b: 108) has calculated that, excluding dead artists, there were 800 one-artist exhibitions during the 1949–50 season, and 1,200 one-artist exhibitions during the 1975–76 season. By 1984–85, this figure was close to 1,900. Many additional artists participated in group exhibitions.

The number of artists all over the country underwent a similar increase. One indication of their number was seen in the fact that Peter Frank, a critic who organized an exhibition of nineteen young artists for the Guggenheim Museum in 1980 selected them from a pool of nearly 10,000 artists, putting in a year of almost constant travel and visiting approximately 1,000 studios (Glueck, 1981: 96). Chamberlain (1980: 14) declared that there was a desperate shortage of exhibition space for artists everywhere. Statistics compiled by the Bureau of the Census showed that, in 1970, 600,000 people in the United States identified themselves as artists. By 1980, the number was one million, an increase of 67 percent (Hart, 1984: 53).[6]

At the same time, the number of museums and corporate collections outside New York City expanded greatly. Until the 1940s, Americans

in many regions of the United States were unaware of the existence of avant-garde art. Ashton (1973: 6) states:

> there were vast geographical areas in the United States where no living painter or sculptor could be found, much less a museum. Although culture, as conceived by Americans, had penetrated the hinterland in the form of public libraries, literary societies, and even music circles, the plastic arts had, for various reasons, lagged far behind. One reason for this was that the artist who happened to be born in a barren cultural milieu usually moved as soon as possible to a metropolis, preferably New York.

Between 1940 and 1980, the number of museums of all types in the United States substantially increased; 67 percent were founded after 1940.[7] In a random sample of museums devoted to the arts, 45 percent were created between 1940 and 1975 (National Endowment for the Arts, 1975). Among museums outside New York City (regional museums) which had purchased paintings by members of our sample, 47 percent were established after 1940. These museums were almost equally divided between those affiliated with universities and those not so affiliated. The former were more recent than the latter. Among the academic museums, 63 percent had been founded after 1940 while among the nonacademic museums the figure was 33 percent (see table 1.3).

Collections of art works by corporations increased even more rapidly than the number of new museums. Of the 67 corporate collections listed in Cattell's *American Art Directory* (1982), 93 percent were created after 1940. Art works by artists in our sample had been acquired by 183 corporations, only 11 percent of which were listed in Cattell's *American Art Directory,* a statistic that in itself suggests that these collections were increasing in number.[8]

To summarize, enormous growth in all aspects of the art market and the organizational infrastructure occurred during this forty-year period and particularly during the latter half of this period. In the following section, we will explore a number of reasons for this phenomenon.

Institutional Collectors and Donors: The New Patrons

How can the expansion of the art market during this period be explained? Several factors outside the art market itself were affecting its

TABLE 1.3

Growth in Numbers of Art Organizations, 1900–1979

Type of Organization	Before 1900	1900–19	1920–39	1940–59	1960–79	Total	N
			Date Founded				
Museums (nonacademic)	20	19	27	19	14	99	124[a]
Museums (academic)	18	5	13	24	39	99	112[b]
Corporate collections	0	3	4	16	76	99	67[c]
Art centers	16	9	16	24	35	100	446[d]

NOTE: Dates of origin were calculated on the basis of entries contained in *American Art Directory* (1982). Excludes museums in New York City.

[a]Includes one museum founded after 1979. Excludes 22 museums for which date of origin was not available.

[b]Includes one museum founded after 1979. Excludes 52 museums for which date of origin was not available.

[c]Includes one collection founded after 1979. Excludes 29 corporations for which date of origin was not available.

[d]Includes one organization founded after 1979. Excludes 32 art centers for which date of origin was not available.

growth and its operation. A major element in the expansion of the art market was the infusion of government and corporate funds. Beginning in the middle sixties, federal and state governments, corporations and foundations began to give more support to the arts in general. For example, support for the arts by the National Endowment for the Arts, which was created in 1965, increased from $1.8 million in 1966 to $131 million in 1983 (Goody, 1984: 147). Corporate spending increased from $22 million to $436 million (*Guide to Corporate Giving in the Arts 2,* 1981). Support by all state governments increased from $2.7 million in 1966 to $125 million in 1983 (Goody, 1984: 148), while foundation support increased from $38 million in 1966 to $349 million in 1982 (Goody, 1984: 149).[9] Museums received the largest share of both corporate, federal, and state funds.[10]

Various explanations for the allocations of government and corporate funds to the arts during this period have been proposed. Ronald Berman (1979) reports that the arts were perceived by government bureaucrats at the federal and state levels as "socially useful," as beneficial for the electorate, like religion and education. In congressional

debates, the social functions attributed to the arts were myriad (Berman, 1979: 47):

> art displaced adolescent violence and anomie, encouraged craftsmanship, discouraged crime, and offered new opportunities for employment. Art was an alternative to drug addiction, an auxiliary to prison rehabilitation, and a solution to the problems of old age. Exposure to art might relieve inner-city tensions and possibly improve the tone of the adversary culture.

Banfield (1984: 54–60) also lists a wide range of benefits that proponents of government legislation attributed to government support for the arts, including the promotion of international understanding and peace, an increase in the nation's prestige and general welfare, and increased opportunities for the poor to participate in artistic activities. Still another argument in favor of government subsidies was the financial crisis of arts institutions in the face of increased demand for their services.

During this period, the arts acquired a political constituency, municipal lobbies that campaigned in Washington for increased levels of funding and that, along with federal agencies and state arts councils, constituted a "bureaucracy of art." Many states began to allocate funds for the arts in the early seventies because of the availability of matching federal funds.

Some observers argued that the allocation of funds for the arts was a result of lobbying by the culture industry (Banfield, 1984) and by real estate developers in New York City (Zukin, 1982). In other words, powerful business interests associated with the tourist industry (hotels, restaurants, and shops) and with real estate developers benefited from the expansion of cultural activities in New York and elsewhere.

Zukin (1982) elaborated these arguments most fully. She claimed that behind the willingness of federal and state governments to fund art and artists were political interests that used traveling art exhibitions as propaganda for the American way of life and economic interests that benefited from the development of an arts infrastructure of galleries and related services that led to the gentrification of certain areas of Manhattan (see also Simpson, 1981). She argued that real estate developers profited from the increase in property values that resulted from the creation of an artistic community in Manhattan's SoHo district while political leaders benefited from the creation of a large pool of arts-related jobs.

Leading business executives claimed that their organizations supported the arts partly as an act of social responsibility and partly out of self-interest: to improve the environment for their employees and to create good public relations (Hunter, 1979). Why did corporations select the arts as a vehicle for public relations? One hypothesis is that they used the arts as a medium of communication with the middle class, by whom the arts are perceived as interpreting the "human condition" and purveying social values and beliefs. A former president of CBS has been quoted as saying that the essential values of the public (Berman, 1979: 50): "are most clearly evident, and in some instances evident only, in the arts—in music, the drama, and the dance, in the architecture and design and in the literature of the people and of the times."

Haacke (1981) argued that corporations were actually seeking to influence liberals within the middle class. By supporting "high culture" they hoped to deflect liberal criticism. He claimed that this policy underlay their support for certain types of museum exhibitions that they believed would improve their image with this segment of the population.

However, while federal, state, and corporate funds accelerated the growth of the art market, the expansion actually began prior to the initial allocations of these funds in the mid-sixties. From this point of view, a significant role must be attributed to the growth of educational institutions in the postwar period, including the increasing enrollments in undergraduate education,[11] and in arts programs specifically, on the undergraduate and graduate levels. Those with college educations are most likely to attend cultural activities in general, according to the National Research Center of the Arts survey (1975: 118), and museums in particular (Useem and DiMaggio, 1977: 30).[12] For the universities, the arts were a means of transmitting humanistic values to the young. In order to expose students to the plastic arts, campus art museums were necessary.

As table 1.3 shows, a substantial arts infrastructure already existed in 1960 before the infusion of federal, state, and corporate funds began. Eighty-six percent of all nonacademic museums, 61 percent of all academic museums, and 65 percent of all art centers existed by 1960. A considerable amount of growth in this infrastructure had occurred between 1940 and 1960. One-quarter of the academic museums and of the art centers were created during this period, as well as one-fifth of the nonacademic museums.

Still another factor was the influence of art centers throughout the country in stimulating the public's interest in art. The Lynds report that in the typical American city they studied in the 1930s, the construction of an art center led to the creation of other groups concerned with artistic activities (Shapiro, 1973: 10). Sandler (1976: 7) reports that the 103 community arts centers established by the WPA in the thirties were visited by eight million people and helped create a new audience for art. Typically these centers concern themselves with local artists and with stimulating the interest of the public in artistic activities generally, rather than with collecting and exhibiting artworks.

All of these factors contributed to the increasing salience of the arts in general and the visual arts in particular. Another indicator of changes in attitudes toward the arts was the amount of attention paid to the arts in the mass media. Articles in the mass media helped to increase the visibility of contemporary art and to move it into the mainstream of popular culture. Certain artists rather than others were the object of media attention, particularly those who were expressing values that were congruent with those of the mass media.

To summarize, changes in social behavior such as increasing levels of education and changes in the allocation of leisure time that were reflected in the attention given to such activities by the mass media led to an expansion of art institutions, including the number of artists and the number of organizations selling and displaying art. This in turn attracted funds from state and federal governments and from business, that led to further expansion, including the emergence of an auction market.

The Artistic Role in Transition

During the forty-five year period of my study, the artistic role underwent a major transformation. While the organizational infrastructure for avant-garde art was changing, so was the social and occupational role of the artist. As early as the 1960s, the position of the artist had changed to such an extent that, according to Buettner (1981: 125), "Artists were at home among the upper middle class because they were members of the same class."

Artists were gradually absorbed into the American academic system. The number of Master of Fine Arts degrees awarded by American universities and art schools increased from 525 per year in 1950 to

8,708 in 1980 (United States Bureau of the Census, 1951; 1982–83). As table 1.4 shows, the percentage of artists in the study who had obtained educational degrees was much higher for the later styles. Virtually all the artists in the study had attended college, university, or art school, but among the older cohorts fewer artists had had either the funds or the inclination to meet the requirements for degrees.

These artists supported themselves in a variety of ways. An important source of support was the academic world, where they served on the periphery as visiting critics or as artists-in-residence, somewhat less marginally as part-time instructors, often commuting from another city, and finally as full-time staff, either in universities, colleges, or art schools. As Appendix table B1 shows, full-time and part-time academic positions became increasingly available to artists during this period. Additional sources of support appeared in the form of state, federal, and foundation funds. Prizes and awards for the purchase of paintings had existed prior to this period, along with fellowships for work at artist colonies, but the total amount of available funding considerably increased (see Appendix table B2). Others worked in commercial art or in art-related occupations, such as editor, critic, curator, or art dealer. Finally, a relatively small number of artists were able to support themselves entirely by sales of their work.

A major consequence of changes in the social situation of the artist as well as in the political and social importance of the arts generally, as seen in the increased resources which were allocated to them during this period, was that the artistic role ceased to be that of an avant-garde

TABLE 1.4

The Changing Social Role of the Artist, Educational Degrees by Style

Educational Degrees	Style					
	Abstract Expressionism	Minimalism	Pop	Figurative	Photo-realism	Pattern
None	75	44	44	33	20	13
Bachelor of Arts/Fine Arts	10	17	22	17	27	23
Master of Arts/Fine Arts; Ph.D.[a]	10	25	30	46	41	51
No information	5	14	4	4	12	13
Total	100	100	100	100	100	100
N	21	80	28	126	51	61

[a]Two members of the study had been awarded Ph.D.'s.

with its concomitant overtones of alienation from popular culture and middle-class values. Since the Abstract Expressionists and the Minimalists benefited from the increasing opportunities available to artists only after their careers were more or less established, these changes had less influence on the character of their work, but many artists in the later styles lost their attitude of opposition toward middle-class values and popular culture. Instead, they internalized values and goals associated with the middle class and with popular culture.

Avant-Garde Art and Artistic Change

A major concern of this book is the role of the avant-garde artist in contemporary society and the nature of the symbolic materials that the artist creates. Is the role of the avant-garde artist that of a "privileged outsider" who provides an alternative perspective on social reality or does such an artist simply produce "the instruments of our domination," as some writers argue? (See, for example, Crow, 1983.)

The concept of the avant-garde is highly ambiguous. There is not a single definition of this term but many. In the last one hundred and fifty years, since the concept first began to be used, members of different art movements and their critics have defined it in a variety of ways. Many authors use the term to refer to almost any art movement while others apply it to certain types of art styles rather than others, generally those that are in opposition either to dominant social values or to established artistic conventions. The concept of the avant-garde is central to the sociology of art because it is a major element in the definition of high culture. High culture itself is variously defined and a subject of considerable controversy as the boundaries between high culture and popular culture are increasingly being questioned (Gans, 1985). A number of issues in the sociology of art converge around the concept of the avant-garde, including the social role of the artist, the nature of artistic innovation, and the social impact of artistic works.

Avant-gardes are usually identified by artists, art critics, and art historians. What can a sociologist contribute to the analysis of avant-gardes that critics and art historians cannot? Because the latter belong to the social system of art, they participate in the identification and social construction of avant-gardes and tend to have a personal commitment to the subjects of their analysis. By contrast, a sociological approach consists of identifying a set of dimensions which are associated with the concept of the avant-garde and of analyzing the contributions of each art movement in terms of those dimensions. Such

an analysis can show how the basis for the attribution of the label "avant-garde" varies in different art movements and how the relative weight attached to each of the dimensions has changed over time. For example, how has the emphasis on the role of the avant-garde as a kind of counterculture or adversary culture, as opposed to its role in revising aesthetic conventions, changed over time? This type of analysis can also reveal some of the reasons for the lack of consensus in the art world concerning the identification of particular movements as avant-gardes.

Before I present a set of characteristics that can be used to identify avant-gardes, I will review various conceptions of the avant-garde that have appeared in the literature on the sociology of art and on art history and criticism. The idea of the avant-garde is closely linked to the concept of high culture, which generally refers to artworks that are based on an aesthetic tradition, either one that has long been accepted as in the case of artworks that are decades or even centuries old or one that is in the process of gaining acceptance. Works in the latter category are sometimes but not always considered to be avant-garde, and different observers will vary in their assessments in this respect. Gans (1974) described high culture as consisting of two elements: classical works which were created in previous centuries or at the beginning of this century and contemporary works of a highly esoteric nature, focused around the solution of technical and aesthetic problems. By contrast, popular culture is generally characterized in terms of its use of formulas—standardized procedures for creating an aesthetic effect (Cawelti, 1976). However, it is clear that not everything that is created in the context of either high culture or popular culture fits the characterization of that form of culture.

High culture is also associated with a particular type of audience, usually middle or upper class in some respect. High culture is frequently created and disseminated in small specialized organizations that serve or are controlled by upper-middle-class clienteles while popular culture is generally produced in corporate settings and disseminated to a mass audience. Some authors argue that there are in fact no inherent differences between high culture and popular culture but that each is labeled as such, depending upon the nature of the settings in which they are presented and consumed. They stress that aesthetic judgments are inevitably influenced by the historical and social situation of the critic (for a review of the Marxist approach, see Wolff, 1981). These authors would like to eliminate the distinction between the two types of culture, but since high culture is often created in a

distinctive context, one that grants greater autonomy to the artist than to the creator of popular culture in the production of a work, this argument is difficult to make.

The term "avant-garde" was first used in France in the first half of the nineteenth century (Nochlin, 1967:5; Poggioli, 1971:9). Its appearance seems to have been a consequence of the increasing fragmentation of society that occurred as a result of industrialization. Until the middle of the nineteenth century, the artist in Europe served an elite whose values he or she expressed and generally shared. When some groups of artists were able to monopolize the patronage of elites (White and White, 1965), those who were excluded developed an ideology of their own that justified their commitment to aesthetic innovation and liberal political views (Shapiro, 1976). By the early twentieth century, when the role appears to have reached its fullest development, it was characterized by its alienation from the rest of society and particularly by its opposition to bourgeois culture.

The images of the avant-garde in the recent literature by sociologists, art historians and art critics are diverse and contradictory. Poggioli (1971: 108) claims that avant-garde art, as a minority culture, must attack and deny the majority culture to which it is opposed. Alternatively, according to Bensman and Gerver (1958), the avant-garde artist attempts to paint in a way that no one else has painted before but uses a body of artistic ideas based on previous art traditions. They argue that as the complexity of the technical and theoretical foundations of avant-garde art increases, social commentary becomes less important and may be excluded altogether. For many art critics and historians, the avant-garde has been identified with aesthetic innovation, which in this century has meant modernism, a preoccupation with problems of visual perception. According to Vitz and Glimcher (1984: 36), the modernists "were expressing . . . a new understanding of visual experience thereby revealing the role of art as a tool by which perception could be extended." This type of art, with its intense preoccupation with aesthetic and technical issues, has been accused of being totally detached from "the concerns, aims and ideals of the culture" (Fried quoted by Alloway, 1968: 51).

By contrast, Peter Bürger (1984), writing in the tradition of the Frankfurt School, argues that the label of "avant-garde" should be reserved for artists such as the Dadaists and the Futurists, whose works attacked the institution of art itself on the grounds that modernist art, as a result of its preoccupation with formal aesthetic issues, has ceased to comment on its social environment.

Still another interpretation (Crow, 1983) views the avant-garde art-ist as a mediator between mass-produced culture and the so-called "resistant" subcultures which redefine popular cultural artifacts in terms of their own social needs. Crow argues that the avant-garde as the research and development wing of mass culture reshapes the "aesthetic discoveries" of marginal social groups that in turn are reassimilated into mass culture.

Finally, the debate concerning the nature of postmodernism con-cerns the extent to which the aesthetic tradition underlying twentieth-century art has been exhausted and is being replaced by new ap-proaches that have as much in common with popular culture as with artistic tradition (Foster, 1983).

Central to the discussion of the avant-garde are debates about the relative importance of the artist's aesthetic and social roles. Is the artist expected to be both a social critic and an aesthetic innovator? What is the relative importance of these two roles?

In this book, I will argue that each new art movement redefines some aspect of the aesthetic content of art, the social content of art, or the norms surrounding the production and distribution of art-works. An art movement may be considered avant-garde in its ap-proach to the aesthetic content of its artworks if it does any of the following: (1) redefines artistic conventions (Becker, 1982); (2) uti-lizes new artistic tools and techniques (for example, the elimination of the easel by Jackson Pollock); (3) redefines the nature of the art object, including the range of objects that can be considered as artworks. Art movements whose tenets include the revival of the aesthetic conventions of an earlier period are unlikely to be consid-ered avant-garde.

An art movement may be considered avant-garde in its approach to the social content of artworks if it does any of the following: (1) incorporates in its artworks social or political values that are critical of or different from the majority culture (for example, Schwartz, 1974: 5, echoing Marcuse, states as one of the possible roles for the avant-garde that of providing a countercultural force and "cultural criticism"; Haney, 1981: 6, an artist, says that art works can "find those metaphors of visualization that . . . define the imagination of a culture"); (2) redefines the relationship between high and popular culture (for example, the use of images from advertising and comic strips by Pop artists); and (3) adopts a critical attitude toward artistic institutions (the epitome of the latter is seen in the Dadaist attack on the legitimacy of art).

Finally, an art movement may be considered avant-garde in its approach to the production and distribution of art if it does any of the following: (1) redefines the social context for the production of art, in terms of the appropriate critics, role models, and audience; (2) redefines the organizational context for the production,[13] display, and distribution of art (for example, the use of alternative spaces ["Alternatives in Retrospect: An Historical Overview, 1969–1975"]; the attempt to create "unsaleable" art works); and (3) redefines the nature of the artistic role, or the extent to which the artist participates in other social institutions, such as education, religion, and politics. Some observers have pointed out that, as a result of the increasing integration of artists into middle-class life, the artistic role has begun to approximate what has been called a "moyen garde" with a well-defined niche in middle-class society (Davis, 1982).

Implicit in this approach to the characterization of avant-gardes is the realization that avant-gardes will differ in the ways in which they challenge established artistic conventions and artistic and social institutions and also in the degree to which they do so. Some movements will be defined as avant-garde by members of art worlds on the basis of their position on only one of these three sets of categories, while others will be defined as such on the basis of their position on all three. However, the redefinition of aesthetic content appears to be the most important factor. Art movements that confine their iconoclastic activities to the redefinition of social content or the production and distribution of artworks are less likely to be labeled avant-garde by members of art worlds. For this reason, the Social Realists in the 1930s and the mural artists in the 1970s who redefined the social content of art and the settings for the production and distribution of art are not considered to be avant-gardes (Cockcroft et al., 1977).[14]

In order for a group of artists to be defined as engaging in activities associated with the avant-garde, they must first of all have some degree of awareness of one another as a social group. As a social phenomenon, a style represents a kind of collaborative endeavor on aesthetic problems, although the intensity of social interaction varies greatly. The greater their self-awareness, the more likely their redefinitions of these three categories of artistic activity will be considered avant-garde by members of the art world. As I will argue in Chapter 2, an artistic style is a social phenomenon and the label "avant-garde" is attributed to artistic groups under certain social conditions.

In order to understand the role of avant-garde art in contemporary society, it is necessary not only to look at its aesthetic and social content

but also to examine the support structure of galleries, museums, and collectors that evaluates and disseminates these works. The changing characteristics of these organizations affect the kinds of styles that are heavily publicized and thus perceived as most characteristic of a particular period. Expansion of the numbers of artists and of the resources for artistic activities has strained existing facilities for the evaluation and dissemination of art, so that these organizations may be as likely to resist as to facilitate innovation (see White and White, 1965, for an analysis of an analogous situation in the nineteenth century). For example, these institutions may simply ignore the more radical reinterpretations proposed by marginal artistic groups. The fact that these organizations now rely on government and corporate grants for support has changed their orientation toward the public, leading them to seek a larger audience in order to justify, to their new patrons, their use of funds. It also provides an incentive to artists to produce works that will be meaningful to a larger segment of the public.

The individual in contemporary society is exposed every day to an enormous amount of visual imagery through television, films, newspapers, magazines, advertising, and books. As many authors have pointed out (for example, Berger, 1972; Walker, 1983), these images are culled from a wide variety of sources in both the distant and the recent past and are constantly being recombined to create new or seemingly new meanings. In contrast to theoretical perspectives which view cultural products as serving the interests of those who control social institutions, contemporary society can be viewed as an arena of conflicting and shifting definitions of reality in which various actors compete with one another to impose their interpretations of events. Escarpit (1977) has suggested that modern society consists of an intricate network of communication channels that corresponds to the needs and identities of diverse social groups, although much of this material is never widely disseminated. Some observers view the cultural products that are disseminated by popular-culture industries as being in a process of continual adjustment and evolution. According to a specialist in mass communication (Snow, 1983: 7), "We live squarely in the domain of *media culture,* a culture being constructed and altered continuously through the linguistic and interpretive strategies of the media."

In view of the enormous impact of the mass media and popular culture in contemporary society, it could be argued that the role of the avant-garde as a source of alternative perspectives and values is increasingly necessary. However, Apple (1981: 7) points out that the major image-makers in American society are not artists and that the

role of avant-garde artists as image-makers in the future is question-able. She argues for increasing communication between the art world and the communications media in order to create "an alternative con-text that encompasses and extends beyond both" and suggests that the future will require "radical changes in our ideas about art."

Outline of the Book

My interest in contemporary art styles is not in providing a detailed case history of the development of each one. Instead, I will examine to what extent works by members of these styles exhibit characteristics that have been associated with the concept of the avant-garde and the factors affecting the reception of these works in the reward system for painting and sculpture as high culture.

In Chapter 2, I explore the social aspects of art styles. What was the character of the artistic milieu and of the social groups that constituted styles that were considered avant-garde? Rather than define the audi-ence for contemporary art styles as a single elite group, I locate different groups of sponsors or "constituencies" and show their connections to the artistic community.

In Chapter 3, I examine the nature of the dominant aesthetic tra-dition of modernism and how it affected the "meanings" transmitted by styles that emerged during the period covered by the study and the extent to which these styles corresponded to the various dimensions of the avant-garde.

In Chapters 4 and 5, I examine the effects of changes in American society during this period, combined with changes in the social situ-ation of the arts, upon the content of artworks in different styles. How can the increasing susceptibility of artists to themes and motifs from popular culture be explained? How does their use of these materials change our perceptions of them? To what extent do representational paintings reflect the social conflicts and tensions of the period? Can the "content" of representational paintings be understood in terms of the presumed social background of collectors and the conservative nature of the organizations that display and purchase these works?

Chapters 6 and 7 examine how the enormous expansion of artistic institutions affected the way these organizations functioned as gate-keepers for avant-garde art. How can the New York art market be characterized during this period? Was there a high level of competition or did some galleries succeed in controlling access to the auction mar-ket and commercial success? How did the major New York museums

respond to new styles as they emerged during this period? What was the role of regional museums and corporate collections in the allocation of artistic rewards? In Chapter 8, I review the implications of the study for our understanding of the nature of artistic roles and the concept of the avant-garde.

Style as a Social Phenomenon

The popular image of the artist is that of an eccentric genius, creating his work in isolation from other artists. This view of artistic activity is widespread among the general public and even among philosophers of aesthetics, art historians, and literary critics (Genova, 1979: 315). From this point of view, style reflects the individual's personal idiosyncrasies—his character and subjectivity.

Critics who write for contemporary art journals frequently imply that styles are shared by groups of artists, but these critics only occasionally allude to social factors affecting the artists who work in a particular style or the social relevance of its content. Some observers suggest that art styles are merely labels arbitrarily assigned by critics, dealers, and curators to suit their pragmatic goals and that these labels do not correspond to social groups.

Alternatively I will argue that the most influential artworks are created within the context of styles that are shared by members of social groups, although the level of consensus concerning aesthetic elements of style within those groups varies considerably. Individuals working independently rarely exert a comparable influence. On the other hand, ideas developed within stylistic groups are often adopted by artists, working outside such groups, who combine them with elements from other styles to produce paintings that are unique but rarely innovative.

As a group phenomenon, a style represents a kind of collaborative endeavor on aesthetic problems, in the sense that members follow each other's work and exchange ideas, but the intensity of their interaction varies, as we will see. Under certain conditions, art movements become establishments that resist artistic change (Kadushin, 1976). This can only occur if members of an art movement control the gatekeeping process that allocates artistic rewards either directly or by means of their association with influential members of the gatekeeping apparatus.

In this chapter, I will examine the social aspects of style, specifically, the differences in the character of artworks produced within styles and outside styles; the nature of the normative consensus concerning the

elements of a style; the characteristics of the social groups that produce styles; and the connection between a style as a social group and a subgroup within the art "public" that acts as a sponsor or as a "constituency" for that particular style.[1] As we will see, the social organization of a style, the social characteristics of its sponsors, and the social context in which it appears affect the extent to which a style is perceived as avant-garde.

Style and the Individual Artist

As I have already suggested, many, perhaps most, artists do not participate in the kinds of social groups that generate stylistic innovations. These artists are primarily concerned with the production of works that will sell rather than with the solution of aesthetic problems or the discovery of new techniques or subject matter. Their works are original in the sense that they are unique objects, but they are not innovative in the sense that they represent a redefinition of aesthetic problems or a new technique.

For example, it is said that about half the galleries in the SoHo section of Manhattan in the late seventies were showing paintings that could be described as "naive Impressionism"—pleasant, charming paintings produced by artists who had no concern for aesthetic issues or aesthetic innovation (Beardsall, 1978: 11). An artist whose work fell into this category was quoted as saying that she had "no preconceived idea of what art should be" (Beardsall, 1978: 11). There was also no element of social commentary or interpretation in these works. As Beardsall (1978) says, speaking of an artist who paints New York's tourist sites: "The pictures represent an optimistic, idyllic vision of a sunny, street-clean, lobotomized Manhattan. . . . they are happy paintings."

Many of the artists working outside the limits of contemporary styles are in a sense making use of formulas in the creation of their work. Formulas involve a great deal of standardization, which makes possible rapid and effective production of new works (Cawelti, 1976). Examples of formulas can be found in literature, popular music, and painting. In this context, the creation of a painting consists of finding minor variations on a familiar theme, of giving new vitality to a stereotype or inventing a new element of color or composition that is still within the limits of the formula. Moulin (1967: 410) describes in similar terms "chromos," paintings which are sold on sidewalks and in certain kinds of galleries:

A very great number of pictures are the products of conventional crafts-manship, obeying in subject and style fixed rules. They constitute the ultimate avatar of academic realism. This kind of artistic production represents the greatest part of artistic activity in the West. In the eyes of connoisseurs, these pictures constitute objects that are easily inter-changeable, that possess in common the capacity to satisfy the most vulgar forms of taste and that are refused membership in the universe of painting.

In effect, artists working outside of styles are generally, although not invariably, acting as entrepreneurs, primarily concerned with pro-ducing and selling pictures rather than with advancing artistic "knowl-edge" (FitzGibbon, 1985). Some of them are financially successful without ever being discussed or reviewed in the art press (Rosenblum, 1981). By contrast, the avant-garde artist is not merely painting pic-tures to please the public; he or she is attempting to paint in a way that no one else has painted before but by using the body of artistic knowl-edge that already exists.

However, artists may be associated with a particular style in a va-riety of ways, and styles vary considerably in the degree to which their members are involved in an artistic community surrounding the style. Some artists belong to such communities and perform important roles in the definition and dissemination of the style. Other artists are merely associated with the style by critics after the style has received public attention; often the latter are older artists whose work is "reinter-preted" in terms of the new style to which it is seen to be relevant.

A few artists change styles periodically[2] while most continue to work in the same style long after it has ceased to be considered aes-thetically challenging in the art world. For example, after the demise of Abstract Expressionism as an art movement at the end of the fifties, many artists continued to work in the style, as is indicated by the following comment (Bard, 1977: 103):

> Our group just couldn't give up our whole concept of painting. . . . In our great disappointment at this "so-called" death of Abstract Expres-sionism, which we didn't understand, we became more isolated from one another, didn't see each other's work as often, but—thank God— an amazing percent of us have gone on working and developing and are now, twenty years later, twenty years better. I still think of these painters as the painters in New York today.

In fact, while new styles emerge with predictable regularity, old styles do not disappear, so that, at the present time, it is possible to

find artists working in New York in a great variety of styles. The fact that styles generate a long-term commitment on the part of some artists is an indication that each style reflects a distinctive "worldview" composed of attitudes toward past and contemporary artistic achievements, appropriate subject matter, and the acceptability of various techniques.

Art Styles as Cultural Networks

The existence of distinct styles presupposes artistic traditions, from which new styles emerge. Other forms of innovation show variations on this pattern. For example, an important characteristic of scientific activity is the way in which scientific research builds upon previous work (Price, 1965). As indicated by the references in their published papers, scientists typically base their efforts upon a small body of published research. For the scientist, it is the recent past that matters. For the social scientist and the humanist, the more distant past is still relevant. Price (1970) has characterized the humanist as drawing upon the entire archive of previous achievements. However, it is evident that some humanities, such as linguistics, behave much like sciences. Similarly, contemporary art styles vary in this respect, some of them emulating artistic achievements from previous centuries, others building upon very recent innovations. Members of each style draw upon a set of ideas that is available to artists at a particular point in time from which they select certain ones to combine in new ways. Each art style presents a particular configuration of concepts and symbols that functions as a "worldview" for its members.

As we will see, among contemporary American artists, "modernism" constituted a set of ideas that had enormous influence upon the subjects they chose to paint and how they painted them. Many of these painters saw themselves as working in a "tradition" of modernism which began with the French Impressionists in the nineteenth century; others were reacting against modernism and saw themselves as "postmodernists."

For some writers, postmodernism was simply the antithesis of modernism (Levin, 1979b). However, the fact that it was difficult to categorize some artists as one or the other suggested that this was not the case. Levin (1979b: 92) said: "Almost everybody during the seventies has been transitional and hybrid." Like the modernist, the postmodernist was often interested in problems of light and visual percep-

tion but, unlike the modernist, he or she was also concerned with subject matter and the expression of feeling (Haney, 1981: 6).

The works of members of each style exhibit the characteristics of that style in varying degrees. The works of leading members of a style, those who are most closely identified with it, tend to exhibit most or all of its characteristics. The works of marginal members may exhibit only one or two. This is one of the reasons why there is sometimes disagreement among critics concerning the members of a particular style. Marginal members may be placed in different categories by different critics, depending upon which characteristics of their work are salient for a particular critic.

In some cases, a member of a style may exhibit all but one of its attributes but that one difference can alter the character of the work considerably. For example, the work of Audrey Flack incorporated the major attributes of Photorealism, such as the presentation of commonplace objects and a concern with achieving technical effects with extreme precision. However, she rejected the detachment that was characteristic of this style. She had strong feelings about her subjects and hoped to elicit such feelings in her viewers (Flack, 1981). Some Photorealists were more committed to the values of modernism than others and this factor differentiated their work from that of others in spite of the fact that they shared other key attributes of the style.

Similarly, in Pattern painting, artists' work varied depending upon whether they had been influenced by Asian or Middle Eastern art, by ethnic crafts, or by popular culture. In Pop, the artist's degree of irony or detachment toward his subject matter led to variations in the works.

In Abstract Expressionism, there were two distinct groups known as color-field and gesture painting. Both groups shared some attributes of the style, while differing from each other in certain respects (Kozloff, 1965; Sandler, 1976: 148). The color-field painters, exemplified by Barnett Newman, were concerned with ideas and the visual impact of color; the gesture painters, exemplified by Jackson Pollock, were more intuitive and absorbed with the expression of their own personalities. At the same time, all of the painters, whether field or gesture, were highly individualistic and jealous of their autonomy, and produced works that looked different from one another although linked by common themes and theories.

Figurative painting was particularly heterogeneous. The Figurative painters were concerned with the past but in various ways, either in terms of the use of traditional subject matter, traditional styles, tra-

ditional iconography, or traditional values.[3] Thirty-one percent of the
Figurative painters were traditional in terms of subject matter only;
these painters were mainly concerned with the aesthetic issues under-
lying abstract painting. Members of a second subgroup (18 percent)
combined an interest in traditional subject matter and style with a
modernist approach. Members of a third subgroup (30 percent) re-
jected the modernist aesthetic tradition altogether and were attempting
to revive premodernist traditions of painting. Some were attempting
to use the same techniques of brushwork and finish as traditional paint-
ers had used. Paul Wiesenfeld, a Traditional Figurative painter, was
described by a critic (Mangan, 1974: 23) as "a devout student of the
Old Masters, evidenced by his use of light and abstraction, his tight,
controlled brushstrokes, the muted color of his earlier works, even in
the glazed finish of his paintings. A well-marked book on Vermeer is
always close by. 'I can never stop learning from him,' Wiesenfeld
observes."

Others were doing genre paintings, groups of individuals in nar-
rative, story-telling situations, taking their compositions and their
themes directly from traditional painters whom these artists admired
(Velásquez, Rembrandt, Vermeer, among others). For example, a work
by a Figurative artist, Alfred Leslie, was described in the following
terms (Smith, 1979: 14): "The composition is after Caravaggio's *Sum-
mer at Emaus*. . . . This painting has not only specific allusions to past
artists and works, but comes out of the whole tradition of genre paint-
ings, including Dutch burghers and early colonials which it resembles
in its arrangements of figures."

Along with traditional composition went the use of traditional icon-
ography, often allegorical, and mythical themes. In some cases, this
was very explicit, as in the work of Milet Andrejevic, who painted
mythical figures in contemporary settings such as Central Park. In
other painters, it was less obvious to the discerning eye, but Kuspit
(1981) argues that such devices pervade much of contemporary realism.

There was little consensus across these groups in spite of the fact
that their members participated in the same organizations and social
networks. Those who painted in a modernist mode accused those who
painted in a traditional mode of "Rip Van Winkleism," while the tra-
ditionalists deplored the "objectivity" of the modernists (Downes,
1976).

Eventually, the ideas that form the basis for any style cease to be
challenging, as the following quotation suggests (Mackie, 1979: 25):

At that point, it [Abstract Expressionism] became a method, even a formula, which posed its own problems and generated its own solutions, but essentially something which could be learnt by a competent painter, and which no longer permitted the kind of exploration of the medium and the self which a good artist finds himself committed to. It no longer demanded enough of the artist, and the crisis of art once again became the anxiety of what to paint.

In art, as in science, the realization that an existing approach is no longer capable of generating meaningful ideas may lead to a state of crisis, followed by its replacement by competing or alternative approaches. Haskell (1984) documents the sense of desperation that young artists felt when Abstract Expressionism was in this phase of its development. She says (1984: 13), "at the very time that Abstract Expressionism was perceived as exhausted and bankrupt, it simultaneously exerted a hegemony so absolute that it offered young artists no room to maneuver." The availability of alternative approaches is a major factor mitigating the extent to which a state of crisis is perceived.

Style and Artistic Communities

The production of artworks within the context of a style is a social activity in which artists are constantly looking at other artists' work in order to validate their own conception of artistic "knowledge," much as innovators in other fields need social validation of their work as an indication of its viability as an innovation. A painter and art critic who was interviewed for the study commented:

> It's a popular ideal that the artist works in isolation, which is literally true, but actually it is very much a community activity. You paint with the knowledge of what everyone else has done. That is why there are always art centers like Paris. The more I paint and learn, the more I realize that art is not a very individualized enterprise. It has to do with what other people are doing.

However, the characteristics of artistic communities vary. In situations where artists are developing ideas, either political or aesthetic, that are divergent from current artistic values, their communities may resemble countercultures in terms of their cohesiveness and emotional involvement. The social community that emerged around the first generation of Abstract Expressionists in the 1940s was a unique phenomenon. The amount of social interaction and the variety of arenas

in which social interaction took place was unduplicated in later art movements.[4] In a situation unlike the one that would obtain twenty years later, the notion of artistic success was completely unknown to these artists. That their paintings might be exhibited and purchased for huge sums of money seemed to them utterly unlikely. In this kind of atmosphere, they needed one another to exchange ideas and convince themselves that the artist's role as such was a viable one. Sandler (1976: 79) says:

> After 1943, the New Yorkers who were venturing into automatist and biomorphic abstraction—among them, Baziotes, Gottlieb, Hofmann, Motherwell, Pollock, and Rothko—became increasingly familiar with each other's work and often exhibited together. This resulted in a loose community based on mutual understanding and respect. Personal interactions were of great importance, for they gave rise to an aesthetic climate in which innovation and extreme positions were accepted and encouraged.[5]

The circumstances that facilitated the emergence of this social community were in part historical, specifically the Federal Arts Project (WPA), which brought some of them initially into contact with one another, and membership in the same organizations, such as the Artists' Union and the group known as American Abstract Artists. Geographical proximity in Greenwich Village was also a factor (Sandler, 1978: 30). During the period when the style was emerging, almost all of these artists were living and working in New York City. All twenty-one members of the first generation of Abstract Expressionists were male. One-third were born in Europe and another third in New York City, the most European of American cities. Furthermore, they were approximately the same age: three-quarters of them were born between 1900 and 1913. Sandler (1978: 30) described the effect of this community on the artists' perceptions of themselves and their work:

> The constant face-to-face encounters and exchanges of strongly held ideas gave rise to a milieu of constant feedback, mutual awareness, and, of course, vehement controversy. This running commentary by the artists made the work *count,* at least because it indicated that the work was seen, taken seriously and had repercussions. . . . This audience *by paying attention* (and it did so enthusiastically) bolstered the artists and contributed to the intensity with which they worked. The energies that gave rise to, and were generated by, semi-public dialogue and the sense of vital community it implied were so elating to the participants that most recognized that they were witness to a rare phenomenon: a living culture and American at that.

Toward the end of the forties, the Abstract Expressionists formed several organizations which reinforced the social relationships among them, most notably a short-lived school, "The Subject of the Artist," and a social club, known simply as the Club, which lasted until the end of the fifties. According to Sandler (1965), the membership expanded rapidly. By the summer of 1950, the original twenty members of the Club had tripled; the Club became "the core of a subculture" which included artists working in other styles and in other arts, critics, and even dealers, such as Leo Castelli (Sandler, 1976: 214).

By the early fifties, there were clearly leaders—primarily de Kooning and Kline—and followers. The followers included a second generation of painters. Rosenberg and Fliegel (1965), who studied the Abstract Expressionists during this period, also found evidence of a tightly-knit artistic community. One of their informants said:

> One has the feeling that everybody knows about everybody else's paintings and there is a kind of running commentary going on within each work. This creates a very concentrated and electric ambience: the least inflection that an individual artist puts into it counts and has repercussions and echoes which other people can pick up and use.

Gradually, however, the group became less an association of equals and instead was divided into factions surrounding the leaders of the movement. Eventually, some of the older artists moved away from New York to Long Island and elsewhere. By the late fifties, as the aesthetic goals of the group became less challenging, the community disintegrated and was replaced by entirely new movements in the sixties.

Among the styles in the study that succeeded Abstract Expressionism, the Minimalists came closest to being a counterculture. Thirty-eight percent of the Minimalists were linked to one another by personal ties or student-teacher relationships, but the group was divided into several cliques: an English clique, consisting of the sculptor Anthony Caro and his students and associates, and three New York-based groups, one of which was centered around the short-lived cooperative, Park Place. These groups were loosely linked to one another through the influence of a few leading members.[6] The character of these groups is suggested by Ed Ruda's description of the atmosphere at Park Place (Ruda, 1967: 31): "Everyone was affecting everyone else so that the exchange was fairly mutual. Impossible to say where particular ideas started or whose influence was stronger and more original."

However, the Minimalist community appears to have been more transient than that of the Abstract Expressionists. During this period,

the atmosphere in the New York art world became less receptive to an avant-garde movement that rejected dominant social values, particularly those of the middle class. Consequently, Minimalism, as an art movement, was a short-lived phenomenon. Only a few members of this group were successful in the art market, as an analysis of auction prices for these artists' works reveals (see Chapter 6). The works of these leading members of the group continued to be influential throughout the seventies, being purchased by museums and discussed by art journals, but the movement as a whole did not endure.

The New York Figurative painters developed a cohesive network that supported its members' advocacy of unpopular artistic values. However, these artists did not perceive themselves as an alienated avant-garde. On the contrary, they seemed to perceive themselves as belonging to a middle-class intelligentsia, who were mildly critical of American society but definitely not in opposition to it. Their network had its origins, during the late fifties, in a small group of artists who began sketching models together, first in the studio of an art teacher, Mercedes Matter, and later in the studios of other Figurative painters (Cummings, 1979: 163). At the beginning, the group included three Abstract Expressionists: Guston, McNeil, and Tworkov, and five members of the senior generation of Figurative painters: Cajori, Dodd, Finkelstein, Georges, and Pearlstein. All of the Figurative painters in the group had been taught or influenced by Abstract Expressionists or had been associated with the Abstract Expressionist community. It is significant that Pearlstein, who views this sketch group as a crucial event in his development as a Figurative painter, described it in an interview in 1972 (Cummings, 1979: 163) as being a group in which there was virtually no exchange of ideas: "Everybody worked totally independently. There was no discussion of each other's work or anything. It was a very exciting thing to be involved in. This went on and on, year after year, until gradually the personnel changed. But some of us are still there. We are still meeting once a week."

In 1968, an organization called the Alliance of Figurative Artists was formed in New York City. The first meeting was attended by a large number of artists, many of them young. Later, one of the artists, Sidney Tillim (1969: 45), described the organization as "an utterly disorganized, rancorous group." According to another account (Kuh, 1971: 88):

> there are no officers, no chairmen, no dues, no obligations. . . . a program committee . . . establishes loose guidelines in order to avoid rep-

etitious hangups. The meetings take various forms, sometimes revolving around panels, sometimes turning into open forums where artists bring their own work, defend it, explain it, and then listen to the uninhibited comments of their colleagues.

In its early years, the Alliance seems to have provided a valuable meeting ground for younger artists. One painter said: "When we first started, everyone who painted figuratively needed to share with each other, because the scene was so unaccepting of that. . . . While I was getting all my ideas together and teaching myself how to paint figuratively, the feedback I was getting there and the ideas were helping me tremendously." A sculptor commented: "To know that so many other artists were working in the figurative field was news to us. We had all considered ourselves kind of separate and isolated. When we all got together, we realized that maybe we weren't so isolated and that the thing we had to do was to continue to meet."

The Figurative painters were the only group to span three generations. Almost one-third had been born before 1930, about one-quarter during the thirties, and over one-third since 1939.[7] Fifty percent had been born in New York or on the East Coast and 41 percent had attended art school in New York City. Seventy-three percent were living in New York or on the East Coast in the late seventies. These social characteristics had undoubtedly affected the nature of the social group that had developed among them. Among those members of the group for whom information about acquaintance ties, personal ties, student-teacher ties, and organizational ties was available (87 percent), only 9 percent were not linked in some way to other members of the group. Twenty-eight percent were linked to one another by student-teacher ties. Eight informants were linked to 92 percent of the group.[8]

As in the case of Abstract Expressionism, older artists with different perspectives on Figurative painting became the informal leaders of the group. Eventually, these different perspectives engendered increasing conflict and led to the formation of factions within the Alliance. Some members became increasingly argumentative at meetings and others stopped attending altogether.

From Counterculture to Acquaintance Network

As the number of artists working in New York increased (Ashton, 1973; Sandler, 1978), the artistic milieu shifted from a tightly-knit counterculture to a set of relatively transient, interlocking subcultures. The intimate face-to-face network of the Abstract Expressionists grad-

ually expanded, changing its structure and significance for its members. From the comments of artists we interviewed and who were interviewed by Cummings (1979), the original clique appears to have become an acquaintance network that crosscut different styles.[9]

The acquaintance network functioned as a social circle (Kadushin, 1976: 108–10) whose members were linked to one another through indirect as well as direct ties, which permitted information and ideas to spread through the entire group.[10] Since social circles have no clear boundaries, members can only describe them on the basis of their immediate contacts and are usually unable to visualize the entire network. Because these networks are not formally organized, they are often associated with formal organizational structures, such as an intellectual journal, a theater group, or a gallery. In this network, galleries played important roles.

Even in the forties, some galleries played a role as foci for social interaction among artists, but their role in this respect appeared to increase over time. Betty Parsons' gallery provided a setting where the Abstract Expressionists could meet to exchange ideas. Tomkins says of her gallery at that time (1975: 52):

> From the beginning, it was also a place where artists felt at ease. [Barnett] Newman was there nearly every day talking with anyone who came in. On Saturday afternoons, a dozen or more artists might gather in the back room and stay several hours, and then go out to dinner together. Newman, Pollock, Rothko, and Still all helped to hang each other's shows, and Betty Parsons gave them complete freedom to do so.

For a few years in the fifties, a group of Abstract Expressionist cooperative galleries existed in and around East Tenth Street, an area where many Abstract Expressionists lived and worked (Bard, 1977; O'Doherty, 1967). For the most part, these galleries served the second- and third-generation Abstract Expressionists who were too numerous to be absorbed by the avant-garde galleries of the period. For them, the co-ops were "their social club, their communications center, their parish hall" (O'Doherty, 1967: 165). Later, Ruda (1967) described Park Place, a cooperative gallery, which showed Minimalist and related works, as being created to be "a suitable place where we could show work and continue the exchange of artistic ideas."

Carl Andre (Interview, *Archives of American Art,* 1972) detected a similar sort of ambience at the Dwan Gallery in the early years of Minimalism:

Virginia Dwan had a sort of salon where people just sat around and talked and made jokes and drank and had a good time or argued and fought or whatever. It was quite a period. There were some amazing things as a result of that. . . . At the end of the season, there was a wide-open show: anybody could bring up anything they wanted and it got put on the wall and there was an amazing cross-section of things. Virginia was a great patron of the arts but it was a very practical kind of patronage, that is, to enable artists to work and get things done and get things shown and to sell their work.

The existence of an acquaintance network made it possible for smaller groups to form within it, devoted to the exploration of promising approaches. In general, social relationships among these artists became less important, except in small groups that emerged for short periods of time to debate the aesthetic issues underlying an emerging style. As one artist commented in an interview: "The art world is made up of subcultures within a subculture." Such groups were most likely to form in the early stages of the development of a style and tended to be short-lived. This was not, however, an indication that they were insignificant.

Such a subculture played an important role in the transition from Abstract Expressionism to Pop and Minimalism, a transition that required a major reconceptualization of aesthetic conventions and techniques, of the nature of art objects, and of their social meanings. This complex process began in a group of younger artists that formed around the Judson Memorial Church in Washington Square and a few downtown galleries, some of them cooperatives, and that included members of several art forms. Haskell (1984: 22–23) said,

> The downtown art scene in those days was remarkably intimate. Everyone knew everyone else—not through the bars that had functioned so effectively as the social meeting ground for the Abstract Expressionists, but through encounters at performance events and gallery openings attended by dancers, painters, sculptors, musicians, poets, and actors. Within this network of artists, aesthetic ideologies and loyalties were neither narrowly drawn nor mutually exclusive; visual artists mingled as freely with dancers and performing artists as with other painters and sculptors, with the result that aesthetic influences moved easily back and forth across disciplines.

Alloway (1975b: 151–52) defined the atmosphere of the short-lived Reuben Gallery as "an easy contact between artist and gallery, an affinity between the act of production and the act of presentation, which was very different from the regular marketing or promotional activ-

ities of art dealers. . . . The first season of the Reuben Gallery was a series of extraordinary exhibitions and happenings, packed with artists whose futures were beginning."

Within these settings, artists who would later be known as Pop artists and Minimalists experimented with "junk" sculpture made out of objects found on the city streets and with Happenings, a new kind of art-as-performance that attempted to translate real-life activities into art.[11] In a period of about five years, new ideas about art were developed, experimented with, and largely abandoned, along with the organizations in which they were created. However, they provided the impetus for the development of new directions in painting and sculpture.

When Pop art emerged, it was centered around a few individuals— Johns, Rauschenberg, Oldenburg, and Lichtenstein—who influenced each other's work. On the periphery were a few others, each of whom was linked to one of the leaders. Social interaction tended to take place between pairs of artists (for example, between Robert Rauschenberg and Jasper Johns and between Claes Oldenburg and Jim Dine). As the Pop movement developed, more of its imagery was taken from material that was readily accessible to any viewer; thus a common symbolic content did not have to be constructed through social interaction. Social interactions among these artists were less intense than among Abstract Expressionists. Alloway (1974: 9, 16) said: "Lichtenstein did not know Warhol's slightly earlier work but was, independently, on a track that led logically to the comics. Early Pop art, in fact . . . is peppered with convergences of separate artists on shared subjects." Jasper John's description of his relationships with other artists (Hopps, 1965: 36) is consistent with Alloway's statement:

> I've never been very close to very many artists. I was very close to Bob Rauschenberg and during a certain period was very familiar with Jim Dine's work and saw it being made. . . . I've seen a good deal publicly but not really been involved with people who were working because I haven't been there very much. . . . Sometimes one would like a rein-forcement that comes from closely contacting someone else who is working, seeing what his responses to his own things are.

Robert Indiana described the tenor of these relationships in an interview years later (Diamonstein, 1979: 160): "Actually, we were not a collective, we were all different artists. Some of us knew each other and some of us didn't." A few of the artists lived on the West Coast and were associated with one another in that setting, although they were influenced by members of the New York group. Although con-

temporaneous with Minimalism, the Pop artists came from different backgrounds, particularly the commercial arts, in which a semiprofessional artistic role was already established. At least one-third of the Pop artists had previously worked as commercial artists. Only four of the Pop artists were influenced by their peers in other styles or by their immediate predecessors, the Abstract Expressionists.[12]

During this period, the acquaintance network acquired a kind of permanence, with the result that cohorts of artists arriving in New York in subsequent decades were absorbed into this network and consequently linked directly or indirectly to a large number of their peers. One member, speaking of the mid-sixties, said: "We had a lot of close friends, a floating group of about 200 people." Members of later styles tended to follow each other's work but there was seldom an intense level of intellectual exchange. A New York informant said: "We all see each other's work. It's important to keep up with what others are doing."

In this context, artists became less dependent upon their interactions with one another, particularly when they were developing aesthetic ideas that were consistent with the dominant aesthetic paradigm, modernism. At the same time, the artistic role became increasingly acceptable in American society, which also decreased their dependence upon one another. According to Buettner (1981: 151), the contemporary artist works within "a highly flexible information network where the variety of stimuli is abundant."

Under these conditions, some styles emerged when artists who had had no previous contacts with one another began to work along the same lines. Many of the Photorealists did not settle in New York City. Only 17 percent of these artists had attended art school in New York City and only 40 percent of them were residing in New York or on the East Coast in the late seventies. One of the earliest critics to write in depth about this group (Chase, 1975b: 7) perceived the entire set of artists more as a cultural than as a social group:

> Hyperrealism is not a movement in the formal sense. . . . Many of the artists have never seen each other. They come from many parts of the United States but they have been subjected to the same influences and are preoccupied in a similar manner by the problem of translating these influences in painting. Perhaps one can speak of a common sensibility based on the relationship between the artist and his subject.

Dealers were instrumental in bringing some of the leading Photorealists together (Doherty, 1979: 53; Meisel, 1981: 7). Meisel said: "Be-

ginning in 1973 my wife, Susan Pear Meisel, transformed our loft into the 'salon' of the Photo-Realists. In that year, they all met one another there, most for the first time, at the first of the now annual Fall parties and since then there have been over one hundred gatherings." However, Robert Cottingham (Doherty, 1979: 53) commented: "We're all good friends now and we see each other at the openings of the gallery's exhibitions, but there isn't the kind of cliquishness that used to be a part of the New York scene in the 1950's and early 1960's."

In the late sixties and early seventies, alternative spaces provided settings in which artists expressed themselves in highly individualistic terms (Foote, 1976). Both settings and works were ephemeral. None of the alternative spaces lasted more than a few years. While co-ops supplement or replace the activities of galleries, alternative spaces challenge the assumptions on which galleries are based. Alternative spaces filled political and social functions of a very different nature than those of the conventional gallery, as is indicated in the following comment by Holly Solomon, who ran one for several years ("Alternatives in Retrospect," 1981: 28):

> It was a time of great distress when everything seemed to be falling apart, . . . opening the space was a political statement. We felt that we couldn't change the world, but that privately we could do something. Starting the space . . . was about maintaining a sense of one's own democracy, being responsible for one's own fear, and it was both a moral obligation and a pleasure.

Solomon moved from this setting to her own commercial gallery, where she showed Pattern painters, some of whom had had their first exhibitions in her alternative space. It appears that these settings fostered new developments, some of which eventually found their way into gallery settings. However, it was a critic who was instrumental in bringing some of the Pattern painters together for informal discussions in the mid-seventies (Marincola, 1981).

In the early eighties, the Neo-Expressionists emerged in the numerous small commercial galleries that appeared in the East Village, showing works by, and often owned by, artists who were unknown and relatively young. Local nightclubs also exhibited works by these artists. As in the earlier period, these galleries became centers for the social activities of artists; they were an integral part of the social networks in the local artistic community (Kardon, 1984).

During the fifties and sixties, the New York art world could be described as an extensive social network in which many participants

performed more than one role (Alloway, 1972: 28–29): artists served as critics; critics as curators and vice versa; art editors as curators; curators as collectors; and collectors as trustees of museums and as backers of art galleries. Groups of artists were linked to groups of sponsors or "constituencies" whose members were able to obtain a sense of new developments and trends through their participation in this network. Messer (in Diamonstein, 1979: 229) described how this network operated, although it was no longer working as effectively at the time of his statement:

> Young artists . . . do not live in the desert. They live in the city, and they know other young artists, and they move frequently in packs while they are young, and in those groupings, leaders develop, so the young artists are the first ones who express respect or awareness toward the best among them. And those young artists again know young curators and know young critics, and they live and work together, and the younger ones bring it to the attention of the middle-aged ones. The middle-aged ones bring it to the attention of the old ones, and eventually some action is taken.

However, as more and more artists arrived and more and more art was being displayed, it became increasingly difficult for the artistic gatekeepers to assess it adequately. Many exhibitions were not reviewed and, as we will see, the works of young artists in the newer styles were less likely to be purchased by prestigious museums than were works by their counterparts thirty years before.

Styles and Their Constituencies

In order to extend its influence beyond the confines of its immediate social network, a style must receive recognition in the art world. In order to achieve recognition, members of a style must obtain a nucleus of supporters in the art world or on its periphery. While the audience for avant-garde art is often perceived as being an upper-middle-class elite, it is actually more appropriate to interpret the audience for these works as consisting of a number of "constituencies," either organizations or subcultures, broadly defined, which purchase or support particular styles (for an analogous interpretation of the audience for popular culture, see Gottdiener, 1985). These constituencies comprise: (1) organizational patrons, such as the government, universities, and corporations that provide financial support for artists and purchase their paintings; (2) professional art experts, such as critics and curators,

who are well versed in the aesthetic tradition and who play important roles in the dissemination and sale of artworks; (3) dealers and private collectors. Each of these groups in turn has distinct subgroups, such as investment-oriented collectors versus old-style patrons, academic critics versus nonacademic critics, and curators of New York museums versus curators of regional museums.

Before 1948, the Abstract Expressionists were largely ignored by the New York art magazines, the mass media, and museums generally. A few critics wrote enthusiastically about them, including Clement Greenberg and James Johnson Sweeney. In addition to writing art criticism, the latter became director of painting and sculpture at the Museum of Modern Art in 1945 where he presumably played a major role in the museum's decision to acquire and exhibit works by these artists (Barr, 1977: 627). Prior to that time, he had been a member of the museum's executive committee. Not all of those who were connected with the museum were in favor of the early acquisitions. Barr (1977: 635) reports that older members of the Committee on Museum Collections opposed these purchases and one member resigned when a Rothko was purchased in 1952.

By the end of the forties, the Abstract Expressionists had acquired a nucleus of powerful supporters in the art world, including curators in key positions at the Museum of Modern Art, critics, dealers, and collectors (Bystryn, 1978; Mulkay and Chaplin, 1982). Many of these individuals represented not so much the values of a social elite as the expertise of a professional subculture devoted to the appreciation of art. Clement Greenberg, a leading member of this group, believed, for example, that art criticism should, like science, exhibit logic and precision and be based on general concepts rather than on intuitive reactions to the stimulus of a particular painting (Kuspit, 1979b). These academically based critics, who were trained in art history and aesthetics, were more theoretically inclined than the nonacademic critics, who were often poets and artists. In general, the academically oriented critics were concerned with the formal qualities of a painting—color, line, plane—while the nonacademic critics were preoccupied with meaning, either in sociological or literary terms (Glaser, 1970–71; Rosenberg, 1964). As time went on, these critics tended to specialize in small segments of the art scene, often the style that had come into prominence when they began their careers (Alloway, 1975b: 259). One writer accused them of "settling down in one area as resident codifiers or propagandists" (Baker, 1971: 144).

Like the Abstract Expressionists, the Minimalists were "sponsored" by influential critics and museum curators, as is seen in the fact that exhibitions at the Jewish Museum and at the Guggenheim Museum were important in launching the style (Ridgeway, 1977). At the beginning of the movement, before major museum exhibitions or substantial numbers of gallery shows had been held, these artists received a great deal of critical attention. Tuchman (1977: 27) described the critics' response to Minimalism:

> Long expository articles appeared quickly in well-circulated art journals (*Art in America, Arts, Artforum, Art Voices,* and *Arts Yearbook*) throughout 1965, even though no major exhibition had yet been held. Only a few shows in New York art galleries and one, or at the most two, one-person installations per artist had actually taken place, so lengthy discourse really preceded prolonged observation.

Battcock (1968: 26) claimed that the Minimalists and their critics were virtually collaborators (see also Tuchman, 1977). Influential Minimalists wrote about their own work and sometimes about the works of the others.[13] Due to their support from critics and curators, the work of these leading members of the group continued to be influential long after the movement had passed its peak.

In contrast to the reception for Minimalism, critical reaction to Pop art and Photorealism was generally hostile (Alloway, 1974: 9; Buettner, 1981: 148; Ivan Karp in Diamonstein, 1979: 189), while the mass media were receptive. Eventually, critics who specialized in these styles appeared but their social connections with the artists themselves seem to have been more superficial than was the case with Abstract Expressionism and Minimalism. The Pop artists did not write position statements, as most of the first-generation Abstract Expressionists and many of the Minimalists had done. Instead, interviews in which the artists stated their views replaced such statements (Alloway, 1972: 30).

Since Pop art incorporated objects and images from comics and advertising, the role of the critic was in a sense superfluous (Fröhlich, 1968). This style of art created a new type of relationship between the artist, the spectator, and the art object. The spectator shared the world of these artists and their subject matter, the everyday world of industrial, urban society; he no longer needed the critic to interpret such paintings for him. The fact that this type of art could communicate so easily meant that collectors were easy to find. Rublowsky (1965: 157) quoted the reactions of Leon Kraushar, an insurance broker, who became an important collector of Pop art:

It was when I discovered Pop art that I became really involved. Here
was a timely and aggressive image that spoke directly to me about things
I understood. The paintings from this school are today. The expression
is completely American, with no apologies to the European past. This
is my art, the only work being done today that has any meaning for
me.

The art dealer Leo Castelli said of Roy Lichtenstein in an interview
(Diamonstein, 1979: 223): "his production has always been very much
in demand, very very easy to sell." Rublowsky (1965: 159) argued that
collectors played a major role in the emergence of Pop art.[14] He claimed:
"Primarily the school was and is a collector's movement. Collectors
were the principal champions of the group, and they were responsible
for the success of the school. In this instance, collectors led the way."

By the twentieth century, the role of the patron had long since
ceased to have the characteristics of personal loyalty, diffuse mutual
obligations, and hierarchical dominance that were associated with that
role in earlier centuries (Zolberg, 1983). The twentieth-century Amer-
ican patron bought artworks in order to conserve them and to bequeath
them to museums. Some of these collectors created museums to house
their collections. Others participated actively on the boards of trustees
of museums and on committees that oversaw museum activities. There
remained an element of personal involvement with the artist and a
protective attitude toward his work that differentiated the twentieth-
century patron from the investor for whom art objects were to be
evaluated impersonally, in monetary rather than aesthetic terms. The
approach of the Italian Count Giuseppe Panza di Biumo toward col-
lecting has been described as follows (Trini, 1970: 109):

> Every choice has been determined by precise personal convictions. The
> sense of adventure is found in affirming his own intuition, and in ac-
> cepting the challenge that every new artist represents. His methods clar-
> ify their own implications when he states that "the works of art, the
> paintings, in a certain sense, are the visible continuation of my person-
> ality." In a sense they also enrich it and direct it in the process of mutual
> exchange.

In the sixties, with the rapid increase in the values of the works of
some contemporary painters, art collecting became a profitable if risky
investment. This aspect of collecting became increasingly noticeable.
Instead of willing their collections to museums, some of the new col-
lectors sold them at auction or at record prices to museums or to other
collectors. The collector as patron-protector of the arts was being re-

placed by the collector whose commitment to a particular work or style was likely to be brief. Robert C. Scull's extensive collection of Pop and Minimal art was sold at a dramatic auction for record prices in the early seventies (Patterson, 1973). Rather than creating a museum for his collection, Scull backed an art gallery (Rublowsky, 1965: 155). Leon Kraushar's major collection of Pop art was sold at his death to a German collector, Karl Stroher, who created a museum in Germany to house and display the works.

For a variety of reasons, Pop art achieved success much more rapidly than the styles that preceded it. Rublowsky (1965: 159) claimed that a highly publicized group show of these artists' works at an established gallery, that of Sidney Janis, succeeded in establishing this style in the art world. Sidney Tillim, a Figurative artist and critic, commented (1965: 19): "It has taken Pop art four years to achieve the hierarchical eminence which it took Abstract Expressionism about ten."

Sidney Janis claimed that each time he sold a new style a new group of collectors came to his gallery (*Archives of American Art,* 1972). This suggests that each style appealed to a different generation or to a different culture class (Peterson and DiMaggio, 1975).[15] Support for Photorealism came from a few dealers and collectors who were based in New York and from museums that were located for the most part on the West Coast. Two galleries in SoHo specialized in Photorealism and sent exhibitions of these works around the country (for a comprehensive list of these exhibitions, see Meisel, 1981). During the seventies, dealers became increasingly active in identifying new styles and marketing them aggressively. New York dealers began to collaborate with dealers in other cities instead of acting independently. Exhibitions were widely publicized in art magazines and sent on tour to museums and galleries in other cities, along with packages of interpretive literature (Simpson, 1981: 37). As the prices of some artworks continued to escalate, the judgments of dealers, curators, and collectors became increasingly important for an artist's career while the influence of the critic declined. Critics began to lament "the meaninglessness of the reward structure" and some predicted the total collapse of aesthetic standards.

With the exception of a few of the Modern Figurative painters who were moderately successful, the Figurative painters lacked a constituency in the New York art market. The most successful dealers, who were, as Simpson (1981: 39) shows, preoccupied with focusing the market "on a limited number of new developments," bypassed these artists as well as the women's movement in art, black art, and com-

munity-based murals (Alloway, 1984: 175). Jeffri (1980: 89) claimed that:

> the tightening of the commercial art market around a handful of galleries and their respective connections with collectors, critics, and museums, and the resultant lack of opportunity for newer artists, especially those doing nontraditional kinds of work, contributed to the rise of cooperative galleries in the 1970's.

More than half the New York galleries in my study had exhibited Figurative painters but these were not the galleries that had access to the auction market. While a much smaller proportion of the galleries (about 25 percent) had shown Pop and Photorealism, some of them specialized in these styles for a period of time and promoted them extensively. Some galleries became closely identified with particular styles, at least during the period when the style first appeared. Rublowsky (1965: 158) said that "three galleries—Leo Castelli, Green, and Stable—introduced Pop art." Sandler (1976: 211), discussing the early years of Abstract Expressionism, referred to the Betty Parsons, Samuel Kootz, and Charles Egan galleries as "the centers of vanguard art."

For the most part, the art professionals disdained works in the Figurative style. As the seventies progressed, criticism appeared to be in a state of "crisis" (Alloway, 1975b: 258–65; Kuspit, 1979a). The appearance of a variety of quite diverse styles challenged a central but rarely acknowledged critical tenet that only one type of art could be valid at a particular time. The Figurative painters suffered from a lack of theorists who could provide intellectual cohesion for the movement. Although a few Figurative painters published theoretical pieces, there was little consensus concerning their ideas (for example, Tillim, 1977; Laderman, 1967, 1968). The movement was described as lacking "a persuasive theory" (Kramer, 1974). Many of the Figurative painters were reviewed by one another (Kalish, 1980: 3) or by nonacademic critics for whom this type of activity was a free-lance, ill-paid adjunct to other jobs and, consequently, both unprestigious and relatively unprofessional. According to Alloway, the art journals followed the lead of the galleries, instead of providing an alternative perspective (Alloway, 1984: chap. 20). Wayne Thiebaud, a Pop artist who became a Figurative artist, complained (Strand, 1983: 197): "If there is a great lack in modernism, it would be the lack of a critical community to provide the artist with confrontation of şufficient depth and seriousness."

To the extent that these artists had a constituency, it was to be found in regional museums, particularly academic museums, and corporate collections. The proportions of these organizations that had purchased Figurative paintings were substantially higher than for other styles in my study (table 7.8).[16] Coincidentally, almost three-quarters of the Figurative painters had taught part-time or full-time in colleges, universities, or art schools. Rosenberg (1965) claims that provincial art is concerned with content and its implications, with "the tension of singular experiences," rather than with form. In other words, it is more concerned with the moral dimension of art than with the aesthetic dimension. To the extent that these characteristics were also to be found in Figurative painting, this may explain the predilection of regional museums for this style.

To summarize, these styles were sponsored by different elements in the art world. Abstract Expressionism and Minimalism drew their support from academic critics and the curators of New York museums who were committed to the modernist aesthetic tradition, while Pop, Photorealism, and Neo-Expressionism drew theirs from dealers and investor-collectors. The Figurative and Pattern painters appeared to lack a major constituency in the New York art world; their supporters were to be found in regional museums and corporate collections. The Pattern painters were primarily favored by corporate collections (table 7.8). Consequently, the styles in my study had varying degrees of success in the New York art market, as indicated by the extent to which they had access to the auction market and to the collections of the major New York museums. The leading members of the older styles, as a result of their influential sponsors, became a kind of establishment that had greater access to artistic rewards than most of their successors. They also were more likely to be considered "avant-garde."

The Social Context of the Avant-Garde

During this period, the social context in which art movements appeared was gradually transformed and this in turn affected the ways in which these movements were perceived. When Abstract Expressionism began, its members were a tiny enclave who perceived themselves as being at odds with the rest of American society and totally isolated. This image persisted long after it had ceased to be an accurate reflection of their situation. In fact, they were highly successful in creating a vital social network that included not only themselves but artists working in other styles and other art forms, as well as influential

critics, dealers, and curators. This social network became the center of the dialogues concerning the nature of the avant-garde during this period and assured the access of these artists to this title. Significantly, as the participation of the first generation of Abstract Expressionists in the social network declined and as factions developed in the group, their influence in the art world waned.

The emergence of Pop and Minimalism required a fundamental shift in the definition of art objects and their social roles. This transformation, which preceded Pop and Minimalism, was accomplished in a small, short-lived counterculture associated with junk sculpture, Happenings, and developments in music and dance. Some of these artists eventually contributed to Pop and Minimalism.

Like the Abstract Expressionists, the Minimalists created a social network. Although it appears to have been more transient than that of the Abstract Expressionists, it included influential dealers, critics, and curators who developed a strong commitment to the particular conception of art that Minimalism represented. In a sense, Minimalism came to represent the epitome of the avant-garde in subsequent decades. By contrast, Pop's status as avant-garde was controversial due to the aesthetic content of these works and the extent of their appeal to collectors rather than to critics.

As the New York art world expanded in size, subsequent art movements established themselves in different ways. The Figurative painters developed a strong artistic community but they were less successful in winning the allegiance of influential critics, curators, and dealers. The title of avant-garde eluded them for social as well as aesthetic reasons (see Chapter 3).

A similar fate attended the Pattern painters, who developed a much more transient social network, embedded to a considerable extent in the feminist movement, and the Photorealists, whose social network was largely created and sustained by dealers and collectors. These groups remained too marginal to the centers of power in the art world to be heralded as avant-gardes.

At the end of the period, the Neo-Expressionists were able to establish themselves in an extremely competitive environment by creating a social network that was closely linked to galleries created by themselves and their friends and identified with a new art neighborhood, the East Village. Their skill at dramatizing themselves and their work succeeded in attracting the attention of the artistic establishment but, ironically, as we will see, these artists rejected the concept of the avant-garde as outmoded in favor of a new interpretation of the artistic role.

The Dual Role of the Avant-Garde: The Aesthetic Tradition and the Crisis of Meaning

While "avant-garde" implies a group of artists whose values are in opposition to the dominant social values, it appears that it is generally the exception rather than the rule for the artist to have been both politically and aesthetically radical. Nochlin (1967) contrasts the unusual case of Courbet, a true artistic and political rebel, with what she sees as the more typical example of Manet, who was aesthetically radical but in terms of his social stance alienated from bourgeois society rather than committed to its demise. Shapiro (1976) in her study of avant-garde artists in the early twentieth century found that while they often held radical political views, their commitment to unconventional aesthetic values was stronger than their political loyalties. They were unwilling to sacrifice art for politics. Poggioli (1971) stresses the "dehumanized" quality of avant-garde art in the twentieth century in which aesthetic issues rather than human beings are the center of attention. The epitome of this type of avant-garde approach was that of modernism, broadly defined, an orientation toward art that produced the major abstract works of the twentieth century and that appears to have inspired many of the theoretical discussions of the avant-garde.[1]

Vitz and Glimcher (1984), who have made an extensive study of modernism, argue that the work of this group of artists can only be understood in the context of modern science and that the content of these works is closely related to the science of visual perception. They show that the distinctive characteristics of modernist art were influenced by this science: abstraction, the elimination of perspective space which led to the flattening of the picture plane, and a preoccupation with theorizing and experimentation on the nature of visual perception. These painters were directly influenced by the visual scientists of their day, such as von Helmholtz, Gibson, and members of the Gestalt movement in psychology. French painters such as Georges Seurat and

Robert Delaunay made intensive studies of scientific color theory. Delaunay's writings were filled with technical words that show the influence of scientific terminology. Even the abstract forms that he used in his paintings were taken from the diagrams of color scientists. The Swiss painter Paul Klee developed his ideas about the principles of contrast and gradation of color by systematically painting color sequences. Vitz and Glimcher (1984: 103–4) state: "A typical scientific color progression is a series of step-like increases or decreases in the purity or strength of a particular color. . . . Such color progressions are frequent in Klee's work."

The modernist aesthetic tradition provided artists with a worldview which shaped their interpretation of reality and defined the problems that they should examine in somewhat the same way that a scientific paradigm shapes the worldview and activities of the natural scientist (Kuhn, 1970), the difference being that the natural scientist is committed to testing and rejecting ideas while the artist is concerned with demonstrating and exemplifying them. The significance of this aesthetic tradition for the artist is indicated by a comment of Robert Motherwell, an Abstract Expressionist (quoted in Sandler, 1976: 202), that "Every intelligent painter carries the whole culture of modern painting in his head. It is his real subject, of which everything he paints is both an homage and a *critique*, and everything he says a gloss."

This type of art became increasingly abstract and esoteric, preoccupied with its own intrinsic problems of visual perception and organization. As Gablik says (1977: 83), it was "an autonomous art of pure relationships." She argues that art in the twentieth century became a "mode of thinking" that involved the construction of formal logical systems, deriving endless combinations from a few basic units such as the square, circle, cube, rectangle, and triangle.

In this chapter, we will show how the aesthetic tradition of modernism left an enduring imprint on the roles that American artists assumed in the postwar period, leading to the exclusion from their work of humanistic values and sociopolitical commentary. These tendencies were supported by the increasing integration of the artist into middle-class and particularly academic roles during this period. In 1950, Willem de Kooning (M. Tuchman, 1970: 30), a leading Abstract Expressionist, when asked whether artists were craftsmen or professionals, responded: "I think we are craftsmen, but we really don't know exactly what we are ourselves, but we have no position in the world—absolutely no position except that we just insist upon being around." But as early as 1966, the critic Harold Rosenberg noted that

(quoted in Buettner, 1981: 125): "Instead of being . . . an act of re-bellion, despair or self-indulgence, art is being normalized as a profes-sional activity within society."

In the 1980s, Davis (1982) claimed that the late twentieth-century American artist exists in a symbiotic relationship with the middle class, which is alternately stimulated and entertained but not threatened by his aesthetic provocations.

While these changes in the artist's social position were taking place, a group of academic critics was becoming increasingly influential in the New York art world. These critics emphasized the formal aspects of modernism at the expense of content and meaning, and conse-quently reinforced the role of the artist as aesthetic innovator rather than social critic. Significantly, those who were excluded from the reward system, particularly women artists, were instrumental in re-viving the neglected dimensions of social opposition in the artistic role.

Commitment to the Aesthetic Tradition and the Crisis of Meaning

During the forties and fifties, the aesthetic tradition of "modernism" had an enormous influence upon the problems with which the Abstract Expressionists and their followers were concerned and upon their treatment of those problems. While Abstract Expressionism is some-times viewed as having been a complete break with the past (Arm-strong, 1964), in fact, according to prominent critics (Carmean in "The Great Decade of American Abstraction," 1974: 16; Rose, 1978: 110), it represented a synthesis of the major styles that dominated the art world during the three previous decades, especially Cubism and Sur-realism. By accomplishing this synthesis, the Abstract Expressionists succeeded in assimilating French art into the American tradition in such a way that subsequent generations of American artists could con-tinue to build on these innovations but at the same time incorporate them into their own experience. French art ceased to be a foreign "import" (Shapiro, 1973: 7) and became an integral part of the Amer-ican art scene.

That the Abstract Expressionists were able to synthesize the major trends in twentieth-century European painting was due to a remark-able coincidence of historical and social factors that brought American painters into direct contact with representatives of these European tra-ditions. In other words, the Abstract Expressionist movement was made possible by the fact that the existing European art tradition was

for the first time transmitted to American artists in America on a personal basis at a moment when these artists themselves had finally developed an artistic community in which ideas could be exchanged, evaluated, and reconceptualized.

One of these artists, Hans Hofmann, was exceptionally well qualified to transmit the European artistic tradition of the twentieth century, having known personally many of the leading European artists during the period when their major innovations appeared (1900–1920) (Rose, 1978: 110), and having, upon his arrival in the United States, assumed the role of teacher. He became the self-appointed theoretician for the movement. Rose credits him with being the main channel for the transmission of vital elements of German Expressionism to the Abstract Expressionists. Although he did not actually teach other first-generation Abstract Expressionists, the atmosphere of his school, combined with his charismatic personality, was such that artists, whether or not they were officially students, were able to participate in the discussions that were taking place (Ashton, 1973: 79).

Hofmann's theoretical writings were largely concerned with explicating how a painter can achieve certain effects in his work by the use of color and by the organization of pictorial space. His major topic was the relationship between color and form: the ways in which the interrelationships between colors can produce the perception of space and volume. Having begun his career as a scientist (Ashton, 1973: 81), he drew his ideas in part from the work of scientists who had written about colors and how they interact and in part from the work of artists such as Picasso, Braque, Matisse, and particularly Robert Delaunay, whom he had known during his youth in Paris (Landau, 1976). According to Rose (1978), Hofmann had a profound knowledge of all the masters of modern French painting, including Matisse and Picasso, as well as the German Expressionist tradition of Kokoschka and Corinth and major art theorists such as Delaunay, Mondrian, and Kandinsky. He viewed his work as building on the ideas of these men just as they had in turn developed their paintings from the innovations of Seurat and Cézanne. Rose (1978: 110) says:

> The significance of Hofmann's fusion of the primary sources of modern color painting—Fauvist primitive expressionism and neo-Impressionist scientific optics—together with Cézanne's conception of an ambiguous shifting picture space was so radical and far-reaching that it is still in the process of being assimilated by both artists and critics.

The one movement with which Hofmann was not familiar was Surrealism, but the arrival from Europe of Surrealist emigré artists at the end of the thirties provided the personal channels for transmission of this tradition to the Americans. The Surrealists furnished essential ingredients for what was to become the Abstract Expressionist style (Hunter, 1959: 134). Their emphasis on the intuitive, romantic elements of painting, embodied in their ideas of "automatism" and the importance of instinct, combined with the principles underlying Impressionism and Cubism to make it possible for the Abstract Expressionists to break away from the geometric abstractions characteristic of Cubism and its offshoots. The work of more than half the Abstract Expressionists was characterized by the use of organic forms, reminiscent of biological organisms, rather than by straight lines and grids.

At the same time, these artists perceived themselves and were perceived by others as being isolated from the mainstream of American society. In spite of the fact that there was a sizable art market (Loucheim, 1944) and a public for certain types of art, the Abstract Expressionists felt themselves to be totally misunderstood by that public. Buettner (1981: 100) commented:

> Whether factually or not, the Abstract Expressionists thought of the artist as a solitary individual, forced into isolation not so much by desire, as by the insensitivity of an ill-informed public. Living at odds with society and the remainder of the accepted art world, these artists existed in a state of "hopelessness". . . . the artist's isolation . . . was an idea that surfaced again and again.

Clement Greenberg, writing in a British literary review in 1947 (quoted in M. Tuchman, 1970: 16), lamented:

> The morale of that section of New York's Bohemia which is inhabited by striving young artists has declined in the last twenty years, but the level of its intelligence has risen, and it is still downtown, below 34th Street, that the fate of American art is being decided—by young people, few of them over forty, who live in cold-water flats and exist from hand to mouth. Now they all paint in the abstract vein, show rarely on 57th Street, and have no reputations that extend beyond a small circle of fanatics, art-fixated misfits who are as isolated in the United States as if they were living in Paleolithic Europe. Most of the young artists in question have either been students of Hans Hofmann or come in close contact with his students and ideas. . . . The forseeable result will be a collection of *peintres maudits*—who are already replacing the *poètes maudits* in Greenwich Village. Alas, the future of American art depends on them.

That it should is fitting but sad. Their isolation is inconceivable, crush-
ing, unbroken, damning. That anyone can produce art on a respectable
level in this situation is highly improbable. What can fifty do against a
hundred and forty million?

Their response to the repressive social climate that developed in the
postwar period was to concentrate upon aesthetic values. Rebellion
against society took the form of a bohemian life-style and the act of
creation itself rather than the "content" of their art (Sandler, 1976:
200). They disdained popular culture and middle-class life-style in fa-
vor of an intense commitment to aesthetic goals and high culture. The
views of Clement Greenberg about the relationship between the avant-
garde (high culture) and kitsch (mass culture) reflected the attitudes of
these artists (Greenberg, 1961b). Years later, Adolf Gottlieb was asked
in an interview: "Whom is art for?" He replied (Siegel, 1973: 59):

> It is for just a few special people who are educated in art and literature.
> I would like to get rid of the idea that art is for everybody. It isn't for
> everybody. People are always talking about art reaching more people. I
> don't see why they should want to reach so many people. For the large
> mass of people there are other things that can appeal to them. The
> average man can get along without art.

Critics often characterized these artists as "manqué religious men,"
"seers," and "myth-makers." Their own conception of the artistic role
is suggested in this statement by Barnett Newman (quoted in Cava-
liere, 1981: 45):

> The new painter is . . . the true revolutionary, the real leader who is
> placing the artist's function on its rightful plane of philosopher and pure
> scientist, who is exploring the world of ideas, not the world of the
> senses. . . . the artist today is giving us a vision of the world of truth
> in terms of visual symbols.

Since the subject matter of painting was of secondary importance
in Hofmann's writings, his approach, combined with their alienation
from their social environment, contributed to what these artists re-
ferred to as "a crisis of subject matter" (Sandler, 1976: 31). "Meaning"
was a major problem for these artists. Their rejection of the nonartistic
culture of their time might have led them in the direction of political
radicalism but the social conditions of the period precluded that. Many
American artists in the 1930s had seen their work as a means of ex-
pressing their dissatisfaction with social conditions in American soci-
ety, particularly with the treatment of the disadvantaged (Shapiro,

1973). The Abstract Expressionists came to maturity during that period and many of them started their careers with the idea that painting should criticize or even attack the social order. The advent of war in the forties made it difficult for painters to be critical of society, and they gradually assumed a neutral position. In 1944, a leading Abstract Expressionist, Robert Motherwell, wrote (quoted in Ashton, 1973: 162): "The artist's problem is *with what to identify himself.* The middle class is decaying, and, as a conscious entity, the working class does not exist. Hence the tendency of modern painters to paint for each other." A comment by Clyfford Still (M. Tuchman, 1970: 153) also exemplified this attitude: "I'm not interested in illustrating my time. . . . Our age—it is of science—of mechanism—of power and death. I see no point in adding to its mammoth arrogance the compliment of graphic homage."

In the early years of the style, they turned to ancient myths and primitive art in search of symbols that transcended their own time and place and that expressed man's deepest psychological needs. Their art became an act of self-discovery and revelation in which their paintings reflected their personalities. Their goal was to replace explicit content with personal symbols suggestive of the preconscious and unconscious mind, "of the unknown within themselves" (Hobbs, 1978: 24). Dreams, hallucinations, and memories were regarded as having greater reality than objects in the external world (Buettner, 1981). According to Hobbs (1978: 18, 25):

> Abstract Expressionist were not interested in the visual world. Their main concerns . . . were to penetrate the world within themselves and to paint . . . their feelings about the world rather than the world itself. . . . the subject matter existed on the fringe, the fringes of civilization . . . and the fringes of the mind, which led them to peripheral imagery, the fringes of vision.

By the late forties, many of the Abstract Expressionists were attempting to eliminate all traces of existing symbol systems in order to create an art that would be stripped of "surface detail and secondary ideas" (Alloway, 1984: 64). For some of them, this meant that they were approaching the process of painting without preconceived ideas, expecting the meaning of the painting to emerge during the act of creating it. They believed that in this way they would find their true subject matter. The desire for complete involvement in the process of painting is said to have inspired Jackson Pollock's method of placing canvases on the floor and dripping paint on them from above. In this

way, he felt that he could literally "be in the painting" (Sandler, 1976: 93). Pollock himself stated (1947–48: 79): "When I am *in* my painting, I'm not aware of what I am doing. . . . I have no fears about making changes, destroying the image, etc. because the painting has a life of its own. I try to let it come through."

William Baziotes (quoted in Sandler, 1976: 93) expressed his attitude toward painting as follows: "What happens on the canvas is unpredictable and surprising to me. . . . There is no particular system I follow when I begin a painting. Each painting has its own way of evolving. . . . *As I work or when the painting is finished, the subject reveals itself*" (emphasis added).

Another member of this style, Franz Kline, stated (Sandler, 1976: 256): "I don't decide in advance that I'm going to paint a definite experience, but in the act of painting, it becomes a genuine experience for me."

The results of this approach were works in which there were no points of culmination: "no sharp climaxes—no focal points on which the eye can settle" (Sandler, 1976: 115). It was an art that did not conform to any preconceptions, eliminating all references to nature. It was also an art whose meanings could be interpreted in many different ways. Like all abstract art, these works were characterized by "uncertainty of meaning and ineffability" (Kuspit, 1978: 121).

Some of these artists saw their work as expressing emotion and feeling in a radically new way. Jack Tworkov (*Contemporary Artists*, 1981: 985) stated:

> The paintings are based on the belief that there is valid non-verbal experience psychological and emotional that can be expressed only through the painting medium, through color, tonality, texture, shape, surface—expressed all the more clearly when it avoids superficial references to "life," "Nature," etc.

Others, like Barnett Newman, believed that their work expressed ideas that had long been central to Western civilization. Newman stated that through his work he was seeking to understand the nature of life and death and that the understanding that he would achieve would be more profound than that of the engineer or the scientist (Cox, 1982: 69). He argued that his series of abstract paintings entitled *The Stations of the Cross* were more meaningful statements about the nature of human suffering than representational paintings of the same event.

Still others believed that they were in fact expressing the deeper social realities of their time that representational painting could not

have exposed. This interpretation was expressed by Adolf Gottlieb (quoted in M. Tuchman, 1970: 67):

> The role of the artist, of course, has always been that of image-maker. Different times require different images. Today when our aspirations have been reduced to a desperate attempt to escape from evil, and times are out of joint, our obsessive, subterranean and pictographic images are the expression of the neurosis which is our reality. To my mind, certain so-called abstraction is not abstraction at all. On the contrary, it is the realism of our time.

In the seventies, the Abstract Expressionists were criticized for their lack of explicit meaning and social implications. Kuspit (1978: 123) commented specifically on the works of Mark Rothko and Clyfford Still:

> the best Abstract-Expressionist painting never . . . conveys a final meaning. . . . The Rothko-Still picture is empty but not nothing; its flatness is activated and its emptiness pregnant. It is because of the intensity and implications of the picture's surface that we cannot enter it as we would an environment. It is too forbidding, too swollen with its own self-absorption and self-esteem, to permit easy penetration of its surface. . . . It is really an abstract wall. This alien abstract surface gives no clues to any content that might make us feel at home on it.

Battcock (1969–70: 48) interpreted their works in terms very different from their own:

> Despite claims to the contrary, the mainstream art of the 1940's and 1950's remains a critic's art rather than an art of rebellion. . . . It has little to do with anything of consequence and, amazingly enough, is all the more impressive because of its vacuity. . . . the midtwentieth century New York Abstract Expressionist turned his back upon the prevailing moral, social, cultural, and ethical crises of a society hell-bent upon its own destruction.

More recently, Guilbaut (1983) has argued that the works of the Abstract Expressionists expressed an ideology of risk and individualism that was compatible with the political ideology of the liberal establishment that emerged in America after World War II. According to his interpretation, this ideology, combined with the depoliticization of these artists, was responsible for their eventual acceptance by elite collectors and for the cooptation of their work by that elite for political purposes.[2] Both Guilbaut and Cockcroft (1974) claim that these artists' works later became "tools in the international propaganda" surround-

ing the Cold War in the 1950s. In this context, they argue that the Abstract Expressionists were depicted as exemplars of political freedom and used to further the imperialist political goals of the United States.

However, according to Meyer (1963), the later paintings, along with avant-garde works in other art forms, expressed a point of view that was completely antithetical to the basic values of Western art and thought. Meyer argued that these works rejected the humanistic orientation of Western civilization which viewed man as the center of the universe, in control of himself and his environment. Instead, they implied a universe controlled by chance in which traditional notions of causality and free will were irrelevant. Their implicit social meaning was that man was no longer the center of the social universe and therefore his feelings and reactions were no longer the reference point for art.

In effect, the efforts of these artists to find a new subject matter (which was in part a reaction against the subject matter expressed in European art and in part a reflection of their intense desire to be original) led them and their successors away from meaning and, concomitantly, from the artist's role as social critic. An unintended outcome of this orientation was an exaggerated emphasis by the subsequent generation of artists and critics on aesthetic issues at the expense of meaning. Ironically, the seer became a technician.

Minimalism and the Negation of Meaning

While the art of the Abstract Expressionists exemplified their withdrawal from social concerns, the art of the Minimalists was an act of negation toward both aesthetic and social values. Theirs was the most extreme position of any of the groups of artists in my study. Once the Abstract Expressionists had achieved a synthesis of major trends in twentieth-century art, those who wanted to move further in the direction of avant-garde innovation found themselves on the frontiers of artistic practice, testing the limits of art itself (Perreault, 1967). How much could an artist eliminate of the traditional elements of art and still produce art? For Minimalism, the art object as an object became the focus of interest. Leepa (1968: 203) explained the nature of Minimalism's detached attitude toward its subject matter: "Minimal Art focuses on sensations based on direct perception of objects, which in painting are the lines, colors, planes, forms, and not on symbolic inter-

pretation of them, as when a line is used to express a subjective emotional state of the artist."

Their focus was entirely upon the art work as an object stripped of social or psychological connotations. Frank Stella, a leading member of this group, stated (Glaser, 1968: 158):

> Any painting is an object and anyone who gets involved enough in this finally has to face up to the objectness of whatever it is that he's doing. He is making a thing. . . . All I want anyone to get out of my paintings, and all I ever get out of them, is the fact that you can see the whole idea without any confusion. . . . What you see is what you see.

His early paintings used a single motif for an entire canvas; the canvases themselves were often polygons rather than rectangles, with holes cut out of the center of the canvas. The Minimalists were even more extreme than the Abstract Expressionists in their rejection of middle-class values. They built on the ideas of Ad Reinhardt, an Abstract Expressionist, who has been called the first Minimalist (Buettner, 1981: 141). Reinhardt wished to expunge from his art all ideas, all emotions, and all values so that his art would have no subject matter and no social or practical value. This point of view is reflected in a statement by a Minimalist, Tadaaki Kuwayuma, who said (1964: 100): "Ideas, thoughts, philosophy, reasons, meanings, even the humanity of the artist, do not enter into my work at all. There is only the art itself. That is all."

To the extent that a humanistic approach appeared in this style, it tended to take the form of a concern with the effect of the art on the observer. David Hall stated ("Primary Structures," 1966): "My concern is to arouse an environmental change in the mind of the spectator through purely visual and mental participation with the object. . . . I feel the process of imbalance and questioning in the mind of the spectator becomes the subject matter." Another Minimalist, Ralph Humphrey, (1975: 56) stated: "The work should make the observers more aware of themselves. As they look at the work, they should realize their own consciousness of themselves."

Their work drew on the psychological theory of "wholes" (Haskell, 1976: 198), or Gestalts, and at times required serious efforts of discrimination on the part of the viewers. For the most part, the significance of Minimalist works lay in their solutions to aesthetic problems and not in their evocation of events and values outside the works (Alloway, 1968: 55). Unlike the Abstract Expressionists, the Mini-

malists sought to eliminate their own personalities from their work. They were not attempting to understand or express themselves through their art. Their sole objective was to reproduce the most fundamental aspects of visual reality (Leepa, 1968). In this sense, their art was the antithesis of humanism (Meyer, 1963). A critic (Leepa, 1968: 206) stated: "the Minimalist believes no definitions of self or of art are possible." Another critic (Rose, 1968: 296) referred to Minimalism as "a negative art of denial and renunciation."

As the style developed, the artists became increasingly concerned with relationships and patterns and not with objects, which ceased to have any intrinsic meaning (Wollheim, 1968: 399). Gablik (1977) argues that the Minimalists were the heirs of the scientific tradition in art. Having removed the subjective, emotional, and symbolic sources of innovation, they turned to rational approaches, such as the permutation of geometrical elements and other mathematical techniques, as well as experimental approaches. New shapes were constructed on the basis of logical operations that were manipulated without regard for meaning.[3] Gablik (1977: 88) quoted Carl Andre as saying: "What I try to find are sets of particles and the rules which combine them in the simplest way, that is, I look not for objects but for parts."

The role of the artist, in their conception, was analogous to that of the scientist or the engineer. A majority of the members of the style saw themselves as "problem-solvers" or as being concerned with scientific or mathematical ideas. Others were concerned with issues that are generally the province of semantics, criticism, and art philosophy (Leepa, 1968: 208). Robert Ryman said (Diamonstein, 1979: 338):

> [Painters] try and solve problems—aesthetic problems concerning painting—very much in the same way that a scientist goes about solving certain problems. . . . You can't work on everything, so you take what interests you most and you explore it, and you find what solutions are possible, what can happen with this, and where it will lead to, and one solution will set off a new problem that enables you to see something that you weren't able to see before, because you didn't know about it.

While painters in earlier styles occasionally resorted to experimentation to perfect their technique for presenting reality, Robert Irwin used such methods to examine and to question the nature of painting itself: image, line, frame, focus, signature, permanence, and objecthood (Weschler, 1982; Levine, 1976; Butterfield, 1976). At one time, he set up a special environmental space in his studio which has been described as follows (Levine, 1976: 76):

The room has rounded corners and all the walls, floor and ceiling were painted white with the power sources and general lighting systems hidden from view. In this space, he worked with almost every conceivable light source such as lasers, spots, and wall washers which he borrowed and rented. . . . Irwin also sought out scientists, especially physicists and people who were involved in perceptual experimentation . . . not only to see what they were doing, but how they were thinking and approaching their view of matter, energy and perception.

Others used precise systems of measurement to create effects that could not be generated in any other way. Charles Ross explained his approach as follows (Varian, 1968: 377):

I would describe this as six sets of prisms with six prisms in each set. The prisms are three inches on a side and are spaced three inches apart within each set. That is, they are spaced evenly, the same distance apart as they are wide, producing a perfectly regular grid. The sets are identical except in length. . . . The perception of space and light through the prisms changes character with the changes of length of the sets.

Along with their rational approaches to innovation went industrial techniques of execution. Many of these artists were sculptors using industrial materials, such as bricks, Styrofoam planks, cement blocks, and wooden beams, and relying on industrial technology and skilled workers to execute their ideas. Brian O'Doherty (1968: 255), who was himself a Minimalist, called them scholar-artists "whose thoughts are carried out by others."

Eventually, many of these artists moved either into Conceptual art (Meyer, 1972), in which the intellectual aspects of the artwork were all that remained, or returned to more traditional modes of art. For those who took the latter route, the experience was apparently associated with a period of emotional and intellectual crisis.[4] On the other hand, the style made possible the emergence of other, even more radical forays into "basic research" on art, the outcome of which has been a complete redefinition of the nature of sculpture (Haskell, 1976: 213).

The Legacy of Modernism

Hofmann's ideas had a major influence on Clement Greenberg, who became one of the leading critics of the Abstract Expressionist movement. Greenberg argued that the goal of the modernist approach was to establish the autonomy of painting as an enterprise by eliminating from its activities effects that were associated with the other arts. Thus,

as Greenberg says, "modernism used art to call attention to art" (1961a: 103). Because the flatness of the pictorial surface was more character-istic of painting than of any other art form, he argued that "modern painting oriented itself to flatness as it did to nothing else" (1961a: 104).

Central to the canons of modernism, as it was developed by both of these men, was the idea that a painting consists of distinct elements or parts. Establishing a relationship among the different parts of a painting—organizing the surface of a picture—was like solving a puz-zle. The more successful the solution, the more important and influ-ential the painting. Bannard (1966: 35), a painter and art critic, commented: "The consciousness and pressure of this simple idea is the basis of the stylistic revolution of modern art. It is the core of the modern 'mainstream,' which one way or the other affects practically every artist."

Hofmann himself in the forties and early fifties became increasingly involved with the mechanics of achieving artistic effects (Cochrane, 1974a), which he conveyed to his students by means of analytic diagrams. Drawings and paintings were meticulously dissected in terms of the juxtaposition of colors and their relationships to two-dimensional planes. Many of Hofmann's students became represen-tational painters, thus extending his influence into subsequent styles (Cochrane, 1974a).

Meanwhile, Greenberg's ideas were adopted and developed by a group of influential academic critics (Reise, 1968a, 1968b). Greenberg himself became "more didactic, more concerned with philosophy and history, and removed from concrete aesthetic encounters" (Reise, 1968a: 256). In other words, the new version of modernism that emerged in the fifties and sixties was one which analyzed art works entirely in terms of their formal characteristics and treated these elements as "the final reality of the work" (Kuspit, 1979b: 172). Painters increasingly concerned themselves with problems intrinsic to painting itself. This meant an emphasis upon the visual configuration of the painting at the expense of meaning, particularly humanistic meanings. Jack Beal ("Seven on the Figure," 1979: 17) argued that the principal thrust of modernism was "to drive us away from nature, to make aesthetics the most important thing in painting." Possibly Greenberg himself fore-saw this outcome when he predicted that "the more closely the norms of a discipline become defined, the less freedom they are apt to permit in many directions" (Greenberg, 1961a: 106). The effects of these de-velopments could be seen in subsequent styles.

When artists turned from abstraction to representation, the aesthetic concerns of modernism remained important for many of them. For example, many of the Figurative painters were dealing with the aesthetic issues underlying abstract painting, including Abstract Expressionism:[5] the surface of the canvas as a two-dimensional picture plane, the use of color in a pure and expressive state, a desire to work within a large-scale image, and a delight in the tactile and physical qualities of paint (Doty, 1982: 35). One of the Modern Figurative painters, Nell Blaine, described the lasting effects of her exposure to Abstract Expressionism (Sawin, 1976: 107): "I never really left abstraction. The sense of organization and the way of putting a picture together comes from the abstract days. I can approach nature with confidence because of that."

The Modern Figurative painters were applying the modernist aesthetic approach to traditional subject matter, such as portraits, landscapes, still lifes, and domestic interiors; machines, shops, and their products were absent. Kahn (1979) points out that the subject matter of these painters tended to be "neutral," "uninteresting in its own right, simple, right-at-hand, everyday." Typical of these artists was the lack of psychological overtones even in situations where they might be considered most appropriate, as was the case in the work of a leading member of this group, Philip Pearlstein, who said of his exceedingly naturalistic nudes (quoted in Mainardi, 1976: 72): "All I am trying to do is to see things as they are." Generally, they attempted to eliminate meaning from their works. For example, Alex Katz said of his work (Strand, 1983: 124, 129):

> I like my paintings to deal most with appearance. Style and appearance are the things that I'm more concerned about than what something means. I'd like to have style take the place of content, or the style be the content. It doesn't have to be beefed up by meaning. In fact, I prefer it to be emptied of meaning, emptied of content.

Many of these painters had no desire to probe beneath the surfaces of their material. They were concerned with the aesthetic aspects of appearances and not with the reality itself, as is suggested in Henry's (1981c: 114, 116) comment on the works of the so-called Painterly Realists who comprised 26 percent of the Modern Figurative painters: "it is painting in which artfulness, the very act of painterly perceiving, is sanctified beyond religion, and even beyond aesthetics, a style in which painting itself is seen as the best equipment with which to face reality."

Often these artists were teaching in universities, colleges, or art schools, either full-time or part-time. By and large, they had discarded the life-style traditionally associated with a bohemian avant-garde and had assumed the role of academic with its concomitant overtones of detachment, both political and emotional, from the larger society. These artists were characteristically pessimistic about the possibility of communicating with the public. A Figurative painter expressed this attitude in a letter to the author:

> I have always felt that . . . art can claim only modest effect on the lives of most people. . . . Significant art is made for the appreciation of other artists. If there is significance or profundity in a work of art, the thing that is significant or profound is something that is understood by one that has a knowledge of the context in which the work is made—in a formal sense, in terms of subject and historical milieu. Beyond a purely visceral appreciation, the uninformed or inexperienced will get only a small part of the significance of a work of art.

By contrast, some of the Figurative painters for whom a commitment to the style of traditional painting had replaced a preoccupation with the aesthetic issues of modernism were more concerned by the separation between contemporary art and social realities.[6] Paul Georges (Cochrane, 1974b: 59) stated: "for art to function in this spiritual role, there must be a subject that communicates with the viewer about life or living, and most modern art lacks a genuine subject. . . ."

Among the Photorealists, interest in aesthetic issues frequently became a preoccupation with techniques and technical effects. Chuck Close said that he was not interested in the invention of shapes and color combinations but in the invention of the means of producing a painting—continuous tone, dots, sprayed dots, scratches, etc. (Harshman, 1978: 142). Blackwell (Meisel, 1981: 83) made a similar point: "Working from the photograph requires a new kind of invention—an invention of means rather than of forms."

To the naive viewer, these paintings appeared to be nothing more than literal transcriptions of a celluloid image onto canvas. However, careful analysis reveals a multitude of small changes that were necessitated by the differences between the two media and that produced a substantially different effect (Mackie, 1978; Seitz, 1972). Some of these artists worked from several photographs of the same subject so that their paintings were composites rather than copies. Meisel (1981: 176) described the advantages of this practice, as used by Don Eddy:

A window creates a triple situation; it has a surface, its transparency allows the appearance of a second image, and it reflects a third vision. Because of the way the eye functions, we never, in reality, see all three as separate images at the same time. By incorporating information gathered from several photographs and forcing it all onto the single focused surface of his painting, Eddy makes the physiologically impossible seem logical. A camera cannot achieve the same result because, like the eye, it focuses on either foreground or background.

In other words, while documenting the physical, observable aspects of reality with great accuracy, some of these painters were attempting to produce a new kind of pictorial reality, the reality we actually see and which cannot be mediated by a photograph. However, in this style as in the modernist version of Figurative painting, aesthetic issues of this nature generally superseded "content." A critic (Raymond, 1974: 26) commented: "The clarity of their technique is deceptive because these works say so many things in their refusal to say anything . . . The elusiveness of meaning could be what they are about."

Pattern Painting: The Artistic Role in Transition

During the middle and late seventies, artists' perceptions of their role in society and their relationship to the public were gradually transformed. Some artists were attempting to make social statements and to have an impact both on the art world and on the public. At the same time, many artists continued to stress the aesthetic aspects of the artistic role, although the aesthetic issues were gradually being redefined in terms of the ambiguous concept of "postmodernism" (Levin, 1979b). These contradictory tendencies were exemplified in the phenomenon of Pattern painting.

Pattern painting originated in the less commercialized sector of the art market and was described as an "artist-generated" movement (Perreault, 1977: 33), as compared with the increasingly frequent phenomenon of "dealer-generated" movements (Simpson, 1981). Some of these painters had their first exhibitions in "alternative spaces," not-for-profit organizations supported by federal or state funds, that were intended to provide settings where artists could express themselves in highly individual terms. From those beginnings, they moved into conventional galleries (Solomon in "Alternatives in Retrospect," 1981: 28).

The Pattern painters sought to merge modernism with non-Western art traditions and with motifs from folk, ethnic, and women's crafts

in order to express humanistic and decorative themes that had been excluded from the domain of modernism. By their use of decorative motifs that have been identified with non-Western cultures and that have often been created by anonymous women artists, they intended to alter the role that had been assigned to these types of art in Western culture. For these artists, decoration was perceived as a humanizing element in the environment rather than as a second-class art, which was the role to which it had typically been assigned by the avant-garde. They sought to evoke in viewers outside the art world a new respect for this type of art and for the values it embodied. By integrating the techniques of domestic crafts such as hooking, sewing, and quilting, and feminine subjects such as houses, fans, and clothing with the concerns of modernist painting, Miriam Schapiro, among others, fused aesthetic issues with psychological and political ones (Frank, 1982). They were making an appeal for recognition of the importance of "feminine" values, such as feeling, sensitivity, and humanism.

Pattern painting was created in part by middle-class women[7] but was intended to reach women in other social classes. Instead of seeing the goals of art primarily in aesthetic terms, as members of previous styles had generally done, some of these artists believed that both the production and the appreciation of art were a means of self-understanding. Harmony Hammond (*Contemporary Artists,* 1981: 381) stated that "art symbolizes the confronting and gaining control of one's life." Miriam Schapiro ("Ten Approaches to the Decorative," 1976) described the ideology which inspired her work as: "the wish to have the art speak as a woman speaks . . . to be sensitive to the material used as though there were a responsibility to history to repair the sense of omission and to have each substance in the collage be a reminder of a woman's dreams."

The desire to communicate with a larger public was not confined to the women in this group. George Sugarman ("Ten Approaches to the Decorative," 1976) said that he wanted his paintings "to be a rich and complex experience for the viewer." Perreault (1977: 36) saw this art as having the potential for breaking down the superficial elitism of Western abstract art. He argued that it could be "more an art of the people than most forms of social realism."

Even artists in this group who worked entirely with nonrepresentational motifs were intending to make a social statement. Specifically, they were attempting to construct abstract designs that would serve as visual metaphors for certain aspects of contemporary society. It was no accident that Mary Grigoriadis (Robins, 1973: 3) referred to her abstract

paintings as "a series of secular icons." In other words, in the works of these artists, abstract motifs were used to suggest and comment upon the realities of contemporary experience. Tony Robbin ("Ten Approaches to the Decorative," 1976) expressed this idea as follows: "patterns—which can be complex in themselves—when juxtaposed, superimposed, or interpenetrated, establish spatial complexity which I think is the most potent metaphor for contemporary experience."

Robbin argued that the way in which space has typically been presented in Western painting since the Renaissance is no longer an adequate expression of our visual experience (Ratcliff, 1978: 101). Unitary and consistent pictorial visual space has been rendered obsolete by the variety and the contradictions of contemporary experience, which is characterized by cross-cultural contact, new technologies of communication, and indeterministic theories of scientific cause and effect.

Consequently, multiple and contradictory spatial systems are beginning to seem more aesthetically and philosophically satisfying. Abstract designs that incorporate spatial complexity and simultaneously perceived events have a high degree of resonance as metaphors for the effects of modern technology and the mass media on our culture. In some instances, these abstract designs act as metaphors for the topography of an industrialized country. William Schwedler's paintings have been described as having the look of "man-ordered landscapes, futuristic airports, freeways of some bizarre L.A. on the outer reaches of the imagination" (Wallen, 1980: 172).

Other abstract paintings by members of this group have been constructed in such a way that their visual meanings are constantly changing, suggesting a parallel with the effects of communication overload in our mass-media-dominated society. These paintings contain ambiguities that give the viewer the feeling that he could never completely absorb their meanings. For example, Kendall Shaw's work was described in these terms (Sawin, 1977: 8): "it is the refusal of these groupings to crystallize into set patterns that gives the work its ongoing resonance. . . . Each painting must be experienced and reexperienced in time as the ambiguous patterns contradict one another." Murry (1980: 14) noted in William Conlon's work that: "It is not clear whether to read the white shapes as being in front of or behind the elements they cover. Though overlapping, all parts are whole and yet ambiguously curtailed, seeming to move in front of and behind each other although they occupy the same plane."

Like Abstract Expressionism, Pattern painting was a synthetic style, but in this case the traditions that were fused had not heretofore been

seen in the same context.[8] Not only did their work build on non-Western sources but it also used elements of the Western art tradition, particularly the work of Matisse, who had experimented extensively with patterns in the early years of the twentieth century. To some extent, the Pattern painters were also the heirs of the Minimalists, applying the Minimalists' ideas about the use of systematic, rational, and mathematical methods to the production of artworks that were at the opposite extreme from Minimalist "objects"—sensuous, colorful, and crowded. Others drew representational motifs from popular culture and embodied them with strong political and emotional overtones (Friedman, 1982: 21). Consequently, the style was, in some respects, controversial and frequently misunderstood. It is not surprising that the work of Frank Stella, a major artist who began his career as a Minimalist and who moved into Pattern painting in the mid-seventies, was viewed as merging all the major art movements (Hopkins, 1976). One critic (Levin, 1979a: 22) said that in Stella's recent work: "all kinds of modernist forms proliferate into wild mutations, and the past styles of our century are synthesized into a new grammar of scavenged ornament—deliberately vacant, aggressively careless—as if Constructivism and Cubism, Surrealism and Pop had become one common language."

Conclusion

Each of these art movements redefined the aesthetic content of art but they did so in different ways. Led by Hans Hofmann, the Abstract Expressionists redefined artistic conventions concerning the appropriate way to approach the canvas. They did not begin with a subject, the subject emerged from their work on the canvas. In a sense, the canvas became the subject. As these ideas were adapted by the second and third generations of the Abstract Expressionist movement and by the Modern Figurative artists, the organization of the canvas and its visual configuration became the essence of the work.

With Abstract Expressionism, the modernist aesthetic tradition became highly esoteric, excluding from its domain humanistic values, decoration, representation, and the rapidly expanding phenomenon of popular culture. The styles that followed Abstract Expressionism either attempted to extend it in even more esoteric directions or, alternatively, to reincorporate into the aesthetic tradition the elements it had discarded. Thus the Minimalists raised questions concerning the nature of the art object itself: the art object was no longer used to represent

something else; it was itself the subject but stripped of all emotional and social connotations. By contrast, some of the Pattern painters attempted to integrate non-Western, nonrepresentational art traditions and Western crafts with modernist principles; others created a new synthesis from disparate elements within the modernist tradition. However, in their effort to assimilate traditional arts, these artists were behaving in a way that is antithetical to the concept of the avant-garde: the avant-garde challenges rather than resurrects the past. The Figurative painters by reintroducing representation and, particularly, the Traditional Figurative painters by attempting to revivify traditional European techniques of painting and the humanistic values associated with them were also violating this norm.

For reasons having to do in part with the political climate and in part with the nature of the norms for painting that developed within the artistic community, many artists during this period concentrated on the aesthetic rather than the social and political dimensions of the avant-garde role. It was primarily those who felt themselves to be excluded from the artistic community and the art market, such as women and minorities, who introduced political or social themes into their work.[9] As we will see in the following chapter, other styles redefined the social content of art in different ways, by incorporating themes from popular culture and by satirizing the aesthetic tradition itself.

Popular Culture as Art: Pop Art as a Transitional Style

In the early sixties, radically new subject matter appeared in some of the artworks produced in New York. An important role in this transformation was performed by the Pop artists, who selected their subject matter from the mass media and manufactured objects, using techniques from commercial art, including advertising and comic book illustration. Totally different in their work from their predecessors, the Abstract Expressionists, and their contemporaries, the Minimalists, Pop artists were at first rejected by critics but rapidly acquired a following of collectors and established themselves as an important element in the New York art world.

A style that satirized and rejected the aesthetic tradition underlying avant-garde art but was at the same time successful in the avant-garde "reward system" raised in a particularly salient manner the issue of the nature of avant-garde art as well as its relationship to popular culture. It appeared to question the widely accepted assessment of a leading art critic, Clement Greenberg, that the avant-garde aesthetic tradition and popular culture were totally dissimilar and that any contact between them would endanger the former (Greenberg, 1961b), a view that was shared by many members of the Frankfurt School (Huyssen, 1975). The uncertainty about how to classify Pop art was heightened by the fact that much of it appeared to reflect rather than challenge the dominant values of American society (Davis, 1977). In this chapter, I will explore the following questions: What was the nature of Pop art; specifically, what was its relationship to the aesthetic tradition of avant-garde art and to popular culture? What was the nature of its influence on subsequent developments in the New York art world?

Pop Art and the Avant-Garde

Even while Pop art was at the height of its success in the New York art world, there was considerable controversy among critics concerning

the aesthetic aspects of these works. Some claimed that the Pop artists enhanced the significance of commonplace subjects and revealed "subliminal" meanings by presenting them in new contexts (Chase, 1976: 22). Others accused them of being unable to develop, of simply repeating their ideas (Moffett, 1974: 32). Bannard (1966) argued that these painters had abandoned the aesthetic tradition of modernism and were no longer contributing to the development of aesthetic ideas. The debate was complicated by the fact that, within modern art itself, there were different orientations toward the aesthetic tradition. As we have seen, the aesthetic tradition of modernism underlay the major abstract works of the twentieth century and provided the foundation for most of the styles in the New York art world.

Running parallel to this development was another movement in avant-garde art, pioneered by a French artist, Marcel Duchamp, at the beginning of the century and characterized by an attempt to break down the boundaries between avant-garde art and everyday life by arbitrarily labeling commonplace objects as artworks (so-called "ready-mades"). By drawing a mustache on a reproduction of the Mona Lisa and exhibiting a mass-produced urinal as a fountain sculpture, Duchamp changed the meanings of these objects, destroying the unique and sacred quality of the former and altering the significance of the latter (Benjamin, 1973; Huyssen, 1980).

During the fifties, John Cage, an avant-garde composer, was extending Duchamp's ideas and applying them to the composition of avant-garde music. Cage's goal was to produce accident-determined art, one in which the artist's self and every distinction between art and everyday experience would disappear. Rejected by his fellow musicians, Cage deliberately sought contacts with artists in other art forms. He was an early member of the Abstract Expressionists' "Club" (Kirby and Schechner, 1965: 67). Under his influence and that of his long-time collaborator, dancer Merce Cunningham, a group of dancers, painters, and poets participated in radically innovative dance programs and "Happenings" at the Judson Memorial Church in Greenwich Village (Jowitt, 1971: 81).

Cage's influence on painters was twofold: he helped them rediscover everyday images, artifacts, and events and also turned them toward a new intellectual course, building on the ideas of Duchamp that art should be full of games, puns, and paradoxes (Sandler, 1978: 170; Perreault, 1968: 259; Rose, 1968: 280). On the other hand, this movement helped to undermine the concept of high culture in the visual arts by exposing it to ridicule and by suggesting that popular culture and high culture were interchangeable.

There were two major strands in Pop art. The first orientation developed from the ideas of the artists who had been involved in Happenings (Baldwin, 1974) and who were seeking to bring about a change in the viewer's attitude toward familiar occurrences. Some of the earliest Pop artists took as their theme the task of demonstrating the underlying ambiguity of the signs and messages that saturate contemporary society. Claes Oldenburg's "store" in which he exhibited sculptures of everyday objects such as signs, clothing, and food represented the iconoclastic aspects of Pop. Alloway (1974: 101) described these sculptures as "manic transformations of the kinds of merchandise actually sold and the display signs in real stores."

The works of Pop artists reflected their ambivalence toward the aesthetic tradition and their desire to connect it in some way with the visual imagery of popular culture. For these artists, the connection between the visual imagery of serious art and that of popular culture had become increasingly problematic. Two comments by Claes Oldenburg are illustrative (Glaser, 1966: 23): "I am especially bothered by the distinction between commercial and fine art, or between fine painting and accidental effects. I think we have made a deliberate attempt to explore this area, along with its comical overtones." A few years later, he said more humorously (Van Devanter and Frankenstein, 1974:216):

> If I didn't think what I was doing had something to do with enlarging the boundaries of art, I wouldn't go on doing it . . . art which has slept so long in its gold crypts, in its glass graves, is asked to go for a swim, is given a cigarette, a bottle of beer, its hair rumpled, is given a shove and tripped, is taught to laugh, is given clothes of all kinds, goes for a ride on a bike, finds a girl in a cab and feels her up. . . .

In general, these artists' treatment of the aesthetic tradition was satirical. Lichtenstein parodied and caricatured famous works from the modern aesthetic tradition, including paintings by Cézanne, Picasso, Mondrian, Monet, and Abstract Expressionism (Seitz, 1972: 64). Mel Ramos parodied French paintings from the eighteenth and nineteenth centuries, such as works by Manet, Boucher, and Ingres (Truewoman, 1975). Jasper Johns created works that drew on and extended the ideas of Duchamp in order to comment on the nature of artistic symbols (Johnson, 1965: 140). These artists seemed to be suggesting that neither art nor the artist should be taken too seriously in modern society.

However, this aspect of Pop art also led away from genuine originality in the direction of pastiche, an element that would become

more noticeable in subsequent art movements. Here, the aesthetic tradition was used as a source of images and themes which were juxtaposed incongruously with one another or with elements of popular culture, producing something rather like an anthology. Jim Dine's work was described as follows (Kozloff, 1964: 37):

> His facture . . . can armingly impersonate, separately or together in the same picture, infantile daubing, narcissistic Abstract Impressionism, a Sunday painter gaucherie, various forms of window display sketchiness, and, now, decorator's enamel color samples. . . . Dine's works are frequently quotations within quotations, or allusions mixed with quotations, or parodies joined with allusions, or a riot of all these possibilities together.

Other artists treated popular subjects differently. The epitome of this alternative orientation toward popular culture was seen in Andy Warhol's work and life-style and in his refusal to make any sort of comment on his subjects, treating in a similar fashion Brillo boxes, photos of electric chairs, and Marilyn Monroe (Amaya, 1971: 220). From a cultural point of view, Andy Warhol was a major figure in this movement, representing in an extreme form the nature of the transition in aesthetic values that has taken place in American art since the sixties. His work represented something radically new, the implications of which have only gradually become evident. In other words, part of Pop art was not simply using themes and images from popular culture; it was in fact a form of popular culture, in terms of the way in which it used these materials.

Although some artists produce highly esoteric works in the context of popular-culture industries, popular culture to a large extent is based on formulas that consist of standardized procedures for creating an aesthetic effect (Cawelti, 1976). In works of this kind subjects that have universal appeal are presented in such a way that complex themes are simplified. Since formulas can be used over and over again with slight modifications, new versions can be produced with great rapidity. These characteristics of formulas are epitomized by Andy Warhol's silkscreen portraits which he began producing in the early sixties. While artists working outside contemporary art styles often select elements from existing aesthetic traditions and reduce them to formulas, Warhol by contrast created new formulas using elements from popular culture. In other words, his themes, his techniques, and often his materials, in the form of mass media photographs, were taken from popular culture. In essence, his subject matter was an implicit

commentary on the impact of "media culture" on modern life (Deitch, 1980; Schjeldahl, 1980).

Warhol's silkscreen portraits were based on photographs of the subject, ranging from publicity stills, news photos, and old family snapshots to Polaroids taken by Warhol himself (Bourdon, 1975: 44). Although based on photographs, they provided less detailed information about the subject's face than portraits by, for example, Figurative painters (Bourdon, 1975: 44). In other words, the complexity of the subject matter was greatly reduced in these portraits, along the lines of a formula. In fact, Warhol was not presenting the subjects of his portraits as they really were but as "glamorous apparitions." Warhol superimposed upon his subjects a simplified and more glamorous version of their visages and personalities. Blemishes and unattractive traits were covered up while the importance of the eyes and lips was generally exaggerated. His intention was said to be to make the portraits "intensely flattering." He did so by creating standardized images of his subjects that fit certain conceptions of beauty that have been widely diffused in popular culture. Paint was applied to the photographic images at various points during the "quasi-mechanical" process of producing the final version, but Warhol emphasized that he did this very casually, even sloppily. In fact, effortlessness was characteristic of all his artistic productions, including filmmaking and writing. Craftsmanship was taboo. Warhol disclaimed any allegiance to an aesthetic tradition. He was said to achieve his best effects as a result of intuition. Critics claimed that his work showed little awareness of formal and conceptual problems (Rubin, 1978: 10).

Popular culture is often produced by groups of collaborators or by an individual with several assistants. In this sense, too, Warhol's style of artistic production corresponded to popular culture. Since the early sixties, when he called his business The Factory, he was continually surrounded by assistants and colleagues. In the sixties, his entourage included a rock band and a film crew. In the seventies, the group acquired a monthly newspaper and a television program, in addition to producing books. Hughes (1982: 8) commented that Warhol mass-produced "his images of mass production, to the point where the question of who actually made most of his output in the Sixties has had to be diplomatically skirted by dealers ever since (probably half of it was run off by assistants and merely signed by Warhol)."

By contrast, the portraits by Chuck Close, a Photorealist, which were also based on photographs, exemplify the nature of avant-garde innovation. Like Warhol, Close frequently used the same photograph in a series of paintings, but there the similarity ends. Where Warhol used a standardized procedure for creating his silkscreen portraits, Close used a different process to create each of his portraits. In this respect, every one of his paintings was different from every other. He has said (Diamonstein, 1980: 115):

> I think there are as many paintings as there are people. And every time I approach another image, to me it poses a totally new set of issues. . . . I know what my paintings are going to look like, but I don't know what I'm going to do in the studio. The problem is to see how many times I can keep going back to the well and still come up with something different.

Having a deep interest in problems of visual perception, Close was particularly concerned with discovering how seemingly trivial alterations could make a fundamental difference in the way a painting was perceived. Unlike Warhol's paintings, Close's paintings revealed a great deal about their subjects. He has compared people's faces to "road maps of their lives" (Diamonstein, 1980: 116). By magnifying their faces many times, he revealed every wrinkle and every laugh-line of his subjects' features. Again, unlike Warhol, he was the sole creator of his paintings and generally spent close to a year on each one.

While Warhol's work is the most explicit example of Pop art as popular culture, other Pop artists used similar themes at times. Robert Indiana used letters and numerals as formulas. Roy Lichtenstein used formulas drawn from another medium, comic strips. Tom Wesselmann created a partially dehumanized nude that appeared repeatedly in his work. Alloway's (1974: 65) discussion of the work of Robert Rauschenberg suggested that it too was based on something analogous to a formula:

> Rauschenberg is a prolific artist who can tolerate a good deal of company as he works. This is because his improvisations, which are constantly inventive, are protected by operational custom. That is to say, his improvisation is concentrated on actions in which he is already proficient. For instance, when printing silk screens on canvases or transferring photographs onto lithographic stones, he is handling familiar material, using it in a serial form from one work to the next.

Shrewd regulatory lore can be found, too, in the combine paintings
which seem so hectic in their intersection of different materials and
sign levels. . . . This underlying simplicity enables Rauschenberg to
improvise at speed, where a more sophisticated structure would impede
him.

Rauschenberg's "combine-paintings" were assembled from exist-
ing materials, such as assorted junk as well as photographs from
newspapers and magazines. Such works implied that the contem-
porary artist no longer creates new images but uses the enormous
"archive" of existing images (Alloway, 1974: 66)

When they depicted human beings, these artists' works shared
with advertising and some other aspects of popular culture a kind of
impersonality that verged on dehumanization. For example, Tom
Wesselmann's nudes had pubic hair, nipples, lips but no eyes. The
relative absence of the human image in Pop art is sometimes seen as
paradoxical, given its connections with everyday life (Alloway, 1974:
24) (48 percent of these artists did not include people in their paint-
ings), but it was also in keeping with the highly stylized and one-
dimensional presentation of objects that was an important element
in Pop art.

The material of many of these works was familiar to the spectator
and its success depended upon that familiarity (Alloway, 1974: 80).
Some observers interpreted these works as largely reflecting rather
than revising the symbolic meanings of popular culture. Moffett (1974:
32) stated: "No interpretation is offered save the tacit irony resulting
from a deadpan presentation of the banal in the context of artistic
seriousness. Context becomes content."

Other critics implied that the effect of Pop paintings on the viewer
was similar to the effects of many advertisements which place objects
that connote certain kinds of images or feelings in the same context
with the products that are being publicized, thereby associating these
meanings with the product (Williamson, 1978: 19, 43). For example,
Bannard (1966: 35) claimed that Pop depended on "prefabricated units."
He said (1966: 33): "It is a part of the nature of these works to act as
triggers for thought and emotion pre-existing in the viewer and con-
ditioned by the viewer's knowledge of the style in its several forms,
as opposed to the more traditional concept of a work of art as a *source*
of beauty, noble thought, or whatever."

Finally, was Pop art an avant-garde movement? Clearly, Pop artists
redefined several of the aesthetic and social dimensions of art. They
redefined conventions about appropriate subject matter by incorpo-

rating materials from comics and advertisements that had originally been created as popular culture and by creating replicas of commonplace objects such as food and household furnishings. Some of these artists, such as Robert Rauschenberg and Jasper Johns, redefined the nature of the canvas by attaching objects to it such as bedding or pieces of wood (Siegel, 1985: 152-53). Others, such as Claes Oldenberg, redefined the art object by creating installations that were actual settings rather than representations of them. New techniques such as the silkscreen process altered the process of creating an artwork.

However, the element of "protest" in Pop art was directed toward the aesthetic tradition itself, in the form of satire and parody, and not toward the larger culture. Pop also attempted to redefine the relationship between high culture and popular culture by revising conventions concerning subject matter and technique that had served to maintain the distinctions between them.

Popular Culture in Subsequent Styles

Pop appears to have been a transitional style that led not only to a renewal of representational art but also to the introduction of new themes, specifically, popular culture and middle-class life-style. To a considerable extent, it made possible the emergence of "middle-class" art within the aesthetic tradition while, at the same time, it undermined the prestige of the aesthetic tradition through its veneration of popular culture. Its effects could be seen specifically in Photorealism, Pattern painting, and Neo-Expressionism but were by no means confined to those styles. On the other hand, in each of those styles, it was possible to find artists who were working entirely within the modernist aesthetic tradition.

Pop's treatment of everyday objects provided a strong impetus for the emergence of Photorealism, which also dealt with manufactured objects but from a different perspective. At least 37 percent of the Photorealists in the study had been influenced by Pop, according to their own statements and critical evaluations. The Photorealists attempted to inject new life into modernism by painting from photographs, a practice that had hitherto been considered taboo.

Like their predecessors in Pop art, members of this style showed varying degrees of involvement in the modernist aesthetic tradition. The attitude of some of these painters toward the aesthetic tradition is suggested in this comment by Robert Bechtle *(Contemporary Artists,* 1981: 81):

[realism] offered the prospect of solving painting problems without being
overly aware of how others have solved them or even knowing what
the problems and possibilities might be. . . . I choose to paint the things
I do—cars, suburban streets, etc.—because they seem to offer the great-
est opportunity of looking without reminding me of other art.

Some of these artists were operating very close to popular culture,
as indicated by their selection and treatment of subject matter, such as
nudes, cars, and animals. While Pop artists tended to present manu-
factured objects outside their usual context, the Photorealists showed
them in their natural settings: city streets, diners, shop windows. But
it was not so much their presentation of these kinds of subject matter
that identified them with popular culture but their projection of the
values of popular culture within these materials. For example, eroti-
cism is a frequent subject in popular culture where it is generally dealt
with in physical rather than emotional terms, with the female as an
object rather than a subject. In some Photorealist paintings, women
were presented as sex objects, as one-dimensional and unblemished as
in advertisements. John Kacere showed women's buttocks lightly
clothed in colorful lingerie while Hilo Chen depicted naked female
torsos in bathtubs and showers (Meisel, 1981: 458-65; 451-54).

A more indirect legacy of Pop art was the desire to evoke an emo-
tional response in the viewer. Most Pop artists had maintained the
detachment toward their subject matter that was characteristic of the
modernist aesthetic tradition but which is not characteristic of popular
culture, where the objective is to elicit the spectator's identification
with the subject matter. Once the use of subject matter from popular
culture became acceptable, this dimension began to appear in contem-
porary painting. For example, Photorealist Audrey Flack claimed that
(Flack, 1981: 30-31) "All of the objects are carefully selected in terms
of the feelings I hope to evoke in the viewer. . . . I hope to reach many
people all at their own level."

Objects such as well-known brands of cosmetics, perfumes, and
cigarettes frequently appeared in her paintings as well as elaborate
pastries, costume jewelry, and photographs of popular culture heroines
such as Marilyn Monroe. As is typical of popular films and television,
her colors were exceptionally strong and dramatic. Symbolically her
work functioned through juxtapositions of images, some congruous,
some incongruous, that were intended to shape the viewer's percep-
tions of these phenomena. By contrast, Charles Bell, a Photorealist
who painted gumball machines and children's toys, used this subject

matter to explore highly technical problems concerning the refraction and reflection of light and the interaction of paint and color (Meisel, 1981: 55-57).

As we have seen, the Pattern painters sought to merge modernism with traditions from non-Western art and from folk, ethnic, and women's crafts in order to express humanistic and decorative themes that had been excluded from the domain of modernism. While some of these artists were attempting to use these materials to make social statements about the role of women in American society in the tradition of avant-garde opposition to the status quo, others drew representational motifs from popular culture or from areas that had strong political and emotional overtones. Again the way they used these materials was significant, as is seen in the following comment on the work of Kim MacConnel (Friedman, 1982: 21):

> Choosing the objects of our contemporary nightmares (the bombs, the missiles, the machines of war), MacConnel converts them into artfully contrived clichés, draining them of content, pacifying their threat and assimilating them into his repertoire of decorative motifs. Like a happy Midas, he has discovered that he can convert anything, any horror, any profundity, any thorny notion, into the bland beauties from which he fashions his hangings.

In other words, the desire to communicate with a larger public led some of these artists away from the aesthetic tradition toward popular culture, crafts, and interior decoration (Robins, 1980). Robins (1980) accused them of producing "artifacts" rather than artworks and of having lost touch with the ideas and values of the aesthetic tradition.

These tendencies reached a culmination in the early eighties in the Neo-Expressionist style, whose members turned for inspiration to rock music, particularly punk, illustrations from the "pulps," B movies, and science fiction (Halley, 1981; Shore, 1980). One of these artists (Richard Bosman, quoted by Ratcliff et al., 1982: 60) said: "For some time, a lot of my imagery has come from Chinese comic books—kung fu comic books. There's not a big difference between a kung fu image and an image of a Western gangster. And I also use images from American pulp magazines. . . . The idea . . . is to come through to the audience, to make contact."

More than any of the other styles that followed Pop, Neo-Expressionistism was obsessed by media images and mass-produced styles of decoration and dress. Again this style was a multifaceted phenomenon. Many of these artists appeared to be recycling images

from the mass media and outmoded styles. While Pop focused upon the artifacts of popular culture, these artists dealt with its themes: violence, explicit sexuality, and romance. For some of them, their use of these themes seemed motivated by a desire to be provocative, to elicit a reaction from their audiences (McGill, 1986). Their works were often taken from the reality of comics, television, and movies, not life (Halley, 1983: 89). Richard Bosman, who painted scenes of men being beaten or responding to undefined catastrophes, was quoted as saying (Siegel, 1983: 127) that he was not interested in political or propagandistic statements: "Nothing is real; it's just paint and everything is fiction."

Some of these painters reduced serious issues to the level of cartoon imagery. Recent paintings by Kenny Scharf were described (Moufarrege, 1982: 72) as full of "green monsters and red human debris, a nuclear cloud scatters frail humans around, the radio blares bepop and the Florida palm fluoresces pink-yellow."

Other members of this style were interested in images that have been seen so often that they have become clichés, such as Marlboro cowboys, cartoon characters, photos from movie fan magazines, electrical appliances, and trademarks, such as corporate logos or brand-name consumer products (Robinson and McCormick, 1982: 150). For some of these artists, these clichés were intriguing because they evoked a sense of nostalgia. They appeared to be using their art in order to come to terms with visual images depicted in the mass media and with styles of interior decoration in which they had grown up. These influences were embodied in elaborately decorated interiors full of kitsch designs and objects. Sometimes these materials were used for ironic comment, as in Rhonda Zwillinger's and Claudia De Monte's satires of mass media conceptions of romance and the traditional female role. Zwillinger's *Suicide Pillow* was described as (Glaser, 1983: 127) "a bauble-infected pillow with sharp edges extending like daggers, betraying the outcome of romantic love . . . meant as a criticism for the rampant marketing strategies that promulgate romance, fashion, and art as pure commercial enterprise."

In David Salle's work, the juxtaposition of incongruous images from popular culture and from art history was both jarring and evocative. He was described as "painting what had already been painted" and "consuming used styles" (Olive, 1985: 85). Still others took the impact of the mass media itself as their topic (Hutton, 1982: 17). By duplicating the ways in which the mass media manipulate images, they demonstrated their impact upon our perception of and emotional re-

sponse to these images. Robert Longo's works have been called "pastiches of mass-media imagery, nightmares and dreams" (McGill, 1986). However, the overload of media images is now such an overwhelming influence on Salle and artists with similar preoccupations, that it is questionable whether the necessary distance for irony can be achieved (Perrone, 1984: 105).

Alternatively, these artists poke fun at the aesthetic tradition, another tendency that began with Pop art. Returning to Duchamp's notion of the contradiction between mass production of images and the supposed uniqueness of the avant-garde art work, they place their own renditions of famous contemporary paintings in ridiculous situations (Glaser, 1983: 126).

While the Neo-Expressionists desired a larger audience than the prototypical avant-garde artist had ever sought, they were, for the most part, not aiming to challenge the public's preconceptions. Charles Clough stated (Ratcliff et al., 1982: 63): "I'm not challenging the world. I don't see how painting can be a threat to anybody. I don't see it as politically effective. I see it as diversionary. Art can inspire people."

The intention of many of these painters was to elicit an emotional rather than an intellectual response from the viewer. To the extent that these artists incorporated ideas from the aesthetic tradition, it tended to be in the form of a pastiche, not in a genuine attempt to innovate on the basis of these sources (Lawson, 1981). A critic (Lawson, 1981: 42) commented: "neoromantic, pseudosurreal aspects of fashionable French and Italian art of the '30s and '40s . . . Renaissance and Baroque painting, Indian miniatures, cheap religious artifacts, a certain type of anything is fair game. And whatever is accepted becomes the equivalent to everything else."

Julian Schnabel's description of the sources of his paintings typifies the attitude of these painters toward the past (Ratcliff et al., 1982: 69):

> My painting comes out of the continuum of art that has been. It's not antiart in any way. Different artists from the past have touched me, and I have looked to their paintings. . . . Vermeer expressed his understanding of light and time in a way that is indelible. If that's Expressionism, then I guess I'm an Expressionist. If not, I would say I'm not an Expressionist; my work is just expressive.

Significantly, in the early eighties, many young artists, including the Neo-Expressionists, claimed that the aesthetic tradition was "boring" and refused to work in it because they perceived it to be cut off from the "real" world (Lawson, 1981). Critics (Plagens, 1981; Lawson,

1981) were beginning to argue that the potential of the modernist tradition had been exhausted, that all the significant variations on these themes had already been used. The Neo-Expressionists, along with members of other new styles in the eighties, desired and sought a mass audience (Shore, 1980: 82), drawing their inspiration from the mass media rather than from the aesthetic tradition. The implications of these developments appeared to be that, in a society dominated by the mass media, popular culture is better able than avant-garde art to provide visual metaphors that reflect the problems and dilemmas of everyday life.

Popular Culture and Resistant Subcultures

Having discussed the increasing infiltration of themes from popular culture in the art movements that succeeded Pop art, I will now turn to an examination of the implications of these developments for our understanding of the role of art in contemporary society. The extent to which avant-garde art and popular culture influence one another has long been debated in the literature. A conventional interpretation, stated decades ago by the art critic Clement Greenberg (1961b, but written in 1939), is that popular culture borrows extensively from avant-garde culture and reshapes these materials according to its needs. By contrast, Crow (1983) has recently argued that avant-garde art draws on materials from popular culture and that this exchange serves the function of renewing and revitalizing both popular culture and the avant-garde aesthetic tradition. Specifically, he cites hypotheses concerning the role of "resistant subcultures" in cultural innovation developed by British sociologists of culture (see, for example, Hall and Jefferson, 1976). According to this thesis, contemporary societies should be conceptualized not in terms of elites and nonelites but as consisting of a wide range of social groups and networks, each with its own subcultural life-style (Gottdiener, 1985: 990). The British theorists maintain that marginal social groups often assume the role of "resistant subcultures." Such subcultures develop new forms of culture by revising the meanings attached to existing, mass-produced artifacts. They argue that such groups have influenced the character of popular music in Great Britain. The prototype of this process is the case of punk rock, in which a marginal subculture altered the conventional meanings of a wide range of commercial phenomena, including fashion and music, in order to express an ideology of alienation and rejection of contem-

porary values. Eventually, this style of music, in considerably diluted form, became popular in the United States as well as in Britain.

Crow (1983) argues that the artistic avant-garde acts as a liaison between resistant subcultures and popular-culture industries. In other words, by drawing on the meanings that marginal social groups have attached to popular-culture artifacts, the avant-garde revitalizes art and in turn passes on its aesthetic innovations to the popular-culture industry. Crow (1983: 253) asserts that "the avant-garde serves as a kind of research and development arm of the culture industry: it searches out areas of social practice not yet completely available to efficient manipulation and makes them discrete and visible." Thus, according to Crow, the avant-garde and popular culture are closely linked; the aesthetic discoveries of the avant-garde are actually derived from a selective appropriation of fringe mass culture as developed by nonelite groups, which is then passed on by the avant-garde in a somewhat different form to the mass culture per se. Using the examples of early Impressionism, early Neo-Impressionism, and early Cubism, he argues that these groups of artists integrated materials from resistant subcultures with their own aesthetic innovations in an atmosphere of intense mutual cooperation and exchange (Crow, 1983: 247).

Crow's discussion raises the question as to whether the meanings that contemporary artists attach to the popular-culture artifacts that they portray are derived from a resistant subculture and whether these artifacts are reincorporated into popular culture in a revised form as a result of these artists' activities.

Pop art contained several distinct tendencies. In general, the Pop artists seemed to be more concerned with altering the meanings of avant-garde art via satire and parody than with altering the meanings of the manufactured objects that they represented in their works. While the latter aim was often stated as their explicit intention, we have seen that instead they were more likely to incorporate the procedures of popular culture into their works. As Dore Ashton commented in the early sixties (Selz, 1963: 39): "[the Pop artist] doesn't aspire to interpret or represent, but only to present. . . . To the extent that it shuns metaphor, or any deep analysis of complex relations [Pop art] is an impoverished genre and an imperfect instrument of art. Far from being an art of social protest, it is an art of capitulation." More recently, Davis (1977: 87–88) stated: "the Pop sensibility is proudly objective and nonjudgmental. . . . the Pop sensibility is markedly indifferent to content and to personality. It accepts what it finds in the world . . .

and uses it quite often directly, without comment, as in Warhol's *Brillo Boxes.*"

Significantly, German critics at first interpreted Pop artworks as satires of American capitalism but subsequently revised their opinion and viewed them as supporting capitalist values (Huyssen, 1975). While Pop art initially took some of its imagery from advertising, it is an indication of the character of these works that the direction of the influence was later reversed (Huyssen, 1975: 86). In some instances, works by Pop artists were simply incorporated into certain kinds of advertisements, such as those by corporations (for example, the use of a photograph of Robert Indiana's *Love*).

For the most part, Pop artists presented manufactured objects outside their usual social contexts. To the extent that these objects were shown in a social context, the context was distinctly middle class, as is seen, for example, in the bedrooms and bathrooms in which Tom Wesselmann placed his numerous versions of the Great American Nude.

Most of these artists were drawing their materials, such as comics, directly from the mass media and not from the ways in which these media had been transformed by marginal users. To the extent that a "transformation of meanings" occurred, it was largely in the context of or as an offshoot of the activities of the artists who were associated with Happenings, a group that corresponded in some ways to the notion of a resistant subculture but one composed of artists rather than members of a lower-class subculture.

Warhol's fascination with homosexuals, prostitutes, and criminals might also be interpreted in terms of the resistant subculture hypothesis. Warhol has been seen as a precursor of the Punk movement that emerged in the late seventies, displaying similar values and representing, like it, a form of "anti-culture" (Kagan, 1978). A major attribute of his contribution to punk was his emphasis on indifference and apathy, combined with a fascination with violence, as seen in his series of portraits of the FBI's "most wanted" men. Warhol claimed that he was obsessed by nothingness and by emptiness and that his art was about "nothing" (Kagan, 1978).

At other times, Warhol appeared to affirm American values, at least those connected with the marketplace, as is seen in the following quotation (Alloway, 1974: 109): "I adore America and these are some comments on it. My image is a statement of the symbols of the harsh, impersonal products and brash materialistic objects on which America is built today. It is a projection of everything that can be bought and sold, the practical but impermanent symbols that sustain us."

While it might seem that he was introducing new materials from deviant subcultures into the cultural mainstream, it seems more likely that he was actually picking up a tendency that was already being exploited in the sexual imagery of Hollywood films in the persona of stars like Marlon Brando and Elvis Presley, both of whom were frequently the subjects of Warhol portraits (Kagan, 1978). Warhol's message dealt with the ways the mass media and popular culture present reality rather than the transformation of that reality by marginal subcultures.

Was there any evidence that the Neo-Expressionists were deriving their ideas from fringe mass culture as developed by nonelite groups? The fascination of these artists with punk-rock music and the inclusion of graffiti artists in Neo-Expressionist shows would seem to suggest that this was the case. Several successful artists who were identified with the movement had begun their careers as graffiti artists. However, there seemed to be little indication that the graffiti artists influenced the other members of the group. Instead, there was often a startling convergence of interest, as Robinson and McCormick (1982: 160) pointed out: "Graffiti shares many of the stylistic elements seen in East Village art—an obsession with trademarks ("tags"), the use of motifs borrowed from the comics and popular culture (custom-car design in particular), and adolescent taste for dramatic, lowbrow imagery."

Once the graffiti artists began to exhibit in commercial galleries, the works of many of them lost their resemblance to typical subway graffiti. In some cases, their paintings began to look more like the mass-media-influenced work of other Neo-Expressionists. As a critic (Storr, 1982: 144) said: "The difficulty is to keep such a furtive art lively once it has been domesticated to serve as gallery material."

As one artist said (quoted by Gablik, 1982: 37): "The vitality of graffiti is in its indigenous situation. It is difficult to accept it on white gallery walls. Then it becomes part of the commodity market. The social context is what gives it its meaning, and this is being ripped from it." There was little real influence across the two groups. Some of the graffiti artists were "assimilated" into the art world; others remained aloof from it and developed their work in different directions. The latter functioned more like members of a resistant subculture, forming collectives but remaining separate from the larger scene and distrustful of commercial success. In this context, these artists were more likely to draw on the grim realities of their social backgrounds to make the kinds of political and moral statements that were relatively rare in the Neo-Expressionist movement.

On the other hand, punk and new wave, products of a resistant subculture that had already flourished in another art medium, music, had a considerable influence on these artists. Punk, which began as a marginal form of rock music, was part of a counterculture with a distinct style of clothing and an ideology of alienation verging on anarchism. The punk aesthetic is said to have had a strong impact upon the emergence of the Neo-Expressionist movement. Robert Longo was quoted as saying (Shore, 1980: 78): "All my visual art is completely inspired by music, specifically by the punk and new wave music that's been happening in New York over the past few years."

Although in England the punk movement was linked to political protest, in America its influence was primarily stylistic, affecting popular music, fashion, underground film, and painting. A number of artists formed their own rock bands dedicated to this type of music. Some critics spoke of a new aesthetic of "visual punk" (Shore, 1980: 85).

To what extent did these artists actually form a counterculture of their own? As we have seen, many of these artists began their careers in the East Village, where they exhibited their work in small commercial galleries and local nightclubs. Some of the artists collaborated with one another, generally in pairs and sometimes in small groups. Robert Longo's large-scale paintings were described as (Cotter, 1984: 7:

> collective and collaborative on almost every level. They represent the combined work of a dozen or more painters, sculptors, and technicians, all of whom are pursuing substantial and growing careers of their own and all of whom Longo credits by name; some have even signed their contributions. They are all working here together in the kind of *bottega* situation which produced much of the public art of the Renaissance.

Another group of artists who called themselves AVANT gave painting performances in nightclubs (Moufarrege, 1982:72). Two of the most successful artists associated with Neo-Expressionism, Julian Schnabel and David Salle, produced joint works.

However, what tends to throw into question the conclusion that these artists had created a counterculture was the rapidity with which they were incorporated into the art market as a whole, including extensive press coverage and guest exhibitions in established galleries (Sandler, 1984: 18). McCormick (1984: 20) reported that "The East Village scene has received, in just about one year's time, a media

and market overload of attention that rivals any recent movement. . . ."[1] Their choice of commercial rather than cooperative status for their galleries reflects the fact that these artists were oriented toward commercial success to an extent that was almost unprecedented (Bourdon, 1985; Dowd, 1985). As Sandler (1984: 17-18) expressed it: "young artists and their friends . . . accept as role models rich and fashionable artists. . . . Eighties artists seek celebrity—the kind of fame and glamor achieved by rock or movie stars—and the tangible rewards it yields."

Both the rapidity with which they were accepted by the establishment and the extent of their desire for acceptance suggest either that the transformation of meanings in their work was not very substantial or that their work was enormously salient in a society in which the mass media supply and control so much of our visual experience. Their success may have simply been further proof that we live in a "media culture."

That the transformation of meanings performed by many of these artists was rather limited is indicated in part by the enormous speed with which the most successful ones worked, as well as by the fact that some were accused (McCormick, 1984: 22, 29) of the "glorification of Americana on its most middle-class levels. . . . Functionalism, Americana, kitsch and cartoonishness form the locus of an art that is . . . deeply rooted in Middle-American values." Another observer claimed that these artists (Ratcliff et al., 1982: 11):

> have settled into some of our pluralist present's most comfortable niches, carefully tended outposts of style-terrain from which trifling attacks on the media, the corporations, and the art world's most tattered fictions look incendiary . . . in their "street-wise" scruffiness, their raunchiness, their bad-taste borrowings from the media they only pretend to attack. . . ."

Conclusion

The rise of Pop art seems to have coincided with changes in the social environment of the artist and a gradual decline in artists' commitment to the aesthetic tradition of modernism. Changes in the social role of the artist and concomitantly the nature of the audience for his work were accompanied by a steady increase in the number of artists that made it more difficult for them to make themselves "visible" in the art market. One way to do so was to replace modernism with meaning systems that were already familiar to their audience.[2] By

drawing their subject matter from the mass media and treating this subject matter in a manner analogous to that of popular-culture in-novators, they found it easier to communicate with a wider audience. These tendencies could be seen in subsequent styles and to an even greater degree in Neo-Expressionism, a style which emerged in the early eighties. While the ways in which "resistant subcultures" had transformed certain types of materials from popular culture provided an inspiration for some of these artists, many others had redefined the objectives of artistic creation in terms of responding to and com-menting upon mass-produced images. The determination of many of these artists to work only with the "central images of our time" (Kuspit, 1982: 142) suggests that we are moving toward a new def-inition of the role of the artist, one which calls into question earlier attempts at classification. These new artists view their role more as popular-culture entertainers than as an avant-garde producing high culture. One Neo-Expressionist artist said (Jedd Garet, quoted by Smith, 1981: 160):

> I don't feel a responsibility to have a vision. I don't think that is quite valid. When I read artists' writings of the past, especially before the two wars, I find it very amusing and I laugh at these things: the spirituality, the changing of the culture. It is possible to change the culture but I don't think art is the right place to try and make an important change except visually, to have people see things differently. . . . Art just can't be that world-shattering in this day and age. . . . Whatever kind of visual statement you make has to first pass through fashion design and furniture design until it becomes mass-produced; finally, a gas pump might look a little different because of a painting you did. But that's not for the artist to worry about. . . . Everybody is reevaluating all those strict notions about what makes up high art. Fashion entering into art and vice versa is really quite a wonderful development. Fashion and art have become much closer. It's not a bad thing.

A critic (Moufarrege, 1982: 69) who has observed the Neo-Expressionist movement extensively.suggests that

> art is approaching show-biz as it strives for greater mass appeal in the eyes of a rapidly growing general public. I believe the role of the artist in these green '80's is similar to that of the rock musician of the 60's. . . . It is the crowd that is the artist's audience and not merely the gallery-frequenting public. . . . What knowledge of art history is needed to move this crowd? What percentage of the crowd has the training? In order to reach more people, art is hitching onto entertainment:

serious and/or fun, a new and different audience is being touched. A different significance appears; the visual artist expands his realm into music and poetry and performance. To move the crowd the artist impersonates himself, translates himself into what is obvious and presents the whole person and cause in a simplified version.

Meyer Schapiro's characterization of the artist (quoted in Crow, 1983: 225) as "a full-time leisure specialist, an aesthetic technician picturing and prodding the sensual expectations of other, part-time consumers," seems particularly appropriate for the group. Like artists who produce popular culture (Peterson and Berger, 1975; DiMaggio, 1977), these artists are either one of a few superstars who have enormous influence in the gallery system[3] or they belong to a large rank-and-file that is relatively unimportant and powerless.

If it is true, as Hall (1979) suggests, that the mass media provide an inventory of the different life-styles and ideologies in contemporary society and seek to provide some kind of consensus among them, the artist may be becoming a participant in this process rather than a proponent of "alternative visions." The critical ambivalence with which Andy Warhol's earliest forays into this territory were met appears to have dissipated in the eighties. This orientation is very different from the Abstract Expressionists' conception of themselves as making "cathedrals" not "out of Christ, man or life" (Barnett Newman, quoted in M. Tuchman, 1970: 110), but out of themselves and their own feelings.

Art and Meaning: Themes in Representational Painting

Most attempts at interpreting the social content of art are based on two theses: that art reflects and validates the values and beliefs of specific social groups, particularly elites, and that art explains or interprets the social conditions affecting these groups, specifically their status relative to other social groups, and comments on human experience more generally. Directly or indirectly, artists assimilate changes in social, economic, and political conditions into the content of their work.

Since artworks are generally purchased by members of a social elite, they are often interpreted as expressing the values and ideologies of such groups. Grana (1971) argues that prior to the middle of the nineteenth century, artists' works frequently constituted social exemplars that justified a rigid and static social structure through their selection and presentation of their subject matter. While the thesis that art reflects the values of an economic and social elite can be applied successfully to many artworks produced in preindustrial European societies (see, for example, Berger, 1972), the relationship between artists and patrons changed as industrialization progressed in the nineteenth and twentieth centuries. As Wolff (1981: 60) points out: "The ideological character of works of art and cultural products is recognized to be extremely complex, their determination by economic and other material factors mediated both by the existence and composition of social groups, and by the nature and interrelationship of their ideologies and consciousness."

With the emergence of postindustrial society in the second half of the twentieth century, the importance of art and all forms of culture greatly increased as well as the proportion of the public with sufficient education to appreciate it. At the same time, American society became predominantly middle class with the members of all social-class levels aspiring to that status, life-style, and attitude, regardless of their incomes (Grote, 1983). As we have seen, many artists acquired a middle-class life-style, along with increased educational status. Some assumed

the role of academic with its overtones of detachment, both politically and emotionally, from the larger society. As a consequence of these changes in the social situation of the artist as well as in the importance of the arts generally, the social and political values expressed in the art styles in this study were not those usually associated with avant-gardes, either alienation from or protest directed toward popular culture and middle-class values.

In this chapter, I will examine the ways in which, directly or indirectly, works produced in two styles of representational painting, Photorealism and Figurative painting, interpreted and commented on American society during the seventies. The Photorealists documented the public aspects of American daily life in street scenes and the exteriors of buildings and homes, particularly commercial establishments (stores and restaurants), commercial products (cars, motorcycles, and plastic toys), and middle-class life-style (suburban houses and country clubs). By contrast, the Figurative artists painted the private lives of the middle class—their friends and relatives, the interiors of their homes, and their personal possessions. I will explore the treatment of three themes by artists in these styles: the situation of the individual in American society; the character of American society, its social structure and social institutions, insofar as they can be inferred from these works; and the nature of reality as seen in their statements about the relationship between their work and its subject matter.

A number of recent studies have analyzed how contemporary American society is interpreted in literature, film, and television plays and thus provide a reference point against which the nature of social themes in contemporary painting can be compared. These artworks can be viewed as cultural indicators of how American society was perceived and interpreted during this period by a particular social group. Since studies of the social content of contemporary art are virtually nonexistent, it is necessary to turn to the sociology of literature and film for a theoretical framework and some hypotheses about the relationship betwen art and social life. For example, Ohmann (1983: 219) argues that, in contemporary American society, the social elite itself does not directly influence the dissemination of ideas, but instead "a subordinate but influential class shapes [literary] culture in ways that express its own interests and experience." He suggests that this class is sometimes critical of the dominant cultural values but ultimately confirms those which are most central, such as individualism. He claims that the "paradigmatic" novel produced by members of this "class" presents social conflicts entirely in terms of individual maladjustment

and neurosis. Discontent is interpreted as a sign of illness or of a personal problem but does not imply any criticism of the social order.

Alternatively, Elkins (1977) has concluded that the science-fiction writer reinforces rather than criticizes dominant cultural values while, at the same time, he or she expresses the worldview of the technically oriented and professional sector of the middle class and attempts to resolve its tensions and role conflicts. Observers of science-fiction literature (Jameson, quoted in McQuarie, 1980) claim that the possibilities for any serious consideration of social conflict or alternative social arrangements in it are very remote. According to these analysts, science-fiction authors are so completely enmeshed in the bourgeois culture disseminated by the mass media and public education that the necessary distance that might lead to an alternative and critical view is lacking. This, of course, was the traditional role of the avant-garde artist—to maintain a degree of separation from bourgeois institutions from which critical assaults could be launched.

By contrast, Long (1981) shows that even within the same cultural form, the best-selling novel, reactions to institutional change varied considerably. Her analysis of best-selling novels shows that a marked change in the character of these works occurred after 1955.[1] They ceased to be written largely from the viewpoint of the white upper-class male and began to express disillusionment and criticism of dominant cultural values. In the late sixties and early seventies, best-sellers revealed a wide range of responses to social change but were particularly characterized by pessimism about the chances for personal fulfillment and by a more realistic assessment of the costs and rewards of economic success. She argues that, in contrast to the hegemony hypothesis, these novels reveal "a world view in crisis" (1981: 284). Norms that had previously defined the nature of achievement, personal conduct, and intimate relationships had collapsed, leaving the individual to confront "an increasingly difficult and unpalatable reality." As Long shows, resolutions of these problems varied widely in these novels; some authors exhibited a genuine attempt to come to terms with real issues; others resorted to clichés and stereotypic solutions. She suggests that these cultural products did not simply reflect social change but helped to shape it by providing interpretations of reality that influenced the perceptions and behavior of their audience. Popular culture, as Wright (1976) has argued, reveals to members of its audience "what their society is like and how they as individuals should act in it."

While some observers claim that our culture is shaped by a particular view of reality that supports corporate capitalism and dampens social conflict and criticism, others find cultural fragmentation and dissensus. Among members of a predominantly middle-class sample, Bellah et al. (1985) found that many, if not most, were unable to interpret their lives in terms of any coherent system of meaning.

The Individual as Social Exemplar or Alienated Antihero

These studies suggest several possibilities. One might expect that representational painters would present the individual as a kind of social exemplar, affirming an upper-middle-class life style. Alternatively, they might focus on individual neurosis and alienation as a response to social tensions. Finally, they might emphasize the powerlessness and pessimism of the individual in response to social forces beyond his control. These hypotheses will be assessed by examining three themes in representational painting: the treatment of personal possessions; the interpretation and use of social rituals, such as meals, leisure activities, and ceremonies; and the characterization of the individual, primarily in portraits.

Sociologists view possessions not only from a utilitarian point of view but also as indicators of the attitudes of their owners and of the images of themselves that they try to project through their belongings (Douglas and Isherwood, 1979). Therefore the presentation of possessions, including rooms or living spaces in painting, is an indication of the artist's attitude toward the social group that owns them. For the artist, they are signifiers of the nature of individual existence and social life at a particular time (Crary, 1976: 4). As one of the Photorealists (Kleeman, in "Real, Really Real, Super Real," 1981: 132) said: "We reflect our personalities by the objects we surround ourselves with— a narcissistic reflection of our own importance in accordance with our individual choices." Similarly, the presentation of social rituals provides an indication of the nature and significance of social ties as perceived by these artists. Finally, throughout the history of painting, the portrait has expressed the individual's social identity, the image of himself that either the patron expected or the artist discerned.

I will examine representative works by artists working in two styles, Photorealism and Figurative painting.[2] Within the latter, I will distinguish between painters who were influenced by the modernist aesthetic

tradition and those who were using an approach derived from tradi-
tional painting.

As table 5.1 shows, these styles emphasized different aspects of
contemporary life. Like the Pop artists, who are included here for
comparative purposes, the Photorealist and Modern Figurative paint-
ers tended to exclude people altogether from their paintings while the
Traditional Figurative painters preferred to paint human beings, often
in portraits or as nudes. The Figurative painters generally were likely
to do landscapes and still lifes while the Pop and Photorealist painters
were more likely to deal with machinery, technology, and man–made
products. While these figures give us a clue to the artists' preoccupa-
tions, they obviously do not indicate the nature of the issues these
subjects implied.

Automobiles, motorcycles, and private airplanes were favorite sub-
jects of the Photorealists. These types of possessions often elicit in
middle–class owners considerable emotional investment. This attitude
was reflected in the presentation of these objects by many of the Pho-
torealists. Possessions were treated as icons. Ron Kleeman (Meisel,
1981: 305) said: "I have always painted icons recording the phenomena
of 20th century religious objects. The race car represents the most
obvious cross–cultural icon, but not the only one. From race cars, I've
gone on to other subject matter, with increasingly subcultural images.
They are still, however, objects of worship." Generally these machines
appeared to be in excellent condition, bright, shiny, and virtually new.[3]
The titles of the paintings often included the brand names for these

TABLE 5.1

*Types of Subjects Portrayed in Representational Paintings, Pop, Photorealism, and
Figurative Painting*

	Types of Subjects					
Style	No People	Portraits, Nudes	Landscapes, Still Lifes	Domestic Interiors	Technology, Manmade Objects, Cityscapes	N
Pop	48	25	14	4	86	28
Photo–realism	35	35	25	5	63	51
Modern Figurative	36	38	85	31	46	39
Modern–Traditional Figurative	13	43	83	43	48	23
Traditional Figurative	3	68	63	24	34	38

NOTE: The data are based on content analyses of representative works by the artists.
See Appendix A.

machines. For the most part, these objects were presented by themselves; the owners were absent.

Other paintings showed consumer goods that had not yet been purchased. Favorite subjects were shop windows full of clothed mannequins, shoes, silver, pastries, candy, and other items and street stands piled with near-perfect fruits and vegetables. Animals were seldom depicted. The level of concern in these paintings with consumer goods implies a view of American society as one in which social relationships are less important than possessions. This impression is further substantiated by the fact that these artists rarely painted the interiors of homes. Instead, they painted the interiors of cheap restaurants and the exteriors of suburban homes.

By contrast, the Modern Figurative painters frequently portrayed the interiors of their summer homes on Long Island and in Maine or their apartments in New York City. Their still lifes showed traditional household objects, such as were already available in the nineteenth century, as opposed to the Coca Cola and Ketchup bottles and paper napkins that appeared in the still lifes of the Photorealists. Technology and the artifacts of popular culture were almost entirely absent from these works. Instead, flowers and traditional household furniture were favorite themes. In other words, the life style depicted by the Modern Figurative painters was distinctly middle class, as is suggested by the following quotation from a review (Berlind, 1981: 145):

> Shorr's silk scarves, occasional jewelry, chinaware and cut flowers, like Manet's roses and lilacs, declare a milieu of social elegance and privilege. Concomitant with their social posture is a certain chilliness, a partiality for calculation over spontaneity. Nowhere are refractory elements allowed to disrupt the consistently authoritative manner of painting. In their emotional detachment, their concern for sheer beauty and their frank association of those qualities with identifiable attributes of class, these paintings make evident contemporary formalism's implicit social allegiance.

Social rituals were virtually absent in the paintings of both the Photorealists and the Modern Figurative painters. In the Photorealist paintings, meals were snacks consumed in fast-food restaurants but not at home. Modern Figurative still lifes frequently included cups, plates, and pottery but these utensils were usually empty. Tables were seldom the focal point for social gatherings. As a critic said of William Bailey (Oresman, 1982: 112), "His objects, in their quiet and monumental compositions, do not seem to belong to the world of use but rather

to a more distant world of a classical aesthetic." There were no cere-
monies and none of the leisure activities such as dancing or Sunday
outings in the park that serve to reinforce social bonds and that were
among the favorite subjects of the French Impressionists in the nine-
teenth century. The occasional parties depicted by these artists were
cheerless affairs.

Portraits were rarely painted by the Photorealists, and in most of
the paintings where human beings appeared as part of a scene, they
were not the primary focus of attention. Figures were often presented
as if they were strangers, faces blurred, in shadow, or turned away
from the viewer. Occasionally they were posed next to automobiles
or in front of suburban homes. Even family life appeared to be sub-
ordinate to the materialistic aspects of American life, as Chase (1976:
17) noted in the work of Robert Bechtle: "Significantly, his family
portrait is not called 'The Artist's Family', which indeed it is, but ' '61
Pontaic.' The family it seems has become just another artifact of mid-
dle-class existence." The ambivalence of the Photorealist toward the
portrait, a very traditional form of artistic subject matter, is suggested
by a rare self-portrait by Robert Bechtle which was entitled "Pink
Toothbrush." The painting showed a reflection of the artist's face in a
bathroom mirror (Meisel, 1981: 42). Another painting which showed
a reflection of part of his face in a living-room mirror was called "56
Plymouth," the car in question being visible through a window in the
lower right-hand corner of the painting (Meisel, 1981: 42).

Unlike the other Photorealists, Chuck Close chose to concentrate
exclusively on portraits. He painted gigantic pictures of close friends
whose faces were meant to be devoid of expression (Meisel, 1981: 112).
His paintings exposed lines and blemishes; heads were frequently un-
kempt in appearance. The portrayal of character and personality was
a side effect of his techniques, which conveyed an enormous amount
of physical information about his subjects. The artist's interest in these
paintings was primarily as material for the exploration of technical
problems.

In a rather exaggerated form, Close's paintings were typical of the
presentation of human beings in the works of the Photorealists. With
the exception of some nudes, individuals were not glamorized in these
paintings. They seemed bland, unpretentious, and unheroic, neither
happy nor unhappy. There was no sign of neurosis, alienation, or
disillusionment, but there was also little attempt to depict social rela-
tionships. Joan Semmel was almost unique among the representational
painters in her attempts to explore the social psychology of sexual

relationships, specifically the woman's point of view toward sexuality. Using her own naked and physically imperfect body as her subject, she painted the sexual relationship from the visual perspective of the female participant. She described her intentions in the following way (Marter, 1978: 12): "What I was trying to get was . . . the feeling of intimacy, of how one really relates to another individual, to another person, to another situation. The real quality of contact, of touch, of the eroticism of touch."

Exceptional in another respect, Duane Hanson, a sculptor whose extremely realistic work allied him with the Photorealist movement, dealt largely, as he put it, with "working class people who just struggle along, doing mundane, boring drudgery . . ." (Mathews, 1981: 61). They were the kind of people who typically inhabit the sorts of settings that Photorealist painters protrayed: tourists, sunbathers, supermarket shoppers, construction workers, housewives, and the elderly. He saw these people as being "caught up in a web of a world gone out of control" ("Real, Really Real, Super Real," 1981: 160) and conveyed both the pathos of their helplessness and frustration as well as the very human weaknesses that had contributed to their predicament. He stated that the purpose of his work was to depict "some of the latent and explicit terrors in our social environment" (Hanson, 1970: 86).

The subjects of the paintings by the Modern Figurative artists were their friends and relatives; they were rarely strangers. Aside from his nudes, who were hired models, Philip Pearlstein's subjects were said to come from "the milieu of the painter or from a circle of art lovers in relatively comfortable circumstances . . . his friends, his family, his equals" (Nochlin, 1981: 27). Alex Katz focused on the elite of the art world (artists, dealers, and writers); his paintings have been described as a "visual social register of the New York School" (Tillim, 1966: 67).

Pearlstein claimed that his favorite subjects, nudes, were objects, not subjects, and that his interest in them had nothing to do with their psychology or their sexuality. Commenting on his commissioned portraits, he said that he never tried to express anything about his subjects (Strand, 1983: 101). Nochlin (1981: 27) said of one of Pearlstein's paintings: "In *Mr. and Mrs. Edmund Pillsbury* (1973), neither feelings nor social judgments nor even the *a priori* knowledge of things or forms are permitted to intervene between the purportedly 'dumb' vision of the artist and the appearance of his models, frozen in place under the chilly light of dentists' lamps."

Katz's most frequent subject was his wife, Ada, followed by his son, Vincent. He is said to have painted his wife at least eighty times (Alloway, 1984) over a period of about twenty years. During this period, his portraits of her became increasingly stylized and idealized (Gallati, 1981: 33). Ada neither matured nor aged. Presented in a variety of situations, her attitude of bemused composure seldom changed. Calas (1968: 218) said of Alex Katz: "Katz's portraits remain impenetrable. This painter shuns the intimate, and sacrifices expression to concentrate on presence which is impersonal and public."

In spite of the fact that their paintings were more likely to deal with people than were those of the Photorealists, social relationships were rarely explored by the Modern Figurative painters. A sense of individuals interacting with one another in a meaningful way was missing in most of their paintings. Instead, people and the settings they inhabited were given equal weight. Their interaction with one another appeared to be either superficial or nonexistent.

While the Photorealists and the Modern Figurative painters appeared to be ambivalent toward the representation of human beings in their paintings, many of the Traditional Figurative painters were committed to a humanist approach that necessitated the inclusion of human figures. According to Schwartz (1974: 35), the artist as humanist "searches for a cohesive vision that will make it possible for men to live in community. . . . Humanism is a search for myth in the desert of disbelief." Some of the Traditional Figurative artists intended their works to represent traditional moral values, as did William Beckman (Beckman, in "Real, Really Real, Super Real," 1981: 66), whose paintings were meant to serve as "reservoirs of understood values," and Jack Beal, who attempted to incorporate "moral messages" into his work with the explicit intention of "making paintings that could lead people in a better direction" (Cottingham, 1980: 62).

While many of the Traditional Figurative painters tended to idealize their human subjects, Alfred Leslie was adept at suggesting character in individual portraits and human relationships in paintings of groups. In one of his many self-portraits, he showed himself at a particularly difficult moment of his life, his vulnerability suggested by an exposed belly and open fly. Leslie addressed a wide range of themes from the detailed reconstruction of a tragic automobile accident to a birthday party for an elderly woman. He was able to create images that functioned as metaphors for the nature of modern life, as in one of his still lifes that included a television set and a telephone surrounded by

articles of personal clothing, suggesting the peculiarity of contemporary life in which isolation is combined with technologically based forms of communication. He called his approach "confrontational painting" (Henry, 1975):

> I wanted an art like the art of David,[4] meant to influence the conduct of people. In order to achieve this, besides looking at David, I eliminated color, line, space, perspective, light, drawing and composition as nearly as I could. In order to further emphasize the individuality and the unique qualities of each particular person I tried to record everything I could see. I also increased the size of the paintings so that there could be no question but that they were meant for public viewing and an institutional life and service. I called this painting confrontational art.

As we have seen, Traditional Figurative painters had rejected the modernist aesthetic tradition and were attempting to revive classical traditions of painting. For some of these painters, this led to a preoccupation with aesthetic issues that was no more conducive to the elucidation of meaning than modernism. Kramer (1973: 457) sensed from the work of Leland Bell that he was conducting "a closed dialogue with the painting of the past rather than a dialogue with life." Other critics complained that Paul Wiesenfeld, who has said that he has never stopped learning from Vermeer (Mangan, 1974: 23), presented objects and situations as if they were "neutral" (Crary, 1976: 4), "without offering a hint at their meaning" (Fort, 1981: 28). The figures in Tillim's historical paintings, despite themes of war and destruction, were described as having "a sense of stability more akin to statues" (Yau, 1978: 7).

The image of man in these paintings was more that of an antihero than a hero. There was little indication of alienation, protest, or neurosis. Instead, the predominant concern of most of these painters appeared to be with the settings and artifacts with which middle-class people surround themselves rather than with the nature of their lives, their personalities, or their responses to their existence.

Nature and the Man–Made Environment: Social Conflict or Social Harmony?

The period during which many of these paintings were created, the late sixties and early seventies, was a period of turmoil in American society, characterized by racial conflict, the rise of a militant feminist

movement, increasing concern for environmental pollution, intense controversy concerning the necessity of war in Southeast Asia, and political scandals at the highest levels of government. Some sociologists have argued that it was a period in which many Americans lost confidence in social institutions (Bergesen and Warr, 1979). Long (1981: 279–80) found that social change was not reflected in best-selling novels published in the decade after World War II, but she found that after 1955, "social changes enter the fictive world with great force." On the other hand, Grote (1983: 169) in an analysis of the situation comedy on television argued that, unlike traditional comedy, the "sitcom" is "a defensive comedy rather than an aggressive one, a comedy oriented to the present or the past rather than to the future, a comedy in which property is sacred, the family is eternal, the parents are always right, and authority always wins."

The ways in which these artists depicted the rural and urban environment were indications of how they viewed American society and its institutions. As one critic said (Mainardi, 1979: 7), "Although much recent landscape painting has been involved in documentation of place, there is another sense in which what is being documented is ourselves." Rural scenes were favorite subjects of the Figurative painters. Landscapes, forests, and gardens were frequently represented, sometimes as a backdrop for a domestic interior. Many of the Modern Figurative painters who chose to paint landscapes had been influenced by the French Impressionists, whose works their paintings superficially resembled. Lennart Anderson (in Gussow, 1972: 113) said of his landscape paintings: "I'm drawn to the nineteenth-century motif. . . . But at the same time I feel that it is a bit of a lie because the world isn't that way." A critic commented on the landscapes of the Painterly Realists (Smith, 1982: 7): "As a statement about the nature of the contemporary landscape, their work seems a little beside the point. . . . There is not enough struggle here, either with the condition of the world or with the abstract language they have inherited, to inspire a feeling of achievement of riveting magnitude."

On the other hand, the landscapes of the more traditionally oriented Figurative painters sometimes revealed signs of an implicit commentary. Rackstraw Downes occasionally documented the encroachment of industry upon the landscape (Ellenzweig, 1975c), while Willard Midgette used the rural Southwest as a background against which to show the uncomfortable relationship of the Indians to the

land outside their reservations (Midgette, in "Real, Really Real, Super Real," 1981: 136).

The Photorealists were not landscape painters so one cannot interpret their representation of nature as an indication of their image of society. Their "urbanscapes," however, suggested a society in which humanity plays a secondary role. This was particulary true of their paintings of New York City, in which streets that are typically teeming with people at certain hours of the day were presented as totally uninhabited. Commenting on the use of the human figure by Richard Estes, a critic (Seitz, 1972: 65) said:

> There are occasional wraithlike figures in his paintings, but these are usually seen from across the street, inside telephone booths, as distorted reflections on polished metal surfaces and store windows, or in fragments through them. By these devices the figure is dehumanized—trapped within a maze of interlocking artifacts.

The Photorealists' image of the city was of a world that was dominated by buildings that housed major corporate enterprises, whose names were often clearly legible in the paintings themselves or in their titles. Sometimes the signs themselves were the center of interest (see Robert Cottingham, in Meisel, 1981). Some of these paintings suggested a conclusion not unlike Wright's (1976) assessment of the evolution of the Western film. Later versions of the Western film formula, unlike earlier ones, presented a world in which the individual had little opportunity for action or influence. According to Wright, the individual hero had been replaced by "professionals" who acted in concert and not necessarily for the benefit of the "people."

While one might infer that their very selection of subject matter was intended indirectly as a statement, the Photorealists themselves stressed that social or moral commentary was not their intention. To the extent that the seamier aspects of American society were depicted, it was strictly from the point of view of the middle class. No matter how sleazy the neighborhood, the sidewalks were clean and the buildings colorful. Robert Bechtle (Meisel, 1981: 27) said: "My interest has nothing to do with satire or social comment though I am aware of the interpretations others might give. I am interested in their ordinariness—their invisibility through familiarity—and in the challenge of trying to make art from such commonplace fare."

Idelle Weber's interest in painting heaps of garbage on the streets of New York City also had nothing to do with making a social

statement (Lubell, 1977: 8). John Salt, who painted abandoned cars, had a similar attitude ("Real, Really Real, Super Real," 1981: 144): "The automobile was very obvious, so ugly and useless and so big, and I just got interested in it. . . . But I don't paint them because they are important or because they have some kind of message. It's just very obvious subject matter."

In the works of the Modern Figurative artists, the city was often seen as a background through a window, the center of attention being elsewhere, on a bowl of flowers or fruit. Alternatively, it was seen in the distance beyond a private garden, as in the works of Catherine Murphy, or from the air. Their urbanscapes and rural landscapes had similar emotional tones. More characteristic of the Traditional Figurative painters was a tendency to superimpose upon urban or rural subject matter an inexplicable aura of mystery. Others attempted to heighten the significance of street scenes by suggesting that there was more in them than there appeared to be. John Button's desolate city streets had enigmatic, dreamlike qualities (Ellenzweig, 1975b). A critic said of the work of Sidney Goodman (Tannenbaum, 1977: 37): "these are contemporary subjects caught at a particular moment in time, yet they are pervaded by a peculiar air of mystery and seem to belong to the past rather than the present."

Henry (1981b: 141) noted that Milet Andrejevic "seeks a reality more meaningful, more magical than our own." Some, like Lennart Anderson and Thomas Cornell, introduced themes from classical mythology into their works (Strand, 1983; Wallach, 1980) or, like Sidney Tillim, recounted historical episodes (Yau, 1978: 7). These works suggest a nostalgia for a more perfect past. Others, like Peter Dean, created fantasy worlds that were intended to comment obliquely on the real world (Anderson, 1977: 21; Welish, 1981: 132). Still others, like Ora Lerman and Gregory Gillespie, created autobiographical works that were permeated with a highly personal vision of the world (Marter, 1982; Davies and Yard, 1977).

On the whole, there was little attempt by these painters "to struggle with the condition of the world" as one critic put it (Smith, 1982: 7). As Nochlin (1981: 26) pointed out, certain types of subject matter were almost totally excluded from the works of representational painters: "images of work, of social injustice, of the poor, of oppressed classes and individuals. No more than factories or urban slums existed as a subject for the nineteenth century realist, Millet, do poor blacks or workers exist for most of our new realists."[5]

Reality in Representational Painting: Substance or Reflection?

An underlying but pervasive concern of most representational painters is that of the nature of reality. Until the latter half of the nineteenth century, many artists and scientists behaved as if there were a single objective reality that could be described and understood by their activities. In other words, both the artist and the scientist believed that reality could be accurately and unambiguously perceived by their efforts. Like the scientist, the artist attempted to describe reality as accurately as possible and occasionally resorted to experiments in order to increase his understanding of it. The epitome of the nineteenth-century approach to the presentation of reality is found in the work of the American painter Thomas Eakins. Eakins behaved as if painting were an exact science (Russell, 1982: 8), calculating his effects so precisely that it is possible to identify the month, day, and hour when the events that are depicted took place. Russell says: "he stood for absolute exactitude. It was basic to his art that everything should be got exactly right, whether it was the movement of a horse, the workings of a precision instrument or the precise degree of squalor that comes over the bed linen in a rudimentary operating theater at the end of a long day."

Toward the end of the nineteenth century, the worldview underlying both science and art underwent a remarkable transformation. As Gablik (1977: 81) shows, the notion of a single objective reality as the subject of scientific and artistic investigation disappeared and was challenged by the view that different interpretations of the same phenomenon were possible, depending upon the vantage point of the observer:

> Modern theoretical physics has given up the notion of an ultimate reality—of finding "a thing in itself" (Heisenberg). Relativity is the understanding of the world not as concrete events but as abstract relations. The tendency of modern physics to view things in terms of the total relativity of all points of view appears simultaneously in the art of the Cubists, who acted intuitively on the realization that an object is never seen from one perspective only but that there are many spatial frames and points of view which can be applied to it— all of which are equally valid.

In the twentieth century, many avant-garde artists abandoned their concern with documenting reality and turned instead to dis-

covering and even inventing new forms of reality. In order to do so, they relied on techniques such as collage, that would introduce an element of chance and unpredictability into their works, and mathematics (generally geometry) as a means of exploring systematically a wide range of visual relationships. The most extreme version of this approach was Minimalism, a style in which, as we have seen, some artists were concerned with relationships and patterns and not with objects, which ceased to have any intrinsic meaning (see also Wollheim, 1968: 399).

Late twentieth-century representational painters lacked a consistent interpretation of the nature of reality. Some of these artists, particularly those who had been influenced by the modernist aesthetic tradition, took the position that the reality they painted was constructed and that its relationship to their actual subject matter was tenuous. This viewpoint was articulated by Janet Fish ("Real, Really Real, Super Real," 1981: 72):

> I do not consider that the appearance of the world has been established. Even though you and I may have each accepted particular conventions as a way to begin to approach seeing, analysis and reconstruction of appearances can only be a matter of imagination. To say that one is a realist is a statement of approach and not a matter of fact.

James Valerio ("Real, Really Real, Super Real," 1981: 56) said: "The more information I got, the more I found that reality is extremely ambiguous. There is of course no *one* reality."

Some of these painters believed that not only could the painter never succeed in accurately duplicating reality but each time he tried to do so he was condemned to produce another and different version of reality. Wayne Thiebaud ("Real, Really Real, Super Real," 1981: 100) expressed this attitude:

> We tend to think of realist painting as an accurate replication of reality. But it is really just a device we use. . . . If you stare at an object, as you do when you paint, there is no point at which you can stop learning things about it. You can just look and look. If you really are a realist painter, you finally realize that what you are doing is a tremendous amount of adoption, adaptation and change. And what is vexing is that there's no end to it.

A critic said of Charles Cajori's work (Turner, 1981: 21) that "the multiplication of successive sightings directed toward a single object yields multiple discrepancies." A painter-critic (Mainardi, 1978: 10)

said of a work by Louis Finkelstein: "It is an ambiguous, open-ended painting, which perhaps more than any other is closest to a statement of Finkelstein's attitude toward the nature of experience—that it is never complete, always forming, open to different readings and interpretations."

One artist suggested that part of the problem lay in the absence of a "paradigm," a shared worldview that would provide these artists with a way of resolving the inconsistencies in their definitions of reality by arbitrarily designating some types of interpretation as real and others as not real. She said (Gretna Campbell, quoted by Passlof, 1976: 101): "What is real? . . . We don't have at this time a set of painting constructions we can agree to believe to interpret nature that answers a pervasive cultural need. The definitions of real for our time tend . . . to go back to the Renaissance and to hinge on the photograph."

At the same time, another and quite different view of reality was expressed by some of these painters. Meyer (1963) argued that the worldview underlying the second phase of Abstract Expressionism, Minimalism, the music of John Cage and his followers, and the "new" or modern novel was one in which the object itself was the chief source of value. Contrary to the orientation that underlies much of contemporary science and philosophy of science, which sees knowledge as being an abstract, man-made construct, these artists "reaffirm the existence . . . and the value of directly experienced sensation" (Meyer, 1963: 180). Elements of this attitude were to be found in the works of some of the Photorealists.

Some Photorealists were attempting to depict their subjects as accurately as possible, with "rendering," as Ralph Goings said (Meisel, 1981: 274), by which he meant "copying with exacting care." Meisel (1981:275) quoted Goings, who painted trucks, vans, and diners, as stating: "Reality is possessed of a visual order and logic at once more dynamic and more subtle than any vista I can contrive. I try to perceive this splendor as objectively as possible and render it with believable authenticity. Realist painting provides an occasion to visually savor reality."

Richard McLean ("Real, Really Real, Super Real," 1981: 134) cited the following quotation from the French "new" novelist Alain Robbe-Grillet, as one that summed up his own attitude toward reality: "Gestures and objects will be there before being something and they will still be there afterwards, hard, unalterable, eternally present, mocking their own 'meaning.' "

Some of the Figurative painters also were labeled Phenomenologists by Goodyear (1981) because they were interested in "collecting data"

and putting down exactly what they saw. He quoted William Beckman as saying: "I refuse to minimize, distort or idealize reality." Rackstraw Downes ("Real, Really Real, Super Real," 1981: 70) said: "My paintings have become quite realistic at least partly because 'things' themselves interest me very much. It is they that draw me to them and make me want to show them 'as they are.' "

Those who viewed reality as a source of data created the most intricately detailed representations, as though they were attempting to impart as much information as possible, while members of the Modern Figurative group usually produced works that suggested rather than duplicated their subjects. For example, Rackstraw Downes (Storr, 1984: 158) was described as producing "a rarely encountered equivalent for direct contact with our environment." At the same time, his concern with reality in and of itself meant that his own personality was eliminated from the work. Storr (1984: 159) spoke of the "near total self-effacement of the artist."

Two distinctly different attitudes toward reality cross–cut these styles: the belief that reality could never be completely understood and that no two observers see the same thing, whether as an object or as a painting; and the belief that reality could be discovered by documenting it with as little distortion or psychological connotation as possible (Chase, 1975a: 92).

The phenomenological approach, as Meyer (1963) pointed out, rejects the humanistic orientation of Western civilization, which viewed man as the center of the universe, in control of himself and his environment. According to this point of view, man is no longer the center of the social universe and therefore his feelings and reactions are no longer the reference point for art. For example, the Photorealists attempted to eliminate the priorities that the photograph has given to certain aspects of its subject matter and to create an effect in which every element of the picture had equal emphasis, so that there were "an infinite number of centers of interest in each painting" (Raymond, 1974: 26). By contrast, post-Renaissance painters had attributed different values to the subjects in their paintings, reflecting a hierarchical interpretation of the universe, with man accorded an important position. This type of hierarchy was absent in the work of the Photorealists. As Chase (1975a: 85) commented, "the Photo Realist replaces the artist's personal, interpretive vision with the recording of visual fact."

In general, the attitude of the Photorealist painters toward their subject matter is suggested by Raymond's comment (1974: 26) that: "Skies are painted with the same hardness as thermopane windows and back-

ground cars are painted with the same clarity as foreground cars . . . nothing is better or worse or more important than anything else. . . . enthusiasm is spread even-handedly over the entire surface of the work."

Artists who adhered to the alternative worldview were most numerous among the Modern Figurative painters. Among the older artists in this group, this attitude was expressed in a concern, inherited from the French Impressionists, with light and how its effects change from moment to moment. Some of these painters centered their activity upon the attempt to capture a particular effect before it dissolved into something else, "the need to catch a moment before it changes," as one painter said (Gretna Campbell, quoted in Passlof, 1976: 102). Others, like Janet Fish, painted their subjects at various times throughout the day so that their paintings became "a composite of the conditions under which it was painted" (Yourgrau, 1980: 97). Fish said ("Real, Really Real, Super Real," 1981: 72): "Since I find appearances to be in constant flux, the painting is constructed out of the analysis of many moments."

Still others were attracted to perceptual problems involving anomalies in the way we ordinarily view the world about us. For example, we think we see a skyscraper in one continuous glance but in fact our minds "piece it together" to create an illusion of stability (Campbell, 1982: 121). Don Eddy ("Real, Really Real, Super Real," 1981: 156), drawing upon modern physics, argued that we do not "see" reality in a unitary fashion. Instead we use various organizational systems (cognitive, innate, cultural) to process raw visual data into a coherent worldview. He believes that it is irrelevant to compare images in a painting to reality; instead, a painting represents a particular combination of organizational systems that have processed raw data into an approximation of "a given culture's understanding of reality."

Some of the younger painters were concerned with illustrating the variety of ways in which a particular visual stimulus can be represented. Among many of these painters, the theme of epistemological uncertainty translated into an almost obsessive concern with reflections. The Photorealists explored this theme in considerable detail, using the ways in which glass facades reflect one another or objects and individuals on the street. Tom Blackwell ("Real, Really Real, Super Real," 1981: 118) said:

The reflective surface—plate glass windows, chrome, stainless steel, baked enamel, and, of course, the ubiquitous automobile and all it has wrought—has changed our world forever. The subject matter of my painting is the interaction of light on all of these man-made surfaces, the reflections, re-

fractions, distortions, interactions of objects and people with these things—
in short, the modern world and the way we see it.

The Modern Figurative painters explored reflections in household
mirrors, or the way objects in a still life reflected one another. A critic
described such a painting by Tomar Levine (Thomas, 1979: 39): "In *Bot-
tles and Shells,* a glass bottle reflects its surroundings on its surface and
in turn is reflected in the highly glossed green area on which it rests. . . ."
Robert Berlind (Yau, 1981: 134–135) explored this issue by presenting
a window in which each pane presented a different view. In another
painting in which two walls of small glass panes meet to form a corner,
"each pane of glass asserts its own individuality through the particular-
ities of its surface distortions. The walls also reflect each other; standing
before this painting is like standing in a hall of mirrors and seeing only
the reflections of an ever-receding space."

Two ambitious attempts to explore the issues underlying the kind of
epistemological uncertainty that reflections imply suggest two alter-
native directions in which modern painters are moving in their attempts
to resolve the philosophical dilemmas of realism. The first direction, as
envisaged in recent work by a Photorealist, Ben Schonzeit, consisted in
producing a series of paintings of the same subject (a "Music Room" in
a museum) which were meant to be viewed in the same context (unlike
the tendency of painters of all periods to paint numerous versions of the
same subject that were usually meant to be seen independently). Each
version of the subject was radically different from the others and con-
stituted only one possible version of the subject, but taken together they
provided an enormous accumulation of information about the subject
(Mackie, 1979). The variety of the images is suggested by the following
description of part of the painting (Mackie, 1979: 26–27):

> If the first painting is sedate and full of propriety, and the second dramatic
> and slightly flashy, then the third (a mylar mirror) is best described as ca-
> pricious—there, then not there, changing, including other things, and so
> on, so that in fact it becomes no guide to the real thing at all; and yet par-
> adoxically, we think of the reflected mirror image as the most reliable and
> veristic of all images.

The point of the picture, Mackie argues, is that it examines our as-
sumptions about what constitutes realistic painting. As Schonzeit him-
self said in a discussion of the work ("Real, Really Real, Super Real,"
1981: 51), "It's really how you choose to see it and what you want to
pull out of it and how you want to interpret it or what reality you put

together and what you think reality is. The closer you get to what you think reality is, the less you know."

While Schonzeit, along with other Photorealists and some Figurative painters, dealt with the ambiguities inherent in physical reality, Willard Midgette and Alfred Leslie dealt with a theme that was less frequently treated by these painters, the ambiguous nature of social reality. One of the last works created by the late Willard Midgette was a full-size piece of interior architecture, showing a series of rooms representing an artist's loft. This constructed "environment" included a living room, a bedroom, and an artist's studio. Some elements of the loft were "real"; others were painted, such as a staircase leading upwards from a "real" foyer. The point of this elaborate work was not only the ambiguity inherent in visual perception but the complexity of human relationships. The environment provided a sequence of emotional as well as visual relationships. Each room had a different mood, depending on the attitudes and behavior of the human figures depicted in paintings and portraits hanging on its walls—lovers, the artist with his models, the artist quarreling with his wife. A critic (Rosand, 1971: 32, 34) said:

> The individual incidents—of hatred and love, domestic and professional, personal and public, masculine and feminine, open and closed—achieve a dissonant harmony that supplies the thematic unity of the work. . . . Like characters in a novel, the figures reveal their fuller life only in the considered context of the whole. . . . The environmental structure affords the possibility of a higher degree of sophisticated self-analysis, permitting the presentation of the personal and professional lives of the artist with their internal relationships of congruity, ambivalence and conflict.

In effect, Midgette is suggesting that the human figure is too complex and too dramatic to be contained within the traditional frame, particularly with the neutralizing devices of modernism (Rosand, 1971). In other words, treating the human figure as it tends to be treated in contemporary realism rules out a huge domain of issues concerning the nature and quality of contemporary existence. Midgette's approach leads toward humanism but in a contemporary manner rather than through an idealized version of contemporary values.

In fact, while the dilemmas of realism are usually traced to the problem of comprehending the nature of physical reality, it would be equally appropriate to attribute them to the contradictions surrounding social reality. As in the case of physical reality, our perception of social reality depends upon the methods used to examine it. Systems of meaning are superimposed upon one another so that we develop the habit of seeing

social experiences from multiple and inevitably inconsistent perspec-
tives. The obsession of many of these artists with reflections may be more
a function of the ambiguity of social reality in contemporary society than
of physical reality. Sociologists emphasize that the individual perceives
himself as having different identities in different spheres of his life. The
lack of overlap between occupational and private identities leads to the
perception of distinct identities attached to each one (see Wuthnow et.
al., 1984: 65– 66). Individuals can plan and change their identities in many
ways, and they are also subject to shifting definitions of themselves by
others. The artist's concern with reflections may actually be a metaphor
for his anxiety about shifting personal identities. A painting by Tom
Blackwell hints at this interpretation. It shows a window of Bendel's
department store in New York City containing several mannequins with
real people on the street reflected in the plate glass window. Chase (1980:
155) comments: "In the kind of visual irony that Blackwell enjoys the
artificial people—the mannequins—are, within the context of the paint-
ing, actual objects, while the 'real' people are only chimeras on the glass."

The complex and multifaceted works of Schonzeit and Midgette
suggest that a single painting is no longer sufficient to capture the
multidimensional quality of contemporary reality in a meaningful way.
This may partly explain a tendency that one sees in other recent styles,
such as Neo-Expressionism and Pattern painting, to crowd the canvas
with a great variety of images drawn from many different sources.

Conclusion

Interpretations of contemporary American society during the same
period were very different in representational painting and best-selling
novels. In the novels, Long (1981) found increasing pessimism com-
bined with disillusionment with dominant American values concern-
ing the importance of economic success and achievement. In the
representational paintings, expressions of pessimism were very sub-
dued. While the works of these artists alluded to the impoverishment
of social relationships, the artists' statements about their works denied
their implications. Although the Photorealists introduced new types
of subject matter into representational painting, certain types of subject
matter were almost totally excluded from the works of painters in
both these styles, such as images of work, of social injustice, of the
poor, and of minorities.

One type of response by the best-selling novelists to social changes
that were affecting the individual adversely was to resort to escapist

formulas, often including violence and explicit sex. An equivalent although very different response on the part of some of the painters was withdrawal into a private and very passive world. Many of the works in both these styles (Photorealism and Figurative painting) convey a sense of calm and an underlying passivity. As John De Andrea, one of the sculptors associated with the Photorealists said (Pollock, 1972: 99), "I set up my own world, and it is a very peaceful world—at least my sculptures are. There is a lot of quietness in those figures . . . a lot of the new Realists . . . have a very passive world like mine." Reviews of Figurative painters commented on the serenity of these works. Phrases such as "meditative calm" (Ellenzweig, 1975a: 21) and "serene" recurred in reviews of these artists' work. A critic said of Robert Godfrey (Kelly, 1980: 12): "If there is a pervasive feeling that is generated by his work, it is one of calm, of stillness—a quality of stillness fragile beyond our ken." Another critic (Storr, 1984: 154), commenting on the work of Fairfield Porter and Rackstraw Downes, said: "these two artists offer an inviting and peaceful retreat from the terrible vastness and agitation of the world—a voluntary confinement where one is free to concentrate on the minor events and discreet sensual discoveries of civilized society."

Many of these artists were deeply immersed in their own environments. A critic said of Janet Fish ("Eight Contemporary American Realists," 1977: 38): "Fish's paintings . . . have tended to function as iconic references to her own studio world, until very recently without overt references to the world beyond the limits of that studio. . . . Fish's paintings are statements about her involvement in art rather than commentaries on modern life." The following comment also suggests the detached attitude toward reality that was typical of many of these artists (Henry, 1981a: 220): "all of Freilicher's paintings are setups . . . it is the artist's very self-consciousness that makes for the painting's vitality, as if reflection were a form of action. Freilicher's is a mode of painting about painting. . . . The setup is, after all, for the artist, the reality."

Ivan Karp, whose gallery exhibited the works of many of the Photorealists, was impressed by the unwillingness of these painters to comment on their subject matter (Karp, 1975: 30): "The message comes, apparent, glorious, and drab, but it has no final meaning. There is only the fact of materiality: neon tubes and plastic, daylight, shadow, and therefore the passage of time." Duane Hanson's comment on contemporary realism makes a similar point and at the same time invokes an alternative (Pollock, 1972: 99):

New Realist painting reflects everyday life or what we are thinking about, whatever it is you recognize, imagery you are confronted with . . . it's just taking it with no comment. To me that wasn't enough. I wanted to comment. . . . For me, I feel that I have to identify with those lost causes, revolutions and so forth. I am not satisfied with the world. Not that I think you can change it, but I just want to express my feelings of dissatisfaction. . . . If art can't reflect life and tell us more about life, I don't think it's an art that will be very lasting and durable. In other words, decoration. Something that looks nice to hang on the wall. It still gives us pleasure, but how meaningful is it? It's just the happy reflection of a world that doesn't exist."

Another way of demonstrating the character of these representational paintings is to compare them with French Impressionist and Post-Impressionist painting in the nineteenth century.[6] Appropriately, French Impressionism represents the beginning of modernism as an aesthetic tradition, while contemporary American representational painting emerged during a period when this aesthetic orientation appeared to some observers to be on the verge of exhaustion. These two styles are similar in some respects but different in others. Artists in both of these styles were preoccupied with problems of light and visual perception. Members of both groups depicted a largely middle-class milieu. However, members of each group had typically different attitudes toward the treatment of these themes.

The Impressionists and the Post-Impressionists were intensely interested in the nature of light and its presentation in artistic works. What differentiated their concern with light and visual phenomena from that of contemporary American representational painters was their conviction that these phenomena could actually be understood and that the problems associated with the presentation of visual phenomena could be solved. The American representational painters were concerned with some of the same issues, but underlying their discussion of their work was the attitude that these problems were inherently incomprehensible. They could be examined but there were no final answers.

A second difference between these two groups of painters lay in the fact that the Impressionists and their followers were interested in change and in the evanescent qualities of human life. They were intensely concerned with capturing a particular moment in time before it disappeared forever (Grana, 1971). As Blatt (1984: 295, 298) said: "They wanted to capture the moment, the flux, the instability, and the impermanence of the spontaneous event, which they con-

sidered the essence of life. . . . Renoir and Degas attempted to capture a moment in time by representing a person at a special instant in a particular activity." By contrast, many of the American painters seemed to be striving to present what was constant and unchanging in the scenes they depicted.

Thirdly, the Impressionists frequently depicted social relationships, such as intimate moments between a couple or in a small group. Grana (1971: 91) says: "while the Impressionists certainly were not the first to paint individuals as individuals, they were the first to paint private moments in public places, to surprise the awakening half-light of curiosity linking two people in the populous midst of others." The Impressionists also exposed the tensions inherent in the relationships between social classes in a highly stratified society. Edouard Manet did not hesitate to affront the conventions of the middle class in his famous painting, "Lunch on the Grass." He also commented on interclass relationships in his painting, "The Bar at The Folies-Bergère," which shows a waitress responding to the attentions of a middle-class customer.

By contrast, the nuances of interpersonal relationships are generally absent in the works of the American painters. While Impressionist and Post-Impressionist painters frequently depicted social gatherings in public places—bars, restaurants, theaters, and dances—such subjects are exceedingly rare in contemporary representational painting.[7] Also absent from the American works are any references to social class. Their works imply a society in which relationships between social classes are entirely unproblematic. For the most part, their subjects are indisputably middle-class while the French painters depicted subjects from a much broader social milieu, including entertainers, artisans, and fellow painters as well as the middle class (Grana, 1971: 79).[8] Finally, the French painters often depicted the social life of the middle class with considerable irony (see, for example, Paul Signac's painting of the stifling atmosphere of a bourgeois *Parisian Sunday*). In the American paintings, middle-class lifestyle is depicted without a hint of satire.[9]

One can only speculate about some of the reasons for the differences between these two groups of painters. Lanes (1972) argues that the characteristics of contemporary representational painting are a result of social rather than artistic factors. He suggests that the major difficulty which these artists face is that of finding images and subjects that have general significance. By contrast, as Baxandall showed, in fifteenth-century Italy, both patrons and painters pos-

sessed detailed knowledge of an elaborate iconography for expressing the religious values that represented the dominant cultural values of the age. Today, the equivalent would presumably be found in the images and themes of popular culture. Since there is no consensus concerning an alternative iconography for expressing contemporary life, contemporary artists tend to draw upon the iconography of previous artistic traditions or to incorporate signs from popular culture.

The French Impressionists seemed to have believed that they could understand and interpret their society, and consequently they did not hesitate to present a point of view concerning the nature of social relationships. The American painters, on the other hand, seemed reluctant to engage in any kind of interpretation of their society. By implication, one might conclude that they found this society too incomprehensible for either interpretation or satire. Bell (1976: 95) suggests that this is in fact the case: "the culture can hardly, if at all, reflect the society in which people live. The system of social relations is so complex and differentiated and experiences are so specialized, complicated, and incomprehensible, that it is difficult to find common symbols to relate one experience to another."

However, as we have seen, the picture of American society in the contemporary novel was also very different, and again one can only speculate about some of the reasons for these differences. One explanation might lie in the social backgrounds of the artists as compared to the writers (Long, 1981), but the two groups were quite similar. Most members of both groups were college-educated, male,[10] and came from urban backgrounds in the Middle West or on the East Coast. However, the artists were more likely to be teaching full-time or part-time in colleges or universities (63 percent) while the writers were more likely to be employed in publishing, journalism, or the entertainment media. It is possible that their academic connections shielded the artists from exposure to the economic realities that shaped the outlook of the writers.

An alternative explanation might be the relative influence of modernism in literature as compared to painting and sculpture. As we have seen, modernism was a powerful influence on most of these artists and helped to direct their attention away from social and political concerns. While modernism has had a similar type of influence on novelists, fewer novelists seem to have adopted this approach. Best-selling novels tend to be written in the tradition of the realistic novel, attempting to recreate real situations for the reader

as an extension of his or her own experiences and to provide models for behavior that are intended to influence the readers' understanding of themselves and of the society in which they live.

Finally, a major factor would seem to be the nature of the audience for these two forms of culture. The price of novels being considerably lower than the price of paintings means that the social-class level of the audience for the former is considerably broader than the audience for the latter. Books can be marketed to a variety of distinct subgroups within the population. Such audiences, even though largely middle-class, are presumably receptive to a broader range of social interpretation and commentary. The contemporary painter is constrained not only by the fact that his private collectors are generally upper-middle or upper-class in terms of income but by the circumstance that his public collectors are highly conservative organizations—museums and large corporations.[11] A comment by Duane Hanson in response to a question about how he created his sculptures is revealing in this respect (Pollock, 1972: 99): "I may also bloody them up a little bit, but you have to be careful about that. Like the soldiers I did. I almost sold them to a museum in Canada, but they had too much blood on them. They objected to too much blood on the soldier's head. *Interviewer: A little blood is OK?* Yeah, a little blood is OK."

Relatively few painters are willing, like Alfred Leslie, to paint works that are intended to be seen but are not for sale. He has said that he has deliberately created enormous canvases because (Van Devanter and Frankenstein, 1974: 208) "these paintings were meant to be public works for institutions. . . . my self-portrait and the other portraits, because of their size, would exist outside of the framework of being for sale, discourage purchase and thereby help in their being seen as works to be understood rather than owned."

Selling Myths: Art Galleries and the Art Market

Art styles develop within reward systems. Groups of artists choose their own cognitive and technical goals but they function within a support structure where they compete for symbolic and material rewards (Becker, 1982; Crane, 1976; Moulin, 1967; White and White, 1965; Zolberg, 1983). Changes in the size and number of the organizations that sell, display, and disseminate artworks affect their interactions with one another and their performance of their gatekeeping functions (White and White, 1965; Hirsch, 1972).

At the beginning of this period, as we have seen, the market for contemporary avant-garde art was small. A few galleries were serving as gatekeepers for a small group of collectors. During the sixties, as the number and types of collectors increased, along with the number of artists and the number of galleries, the character of the art market changed. Theories of market behavior developed by economists suggest that when a large number of small firms compete with one another, there is likely to be a high level of competition and a wider diversity of products (Peterson and Berger, 1975). As markets increase in size, a few organizations establish positions of leadership, thereby limiting the level of competition and the incentive to innovate. In such a situation, certain galleries would be expected to behave like an oligopoly, selecting styles that would appeal to the largest number of buyers. It is unlikely that such styles would be radically new.

In this chapter, I will show how the galleries' gatekeeping roles were affected by changes in the relationships between these organizational actors and their environment. What were the consequences of changes in the gatekeeping process for artistic careers and for the reception of artistic innovation?

For the most part, art galleries are small businesses, typically consisting of the owner-director and a few assistants. There is an analogy between museums and galleries on the one hand, and large corporations and small industrial firms on the other. In both cases, the smaller

organizations tend to be the innovators. In this situation, it is generally the gallery that makes the initial contacts with new artists. It is through the efforts of the gallery's staff that these artists eventually reach a larger audience. In making a decision to give a new artist his or her first exhibition, gallery owners and their staff must do so largely in the absence of other judgments. Critics rarely write about artists until their work has been exhibited. Museums are unlikely to exhibit their work unless it has already been shown in a gallery. Moreover, in the case of new talent, galleries are in the difficult situation of attempting to sell a product that is too new to have a firmly established price.

In other words, the business of selling art is a most unusual one. The nature of the commodity itself—it has been described as "dealing in myths"—is responsible for this. The "commodity" is expected to succeed on its own merits—to sell itself—so that attempts to rationalize business practices or to engage in any type of promotion other than display itself is considered suspect.

The environment of the avant-garde art gallery is carefully designed to convey an impression of complete detachment from the mundane business world and even from the outside world in general. White, windowless, and hushed, an avant-garde art gallery is like a stage set in which all attention is focused on the work of the current artist. O'Doherty (1976a: 24) has pointed out that all references to the external world are carefully suppressed so that the focus upon the artist will be complete:

> The work of art is isolated from everything that would detract from its own evaluation of itself. This gives the space a presence possessed by other spaces where conventions are preserved through the repetition of a closed system of values. Some of the sanctity of the church, the formality of the courtroom, the mystique of the experimental laboratory joins with chic design to produce a unique chamber of esthetics.

This atmosphere of aristocratic detachment was entirely appropriate when the typical avant-garde gallery's clients were a few wealthy collectors. However, as the market changed, the gallery had to begin to concern itself with attracting a public. Paintings had to be displayed more frequently in a wider variety of places, including the mass media, if the attention of these organizational collectors was to be obtained. The gallery which had been, according to O'Doherty (1976b: 42) "the limbo between studio and living room where the conventions of both meet on a carefully neutralized ground," yielded some of its privileged status to alternative spaces, regional museums, and even corporation

reception rooms. In the mid-sixties, an astute critic (Goldin, 1966: 29) expressed this idea in the following way:

> Today the public exhibition of art is necessary to establish its value. A style or an individual artist's work can become important *because* it is seen, and the confrontation of the work and the audience is held to be desirable in itself. This factor puts a new weight on the gallery that functions less like a shop and more like a theater. The work's ability to hold an audience seems a condition and measure of its value, as the audience-reaction is the measure of a play's.

As the number of sellers increased, competition presumably became more intense. There were a large number of very small businesses and a small number of large ones, all selling products that were similar to one another. Moulin (1967: 46) argues that in an art market all products are different from one another and in essence not substitutable. Hence, competition in the economic sense is imperfect. However, one can argue that this market is competitive in the sense in which this word is used in economics. While the ideology of the art world views artists as individualists who produce works that are distinguishable from the works of all other artists, considerable training and sophistication are necessary before a viewer can discern and recognize the differences among the products of artists working in the same style or even closely related styles.

The factor that sets the avant-garde art market apart from other markets is the extreme ambiguity concerning the value of the objects that are sold. While in a sense all the objects are alike (for example, paintings are pieces of canvas with paint or other substances spread over them), enormous differences in price exist. Value is not attributed to these objects on the basis of production costs, as in other markets, and, only to a small extent, on the basis of the costs of merchandising them. Instead, value is attributed entirely on the basis of evaluations of quality by experts, including critics, museum curators, and, to some extent, eminent collectors. However, the criteria which they use to evaluate quality change as styles change, and these evaluations are often inconsistent. The correlation between early evaluations of artworks and their eventual value can be very low. The early reviews of Abstract Expressionism were very poor although the Museum of Modern Art purchased some of these works as soon as they were shown. Within five years, the values of some of these paintings had more than tripled (Ashton, 1973: 211).

Under these conditions, three principal strategies are available to sellers: (1) increasing the differentiation between their products and those of other sellers; (2) increasing the visibility of their products; and (3) establishing a leadership role in the market by the sheer fact of their size or by their ability to represent the most prestigious and visible artists. The hypothesis that a few galleries "control" the New York art market has sometimes been asserted, but can it actually be shown?

The most successful way for a dealer to differentiate his products from those of other dealers was the introduction of a new style. In fact, as the number of new galleries increased during the period covered by my study, the number of new styles steadily increased. From a purely economic point of view, this proliferation of styles can be seen as the anticipated outcome of the structure of the market.

In the late forties and early fifties, Bystryn (1978) found that some dealers were particularly committed to fostering artistic innovation, which would imply a readiness to introduce new styles on a regular basis, while others were primarily concerned with marketing a product using shrewd business management. Defining a serious commitment as representing over five artists in a particular style, only 27 percent of the galleries had made such a commitment to one or more of the styles in my study. Among these thirty-six galleries, thirty-one (86 percent) represented over five artists in one style, four (11 percent) in two styles, and only one in three styles. If one restricts the category of gatekeeper to those galleries that represented more than five artists in one of these styles, it was evident that very few galleries performed this role more than once. The majority of these galleries did not commit themselves to any of these styles; instead, it appeared that their commitment was to artists as individuals rather than to artists as members of a style.

These data suggest that some galleries established a niche in the market based on a particular style so that there was little advantage in adding new ones. There may also have been another more subtle factor influencing their behavior. For some dealers, commitment to a style apparently involved commitment to a worldview that made it difficult for them to perceive alternatives. Betty Parsons, whom Bystryn presented as an example of a "gallery gatekeeper," is a case in point. In the late forties, she exhibited many of the leading Abstract Expressionists at a time when many critics were unreceptive to their work. Later she exhibited Minimalist artists, but she exhibited virtually nothing in the other styles in the study. Of Jasper Johns, whom she turned

down in the fifties, she was quoted as saying: "I just couldn't see him at the time" (Tomkins, 1975: 59). Ivan Karp, a leading dealer in the seventies and eighties, observed that each gallery represents a certain point of view, a way of seeing, which is supposed to be the only and exclusive point of view (Interview, *Archives of American Art,* 1969).

In fact, among these thirty-six "gatekeeper" galleries, there was evidence of specialization in particular types of styles, suggesting commitment to a paradigm or worldview: 33 percent had made a commitment (i.e. representing over five artists) only to the established styles (Abstract Expressionism, Pop, Minimalism), 19 percent only to the new styles (Pattern painting and Photorealism), and 39 percent only to Figurative painting. Only 8 percent of the galleries were committed to styles that belonged to more than one of these categories.

Was there any indication that the "gatekeeper" galleries had a dominant position in the art market? One indication of this could be seen in the extent to which they had been able to enhance the visibility of their clients' work, using tactics that included purchases by prestigious museums, retrospectives of their works in museums, exhibitions in prestigious museums, frequent exhibitions, travelling exhibitions in the United States and abroad, purchases by elite collectors, personal publicity, and auction sales. Some New York dealers developed associations with dealers in other parts of the country who exhibited the works of their artists on a regular basis (Tomkins, 1980b). Others hired public-relations firms whose task was to attract the attention of the mass media to the gallery's artists. Clearly the "gatekeeper" galleries represented the most visible artists (see table 6.1). In other words, these galleries represented the artists in the study that had most frequently received retrospective exhibitions and whose paintings had most frequently been purchased by leading museums (see table 6.1). Members of this group were more likely than other galleries in the sample to represent over five artists whose artworks had been purchased by the Museum of Modern Art, the Whitney, and other New York museums.[1] These galleries were also more likely to be leaders in the sense that they had been the first to exhibit particular artists. Among the gatekeeper galleries, a small group of eleven galleries that had been active in several styles[2] were clearly more likely to represent successful artists than all the other galleries.

Another indication of the leadership role played by the gatekeeper galleries was their access to the auction market. Before 1970, works by contemporary American avant-garde artists were only occasionally

TABLE 6.1

Gatekeeper Galleries and the Reward System

	Type of Gallery[a]
Leadership[b]	.61[c]
Artistic Success: Auction Sales[d]	.63
Artistic Success: Retrospectives[e]	.82
Artistic Success: Museum Purchases[f]	.74

[a]The categories were oligopoly-gatekeeper; gatekeeper; other (see text for definitions of these terms).

[b]Leadership was defined as being the first gallery to exhibit a particular artist (ties were acceptable). Galleries were differentiated in terms of having been leaders in more than one style, in only one style, or not at all.

[c]Gamma coefficients (Goodman and Kruskal).

[d]Artistic Success: Auction Sales was defined in terms of the number of artists shown by the gallery whose works had been auctioned (none, 1–5, over 5).

[e]Artistic Success: Retrospectives was defined as the number of artists shown by the gallery who had had retrospective exhibitions of their work (none, 1–5, over 5).

[f]Artistic Success: Museum Purchases was defined as the number of artists shown by the gallery whose works had been purchased by the Museum of Modern Art.

auctioned. After that period, auction sales of these works became much more frequent, although less than one-third of the artists in the study (28 percent) had participated in that market. Pop, Minimalist, Photorealist, and Figurative artists whose dealers were among the eleven leading gatekeeper galleries were more likely than other artists to have had works sold in the auction market (gamma for this group: .71).[3]

Within all five styles, prices in the auction market were highly stratified (see table 6.2). In each style, a few artists commanded very high prices, others were in the middle range, and the majority obtained relatively low prices (see table 6.2). The differences between the median prices for each style and the highest prices received by artists in these styles indicate the disparity in prices between the leading artists and the "rank-and-file."

As table 6.2 shows, prices varied in the different styles. Prices were highest for Abstract Expressionists and were substantially lower in the other styles.[4] Among this group, the Pop artists had obtained the highest prices, as indicated by the median price for these artists' works. Significantly, the Minimalists who had deliberately attempted to create works that defied the notion of the art object as a commercial commodity had the lowest median price among these styles.

The factors associated with high auction prices varied in different styles. Among the Abstract Expressionists, the only factor that was

TABLE 6.2

Auction Prices by Style, 1970–82

	Style				
Prices	Abstract Expressionism	Pop	Minimalism	Photo-realism	Figurative
$5000 or less	11	22	68	43	53
$5001– $20,000	5	22	14	37	32
$20,001– $50,000	21	22	7	16	16
$50,001– $100,000	5	6	4	0	0
Over $100,000	59	28	7	5	0
Total	101	100	100	101	101
N	19	18	28	19	19
Median price	$128,750	$25,000	$3684	$6875	$4250
Top price	$550,000	$240,000	$420,000	$130,000	$26,000
% of artists auctioned	90	64	35	37	15

NOTE: The prices are based on the highest price each artist received during this period (*Auction Prices of American Artists, 1970–78; 1978–80; 1980–82*).

strongly associated with high auction prices (over $100,000) was the artist's death. The artist's death, by foreclosing the possibility of future works, made his work rare.[5] Among members of the other styles, 80 percent of those whose works had been sold for high prices had been associated with one of the eleven leaders among the gatekeeper galleries.[6] Women were largely excluded from the auction market; the few whose works were auctioned did not receive high prices. These data suggest that certain galleries had access to elite collectors who in turn were increasingly likely to treat paintings as investments to be bought and sold like stocks on Wall Street. On the other hand, as table B3 indicates, not all artists who were associated with gatekeeper galleries obtained high auction prices. This type of association was most important for the Pop artists and least important for the Figurative painters. Other factors also played a role. Among the Figurative painters, recognition by the New York artistic reward system was a more important factor. In the other styles, this factor was of equal importance.

By the end of the period covered by our study, the New York art market consisted of two markets: an auction market to which access was controlled by a small group of leading galleries and a general market in which the number of sellers, and hence the level of competition, was steadily increasing, as was suggested by the relatively low survival rate among the sellers of avant-garde art other than members of the oligopoly.[7]

As we have seen, the highest economic rewards were restricted to those artists who were associated with a few leading galleries. However, the auction market was also risky and unstable,[8] as indicated by the fact that auction prices of many living artists did not keep pace with the rate of inflation during the seventies and early eighties.[9] As table 6.3 shows, the auction prices of about one-third of these painters did not increase in real terms. In two of the older styles (Pop and Minimalism), prices of more than half the artists whose works were auctioned during that period decreased.

Little information about prices outside the auction market was available. One observer stated that less than 1 percent of all easel paintings that are offered for sale in any given year find buyers (Kent, 1959: 62). During the seventies, as more and more art was being created, it be-

TABLE 6.3

Changes in Real Values of Art Works by Style

| Style | Change in Auction Prices, 1970–82 | | | | |
	Over 100% Increase	1–100% Increase	Decrease	Total[a]	N
Abstract Expressionism[b]	72	11	17	100	18
Pop	21	21	57	99	14
Minimalism	31	13	56	100	16
Photorealism	44	22	33	99	9
Figurative	69	8	23	101	13
All styles	49	14	36	99	69

NOTE: Prices were standardized in terms of 1972 values (*Economic Report of the President*, 1983: 166) and in terms of size (see n. 9).

[a]Includes only those artists whose works were auctioned during more than one time-period within the 1970–82 period (1970–74, 1975–79, 1980–82). Within each period, the highest prices were used (*Auction Prices of American Artists, 1970–78; 1978–80, 1980–82*).

[b]For this style only, auction data from 1963–65 were included in the analysis (Bérard, 1971; *The Art Collector's Almanac, No. 1, 1965*).

came increasingly difficult for dealers to assess it adequately. Some dealers reported seeing an average of five thousand sets of slides representing young artists' works per year. Many artists could not find galleries. Co-ops and alternative spaces were formed in an attempt to provide outlets for new developments. These organizations were reacting to an establishment that appeared to be increasingly resistant to new styles.

On the other hand, the New York art market continued to respond to new styles because new galleries were continually appearing: new gatekeeper galleries replaced old ones while alternative spaces and co-operative galleries supplemented commercial galleries. Without the continual expansion of the organizational infrastructure, the histories of these styles would have been substantially different.

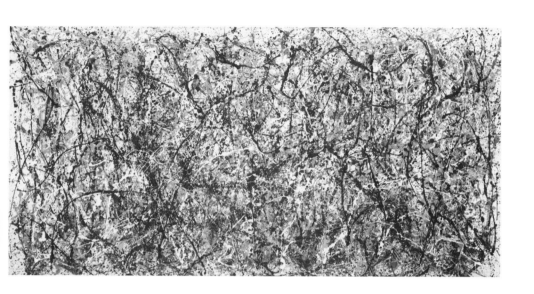

1

Jackson Pollock

One (Number 31, 1950) (1950)
Oil and enamel on canvas. 8'10" × 17'5⅝"
Collection, The Museum of Modern Art, New York.
Sidney and Harriet Janis Collection Fund.

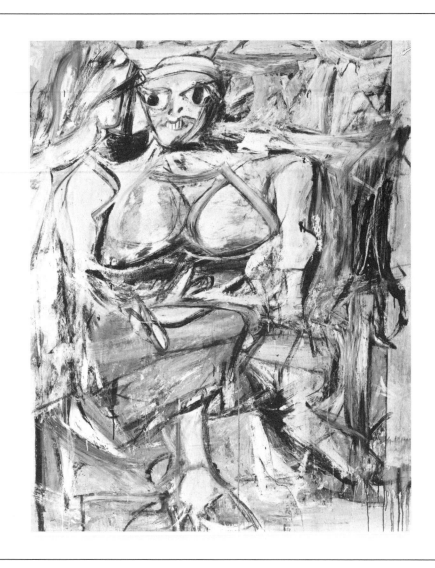

2

Willem de Kooning

Woman, I (1950–52)
Oil on canvas. 6′3⅞″ × 58″
Collection, The Museum of Modern Art,
New York. Purchase.

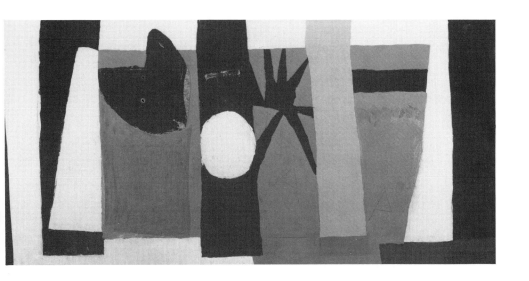

3

Robert Motherwell

The Voyage (1949)
Oil and tempera on paper mounted on composition board. 48″ × 7′10″
Collection, The Museum of Modern Art, New York.
Gift of Mrs. John D. Rockefeller III.

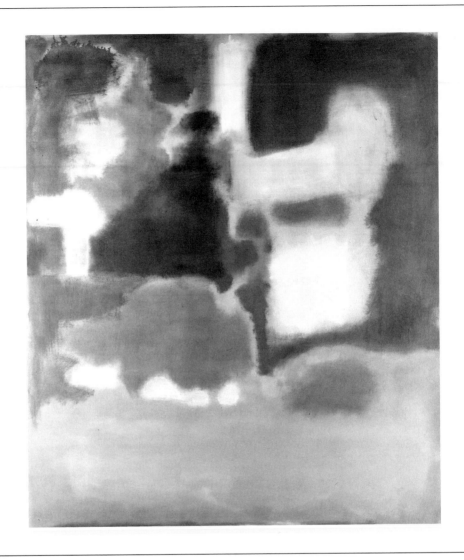

4

Mark Rothko

Number 18, 1948 (1948)
Oil on canvas. 67⅛″ × 56″.
Collection, Vassar College Art Gallery, Poughkeepsie, New York.
Gift of Mrs. John D. Rockefeller, III.

5

Frank Stella

Gran Cairo (1962)
Synthetic polymer. 85½″ × 85½″
Collection, Whitney Museum of American Art, New York.
Purchase, with funds from the Friends of the
Whitney Museum of American Art.

6

Charles Ross

Islands of Prisms
Photograph of installation at the
Finch College Museum of Art,
New York, 1967.

7

Donald Judd

Untitled (1965)
Perforated steel. 8″ × 120″ × 66″
Collection, Whitney Museum of American Art, New York.
Fiftieth Anniversary Gift of Toiny and Leo Castelli.

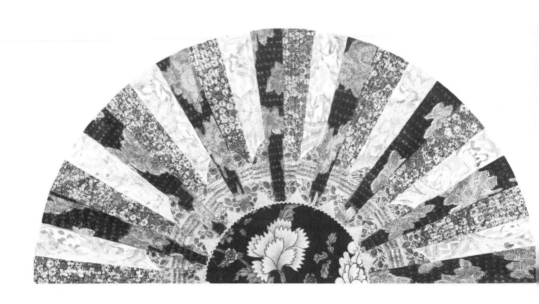

Miriam Schapiro

Golden Fan (1979)
Acrylic paint with fabric collage on canvas. 4′ × 8′
Private collection, New York.

9

William Conlon

Halley's Comet (1979)
Acrylic on canvas, 72″ × 86″
Courtesy Andre Emmerich Gallery, New York.

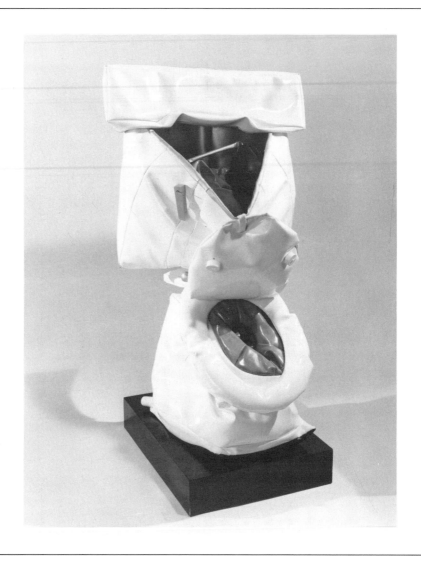

10

Claes Oldenburg

Soft Toilet (1966)
Vinyl filled with kapok, painted with liquitex, and wood. 52″ × 32″
Collection, Whitney Museum of American Art, New York.
Fiftieth Anniversary Gift of Mr. and Mrs. Victor W. Ganz.

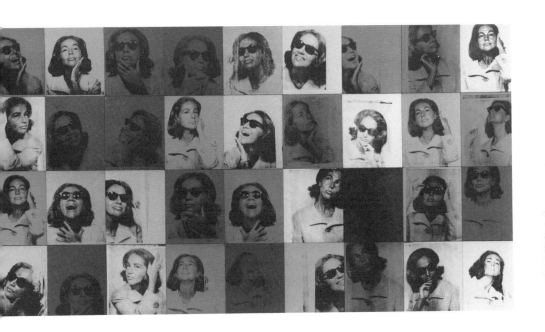

11

Andy Warhol

Ethel Scull 36 Times (1963)
Synthetic polymer paint silkscreened on canvas. 79¾″ × 143¼″
Collection, Whitney Museum of American Art.
Gift of Ethel Redner Scull.

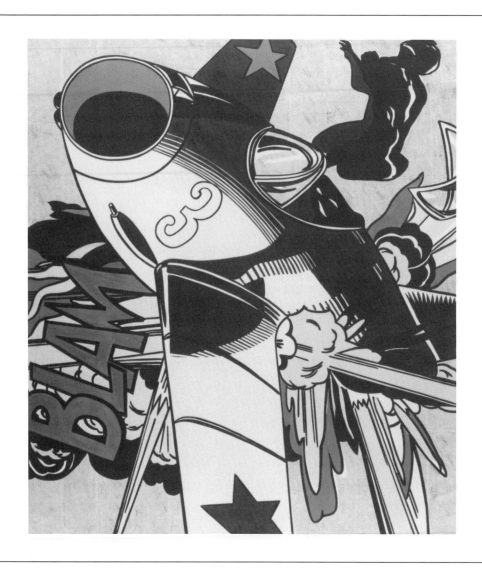

12

Roy Lichtenstein

Blam! (1962)
Oil on canvas. 68″ × 80″
Collection of Richard Brown Baker.
Courtesy of Yale University Art Gallery,
New Haven, Connecticut.

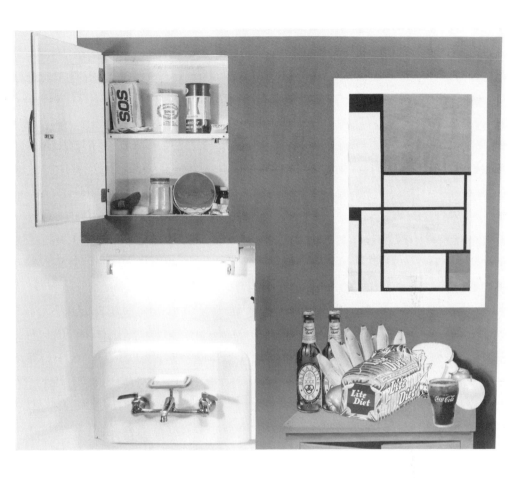

13

Tom Wesselmann

Still Life #20 (1962)
Collage in paint, wood, light bulb, switch,
items in chest, etc. 41″ × 4′ × 5½″
Collection, Albright–Knox Art Gallery, Buffalo, New York.
Gift of Seymour H. Knox, 1962.

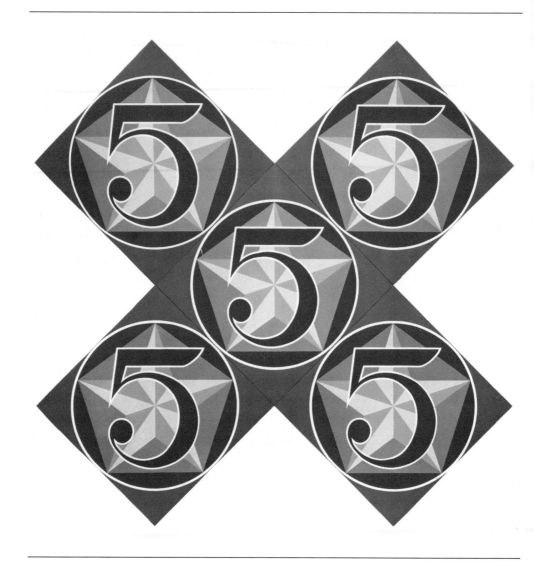

14

Robert Indiana

The X-5 (1963)
Oil on canvas. 5 panels: each panel: 36″ × 36″
Collection, Whitney Museum of American Art. Purchase.

15

Rhonda Zwillinger

Give Me Liberty or Give Me Romance (1983)
Installation. Photograph by Andreas Sterzing.

16

Kenny Scharf

When the Worlds Collide (1984)
Oil, acrylic and enamel spray paint on canvas. 122″ × 209¼″
Collection, Whitney Museum of American Art.
Purchase, with funds from Edward R. Downe, Jr., and Eric Fischl.

17

Robert Longo

Master Jazz (1982–83)
Lacquer on wood; charcoal, graphite and ink on paper;
silkscreen and acrylic on masonite. 96″ × 225″ × 12″
Private collection.
Courtesy Metro Pictures, New York. Photo: Pelka/Noble.

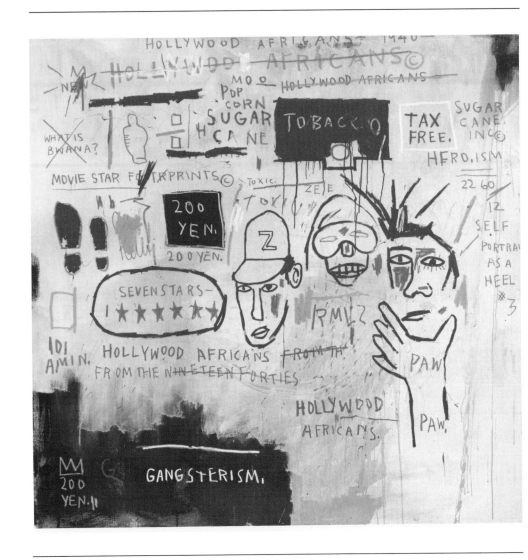

18

Jean-Michel Basquiat

Hollywood Africans (1983)
Acrylic and mixed media on canvas. 84″ × 84″
Collection, Whitney Museum of American Art.
Gift of Douglas S. Kramer.

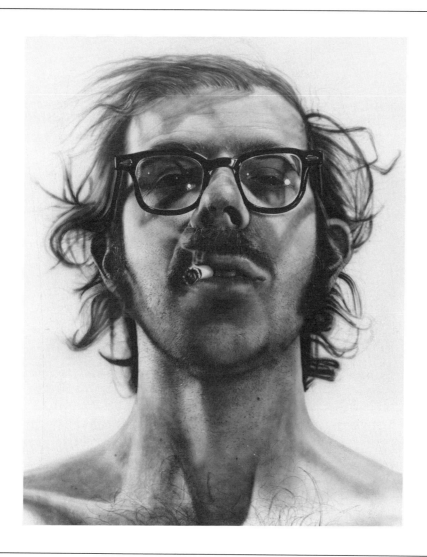

19

Chuck Close

Self-Portrait (1968)
Acrylic on canvas. 8′ 11½″ × 6′ 11½″
Collection, Walker Art Center, Minneapolis.
Art Center Acquisition Fund, 1969.

20

Richard Estes

Central Savings (1975)
Oil on canvas. 36″ × 48″
Collection, The Nelson-Atkins Museum of Art, Kansas City, Missouri.
Gift of the Friends of Art.

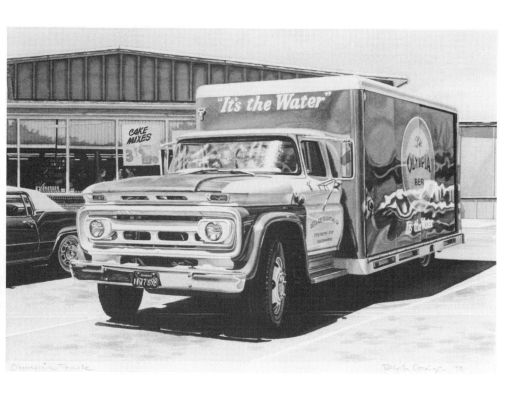

21

Ralph Goings

Olympia Truck (1972)
Watercolor. 9″ × 12½″
Collection, Richard Brown Baker.
Courtesy Yale University Art Gallery, New Haven, Connecticut.

22

Robert Bechtle

'61 Pontiac (1968–69)
Oil on canvas. 60″ × 84″
Collection, Whitney Museum of American Art.
Purchase, with funds from the Richard and Dorothy Rogers Fund.

23

Ben Schonzeit

The Music Room (1977–78)
Oil on canvas. 96″ × 96″; acrylic on canvas, 96″ × 96″;
oil on canvas, 96″ × 48″; mylar mirror, 96″ × 48″
Private collection.

24

Jane Freilicher

In Broad Daylight (1979)
Oil on canvas. 70″ × 90″
Collection of the McNay Art Museum, San Antonio, Texas.
Gift of the Semmes Foundation.

25

Fairfield Porter

Interior in Sunlight (1965)
Oil on canvas. 45″ × 45″
Collection, The Brooklyn Museum.
Gift of Mr. and Mrs. John Koch.

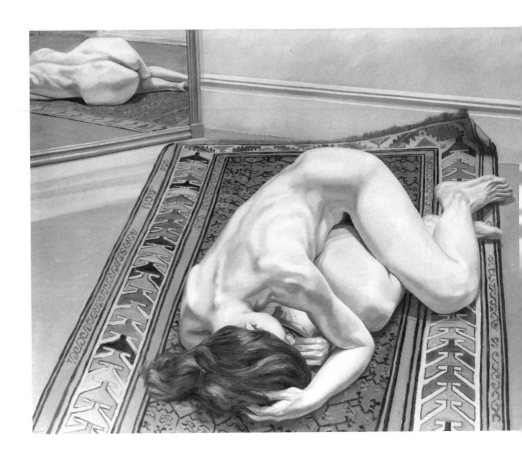

26

Philip Pearlstein

Female Model on Oriental Rug with Mirror (1968)
Oil on canvas. 60″ × 72″
Collection, Whitney Museum of American Art, New York.
Fiftieth Anniversary Gift of Mr. and Mrs. Leonard A. Lauder.

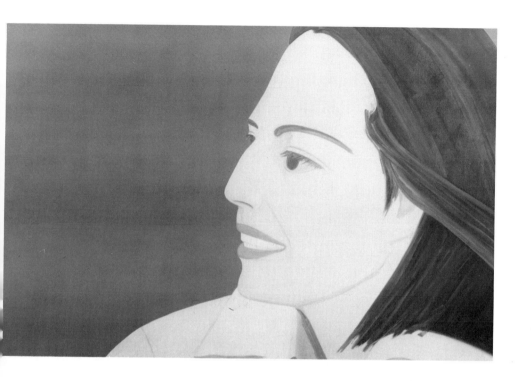

27

Alex Katz

The Red Smile (1963)
Oil on canvas. 78¾″ × 114¾″
Collection, Whitney Museum of American Art, New York.
Purchase, with funds from the Painting and Sculpture Committee.

28

William Bailey

Monte Migiana Still Life (1979)
Oil on linen. 54¼″ × 60³/₁₆″
Collection, Pennsylvania Academy of the Fine Arts,
Philadelphia, Pa.

29

Rackstraw Downes

Behind the Store at Prospect (1979–80)
Oil on canvas. 18¾" × 46¹¹⁄₁₆"
Collection, Pennsylvania Academy of the Fine Arts, Philadelphia, Pa.
Purchase, with funds from the National Endowment for the Arts
and the Contemporary Arts Purchase Fund.

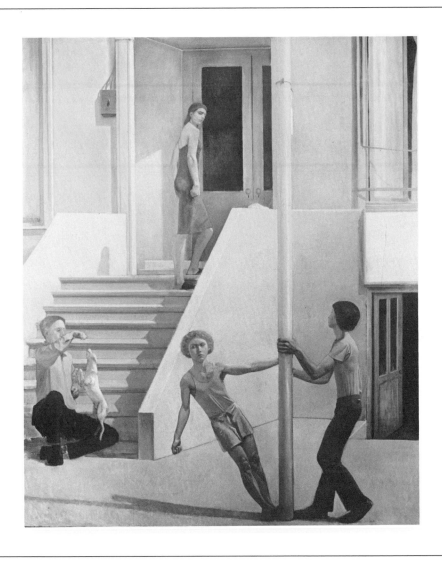

30

Lennart Anderson

St. Mark's Place (1969–1975)
Oil on canvas. 97″ × 72″
Collection, University of Virginia Art Museum, Charlottesville, Virginia.
Purchase, in part with a grant from the
National Endowment for the Arts.

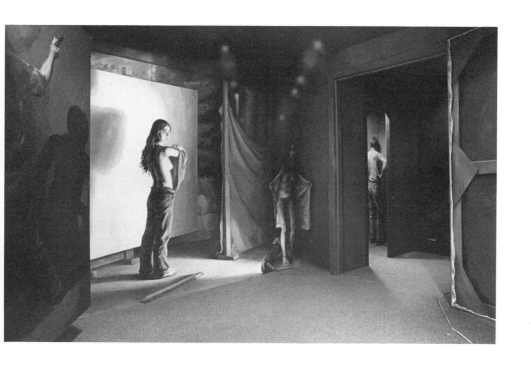

31

Willard Midgette

The Loft (*Models and Bedroom*) (1971)
Installation.
Photograph courtesy of Allan Frumkin Gallery,
New York.

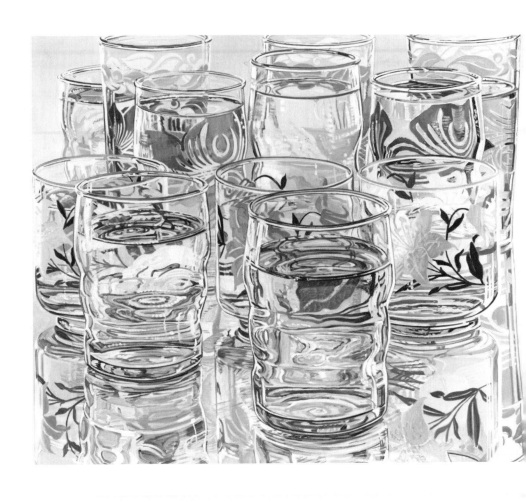

32

Janet Fish

Painted Water Glasses (1974)
Oil on canvas. 53¾″ × 60″
Collection, Whitney Museum of American Art,
New York. Gift of Sue and David Workman.

Art Museums and the Reception of Avant-Garde Art Styles

Between the two World Wars, several museums were established in New York, including the Museum of Modern Art (1929), the Whitney Museum of American Art (1931), and the Solomon R. Guggenheim Museum (1937).[1] However, it was not until the mid-forties that these museums began to concern themselves with what had become the avant-garde in American art. Before that time, these organizations and almost all galleries were concerned either with European art or with American art in a realistic style (Rose, 1975a: 124). They were largely indifferent to abstract art (Ashton, 1973). During the thirties, avant-garde artists created their own organizations, such as the American Abstract Artists, which lobbied for the acceptance of abstract art. In 1940, some abstract artists picketed the Museum of Modern Art to call attention to the museum's neglect of their work (Barr, 1977: 632).

Among the New York museums, the two which had the most influence on artistic developments during the period of this study were the Museum of Modern Art (MOMA) and the Whitney Museum. The other museums, mainly the Guggenheim, Jewish, Metropolitan, and Brooklyn Museums, generally played minor roles, although, as we will see, with respect to the emergence of Minimalism and Pop, the Guggenheim Museum and the Jewish Museum were influential. In this chapter, I will be concerned with the reception that these organizations accorded new art styles, as they appeared, and the significance of these styles for these organizations. How were their decisions to acquire or exhibit works by these artists affected by changes in the art market as a whole? How did these organizations themselves change during this period and how did these changes affect their roles as gatekeepers? In other words, we would expect that these organizations, faced with the continual appearance of new styles, would tend to resist the acceptance of new styles that represented major shifts in aesthetic orientation. I will explore three possible explanations for their behavior: (1) *Commitment to a paradigm:* Consistency in the selection of certain styles rather than others would suggest that museum curators were

committed to a common "worldview" or paradigm and that they were unable to perceive the merits of paintings that did not fit the prescriptions of the paradigm; (2) *Bureaucratization:* Some of the New York museums, including the two that were most influential with respect to avant-garde art, expanded considerably during this period. The staff of the Museum of Modern Art, which had been very small before World War II, was 167 in 1948, 246 in 1959, and 537 in 1970 (Goldin and Smith, 1977: 93). The staff of the Whitney Museum of American Art also increased in size although not to the same extent as that of MOMA. This suggests that these museums might have become less responsive to new art movements because they had become large and bureaucratic. Allen's (1974) study of New York museums in the late sixties and early seventies found two parallel administrative structures in these museums: the curatorial section, which made aesthetic decisions, and the business-administrative section, which controlled the budget. The latter was more bureaucratic than the former and, significantly, was increasing in influence during the seventies due to the necessity for stricter budgetary controls; (3) *Changing conceptions of the museum's role:* A third interpretation of the acquisition policies of these museums is that their conception of their role changed during this period in such a way as to make recent developments in contemporary art styles less relevant to their activities. Formerly, the functions of these museums were viewed as those of conserving aesthetic objects or assessing their value in terms of a historical tradition. Their primary audiences were collectors, patrons, critics, and scholars who belonged to a social network which was described in Chapter 2. Toward the end of this period, the New York museums began to move toward a different definition of their role, one in which they were required to serve a broader segment of the public and to expand the range of materials they presented. At the same time, increases in the numbers of regional museums and corporate collections meant that there were additional markets for these artworks.

New York Museums and Avant-Garde Art

The Museum of Modern Art: Europe vs. America. During the 1930s the importance of the Museum of Modern Art was largely as a channel for the diffusion of artistic ideas from Europe, primarily from France. As we have seen, European and particularly French artists of the late nineteenth and early twentieth centuries had an enormous influence

upon many of the artists in our sample. Geldzahler (1969) has remarked that the presence of such paintings in New York City was an important factor in the artistic development of painters in the postwar period, particularly of the Abstract Expressionists.

However, the Museum of Modern Art began buying Abstract Expressionist paintings almost as soon as they were exhibited in galleries.[2] For example, the Museum bought a painting from Jackson Pollock's first exhibition at the Art of This Century gallery in 1943. By 1948, it had purchased paintings by seven out of twenty-one members of this group (33 percent) and by 1953 it had acquired paintings by twelve members (57 percent) (see table 7.1) (Barr, 1977; Legg, 1977).[3] By 1980, the entire group was represented in the Museum's collection (see table 7.3).

Perhaps because of the prevalent attitude toward these painters in the New York art world, the Museum included only two of these artists in exhibitions before 1948, but by 1953 almost two-thirds of them had been exhibited (see table 7.2). By 1980, 81 percent had been

TABLE 7.1

Reception of Art Styles by MOMA and Whitney
Percentage of Artists Purchased by Time Period

% of Artists Purchased by Style	Time			
	Date of Origin	After 5 Years	After 10 Years	N
Museum of Modern Art				
Abstract Expressionism	1943	33	57	21
Pop	1958	29	43	28
Minimalism	1963	23	50	80
Figurative	1968	9	10	126
Photorealism	1972	12	27	51
Pattern	1975	15	18	61
Whitney Museum of Modern Art				
Abstract Expressionism	1943	19	52	21
Pop	1958	7	61	28
Minimalism	1963	35	44	80
Figurative	1968	21	25	126
Photorealism	1972	20	27	51
Pattern	1975	23	30	61

NOTE: The data are derived from the following sources: Barr (1977); Legg (1977), Whitney Museum of American Art (1986), annual reports of the museums, and artists' biographies.

TABLE 7.2

*Reception of Art Styles by MOMA and Whitney, Percentage of Artists Exhibited
by Time Period*

% of Artists Exhibited by Style	Date of Origin	After 5 Years	After 10 Years	By 1980 Artists with 3 + Exhibitions	Retrospective	N
			Museum of Modern Art			
Abstract						
Expressionism	1943	10	62	81	24	21
Pop	1958	29	39	18	7	28
Minimalism	1963	34	41	16	3	80
Figurative	1968	13	17	2	0	126
Photorealism	1972	16	18	0	0	51
Pattern	1975	18	21	0	0	61
			Whitney Museum of American Art			
Abstract						
Expressionism	1943	33	52	71	29	21
Pop	1958	11	54	46	4	28
Minimalism	1963	55	61	39	5	80
Figurative	1968	30	33	16	2	126
Photorealism	1972	35	37	14	0	51
Pattern[a]	1975	51	51	0	0	61

NOTE: The data are derived from the artists' biographies.

[a]Excludes shows that took place before the artist began to work in this style.

included in three or more exhibitions and five (24 percent) had been given retrospective exhibitions, a major accolade for a living artist. The importance of an exhibition at MOMA for an artist's career is indicated by Alexander Calder's remark that "whatever my success has been, (it was) greatly as a result of the show I had at MOMA in 1943" (Barr, 1977: 645).

The Museum responded more slowly to later styles. Five years after the advent of Pop (1963), it had acquired eight of these painters (29 percent). After ten years (1968), it owned 43 percent and by 1983 64 percent (see tables 7.1 and 7.3). Although the Museum exhibited 29 percent of these artists during the first five years of the style, it had exhibited only 39 percent after ten years (see table 7.2).

The MOMA's response to Minimalism was similar. Twenty-three percent of these artists were acquired within the first five years and 50 percent within the first ten (see table 7.1). By 1983, the Museum owned works by 56 percent of these artists (see table 7.3). As table 7.2 shows, the museum exhibited these artists in about the same proportions as Pop: 34 percent by the end of the first five years and 41 percent at the

TABLE 7.3

Collections of New York Museums by Style, 1983

Style	% of Artists in Collection					
	MOMA	Whitney	Guggenheim	Metropolitan	Brooklyn[a]	N
Abstract						
Expressionism	100	95	71	90	57	21
Pop	64	64	43	43	43	28
Minimalism	56	50	23	15	14	80
Figurative	21	25	2	17	23	126
Modern	23	31	0	28	31	39
Modern-Traditional	13	30	4	4	17	23
Traditional	37	32	3	18	29	38
Unclassified	4	4	0	8	4	26
Photorealism	25	27	22	8	39	51
Pattern	18	30	10	8	8	61

NOTE: Data are derived from Barr (1977), The Brooklyn Museum (1979), Legg (1977), The Whitney Museum of American Art (1986), annual reports of museums, and artists' biographies. By 1983 the Jewish Museum had acquired only two of the artists in this study.

[a]Paintings representing 33% of the Brooklyn Museum's artists in these styles were acquired during or after 1979.

end of ten years. Neither the Pop nor the Minimal artists received as many exhibitions per artist nor as many retrospectives as the Abstract Expressionists (see table 7.2), although larger proportions of artists in both these styles were exhibited within the first five years.

Subsequent styles received considerably less attention from MOMA. After five years, only 15 percent of the Pattern painters were in the museum's collection. However, 18 percent had been included in group or individual shows at the museum. Twelve percent of the Photo-realists were acquired within the first five years and 16 percent of them were exhibited (see tables 7.1 and 7.2). These styles emerged in the early seventies in an atmosphere that had changed once again; the decade was one of pluralism, characterized by many and diverse styles. Neither Pattern painting nor Photorealism attracted widespread atten-tion, either from critics or the mass media.

The reception which MOMA accorded to Figurative painting was the least enthusiastic. By 1973, the museum had purchased only 9 percent of the painters in this group. Most of these paintings were purchased in the early sixties, possibly in response to protests by realist painters in 1958 and 1960 against the poor representation of realist painters in the museum's collection (Barr, 1977: 632). During a period (1973–77) of steadily increasing activity by Figurative painters, few

paintings by members of this group were acquired by the museum (see table 7.1). Few Figurative artists were exhibited by the museum: 17 percent by 1978 (see table 7.2). With the exception of Neo-Expressionism, the Museum's response to new styles became increasingly conservative over a period of four decades. Twenty-two percent of the Neo-Expressionists were acquired and 46 percent were exhibited in the early eighties (not shown in table 7.1).

The Whitney: A Commitment to American Art. Unlike the Museum of Modern Art, the Whitney was founded specifically to help living American artists. It therefore has a commitment both to contemporary art and to American art. The Whitney was somewhat slower than MOMA in its response to Abstract Expressionism and Pop, but after ten years its collections of these styles were as large or larger than MOMA's (see table 7.1). However, the Whitney provided an environment which was more receptive to the acquisition of paintings in the newer styles than MOMA but less receptive than the regional museums as a whole (see tables 7.6 and 7.7). Like MOMA, its response to Neo-Expressionism was more enthusiastic than its response to other recent styles (35 percent of these artists were acquired in the early eighties).

The Whitney stressed exhibitions[4] and consequently was more active in exhibiting the works of artists in these styles than in acquiring them. Compared to the Museum of Modern Art, the Whitney exhibited higher percentages of artists in every style but Abstract Expressionism and Pop (see table 7.2). Moreover, the Whitney exhibited higher proportions of artists in these styles (with the exception of Pop) during the initial phases of their development (see table 7.2). In this respect, the Whitney was more receptive than MOMA to the more recent styles in the study, Photorealism, Figurative painting, and particularly Pattern painting and Neo-Expressionism (62 percent of the latter were exhibited in the early eighties). In part, this is a reflection of the Whitney's practice of holding annual or biennial exhibitions for which the staff makes substantial efforts to identify and display new artistic ideas. However, Golub (1973: 36), on the basis of an analysis of the artists who had exhibited in the annual and biennial exhibitions, showed that while the Museum included new artists in its exhibitions, such artists were seldom shown a second time in their exhibitions. Instead, certain established New York artists were repeatedly shown. He concluded: "The Whitney has been a strong force for the stabilization of reputations."

TABLE 7.4

Styles Exhibited by New York Museums through 1980

Style	MOMA	Whitney	Guggen-heim	Jewish	Metro-politan	Brooklyn	N
% of Artists Exhibited by 1980							
Abstract							
Expressionism	100	90	86	14	33	5	21
Pop	54	78	29	29	4	4	28
Minimalism	41	61	51	57	13	3	80
Figurative	17	30	2	3	2	17	126
Modern	18	38	0	5	5	21	39
Modern-Traditional	9	26	0	0	4	13	23
Traditional	26	42	8	5	3	21	38
Unclassified	8	4	0	0	4	8	26
Photorealism	18	37	4	0	0	10	51
Pattern	20	49	7	5	4	8	61

NOTE: Data are derived from artists' biographies.

Other New York Museums. Except in the cases of Abstract Expressionism and Pop, the Guggenheim and Jewish Museums acquired and exhibited few paintings by artists in the styles in the study (see tables 7.3 and 7.4). While the Guggenheim exhibited a large proportion of the Abstract Expressionists, it did so in the sixties, long after the movement had passed its peak. However, both museums were active in the early stages of Pop and Minimalism. Both museums organized important exhibitions which contributed to the definition of Minimalism as a movement[5]. The Jewish Museum gave retrospective exhibitions to two Pop artists very early in their careers[6] and included them in several group exhibitions.

By contrast, the Guggenheim's interest in Minimalism was a logical development of its concern with nonobjective art and it developed into a long-term commitment. Goldin and Smith (1977: 100) state that "the Guggenheim's boldest and strongest exhibitions often seem to lead to or derive from Minimalism," a tendency that continued in the seventies.

More strongly committed to the past than the other museums in this group, the Metropolitan made only sporadic efforts to participate in the development of contemporary art. Until the eighties and the opening of its huge twentieth-century wing, its collections and exhibitions of contemporary art seemed to reflect largely the efforts of certain staff members rather than a consistent policy. With its interests fragmented in a variety of historical and educational areas, the Brook-

lyn Museum also had a minor commitment to contemporary art until the late seventies. Before then, the paintings it did acquire are said to be of poor quality (Goldin and Smith, 1977: 104).

Conclusion. Over a period of four decades, New York museums became gradually less responsive to emerging art styles. Overall, there was considerable consistency in their choices among various styles. How can their behavior be explained?

Commitment to a paradigm. This argument was advanced by Godfrey (1979) and Kramer (1977), both of whom argued that critics and curators were committed to the precepts of modernism that call for continual innovation along certain lines and that therefore they were unwilling to consider contemporary Figurative painting in which the artists were renewing or reviving the art of the past. Curiously, however, among the Figurative painters that were selected for the collections of MOMA, the Whitney, and the Brooklyn Museum, traditional painters either predominated or were acquired as frequently as those who had been influenced by modernism (see table 7.3). This suggests that additional explanations for the relative neglect of Figurative painting by these museums must be considered. In the late sixties, several important resignations took place, so that the direction of the Museum of Modern Art underwent significant changes at the beginning of the seventies (Barr, 1977). Those who were in charge of museum policy toward the acquisition of contemporary painting were strongly committed to early twentieth-century painting, of which the Museum's collection is outstanding (Goldin and Smith, 1977: 94). Goldin and Smith (1977: 95) comment that: "Since 1970 in particular, the museum seems to have operated at a number of extremes which leave a great deal of middle ground uncovered in terms of historical periods, artistic styles and types of exhibitions."

These authors also point out that the museum seems not to have moved beyond its commitment to Minimalism, a characteristic that we find in other New York museums, particularly in terms of exhibitions. During the seventies, the Whitney's director stressed twentieth-century art as a whole rather than the contemporary period (Goldin and Smith, 1977).

Bureaucratization. A second interpretation is that these museums were less responsive to new movements in art because they became large and bureaucratic. However, the six museums in the study varied considerably in size from the Jewish Museum, which had a staff of twelve in the early seventies, to the Metropolitan, which had a staff of 760 in

the same period (Allen, 1974: 186). One would expect the larger museums to be more susceptible to bureaucratization than the smaller ones, but the smaller museums also did not respond to the new styles. For example, the Guggenheim Museum, whose staff has remained relatively small in spite of the fact that its endowment is as large or larger than that of its peers (Goldin and Smith, 1977: 101), has consistently acquired paintings that show a strong commitment to "the pictorial values of sixties' paintings."

Allen's (1974) study of New York museums in the late sixties and early seventies found them to be relatively unbureaucratic. Decisions were generally based on professional expertise rather than on formal rules. Allen concluded (1974: 173):

> Whereas in the rationalized, routinized economic organization, rules are well defined and conscientiously enforced, and authority is hierarchical and positional, in the art museum flexibility not formalization is necessary; rules and procedures are expedient not directive, and authority is based on professional expertise.

However, there were indications that the larger museums were moving in the direction of greater bureaucratization as a result of internal and external pressures. In the early seventies, the MOMA was beset with financial deficits and labor difficulties that lasted through much of the decade. The Whitney also experienced budget deficits and abrupt changes in policy and curatorial staff (Goldin and Smith, 1977: 97). Expenditures for acquisitions dropped from about $290,000 in 1969–70 to between one-quarter and one-half that amount between 1970–71 and 1975–76 (*Bulletin of the Whitney Museum of American Art*, 1978). Acquisitions declined from 215 works in 1971 to 53 in 1976 (*Bulletin of the Whitney Museum of American Art*, 1982).

A major factor in this shift in organizational style appeared to be financial deficits (Allen, 1974: 89–90), a factor which had ramifications for the acquisition of paintings, the mounting of exhibitions, the remuneration of employees, and orientation toward the public, whose patronage became increasingly important. This in turn led to a reconceptualization of goals and affected internal organizational arrangements for achieving those goals. In other words, there were indications that the criteria for directing these museums were becoming administrative and financial rather than professional (Allen, 1974: 157).

Changing conceptions of the museum's role. In the seventies, the New York museums began to move toward a different definition of their role, one in which they were required to serve a much broader segment

of the public and which required them to expand the range of materials they presented. Labor difficulties and protests by groups of artists whose works were insufficiently represented helped to speed them along this route. As a result, the groups toward which these museums oriented their activities changed in the seventies from the informal network of collectors, patrons, critics, scholars, artists, and dealers to, on the one hand, an interorganizational network involving government agencies and corporations (Allen, 1974), which were increasingly involved in funding exhibitions and administrative needs, and to the general public on the other (Hightower, 1970). A number of the exhibitions which were arranged by these museums in the seventies had little to do with avant-garde art per se but attempted in various ways to respond to social changes and social problems.[7]

Oldenburg, director of the Museum of Modern Art, commented that increased corporation and government support had made it possible to present "some particularly ambitious and significant exhibitions" (Wilson, 1978: 141). The Whitney also placed great importance upon obtaining corporation and government grants for exhibitions (Goldin and Smith, 1977: 98). Messer, director of the Guggenheim voiced similar priorities (Diamonstein, 1979: 237–38):

> The history of recent years has been one of increasing participation of government on various levels, and we have been quite fortunate in having attracted sizable support from the New York State Council and from the National Endowment for the Arts; without that effort, functioning would really be impossible. . . . Our plan is to . . . enlist the support of a growing membership; play as hard for the government dollar as we can, and seek corporation support.

In the earlier period, when museum staffs were smaller and had interacted with artists and dealers on a personal level (Tomkins, 1971), it had been possible to locate and to obtain a sense of new developments and trends. In the seventies, the activities of this network became less important to museums whose expanded staffs were orienting themselves toward meeting the needs of corporations and government agencies and toward increasing their attendance statistics to demonstrate the breadth of their public appeal.

Consequently, the system, which had been a nonhierarchical network, became increasingly stratified, consisting of informal networks of artists, critics, and dealers on the one hand, and formal organizations on the other. The staffs of these organizations interacted with artists through intermediaries, primarily dealers, in ways that are not without

analogies to the relationships between popular culture industries, such as the popular music industry, and the artists who perform and create the material that these industries sell (Hirsch, 1972). Alloway (1977a) has documented the dependence of museums, such as the Whitney, upon a few galleries in their selection of artists for exhibitions in the seventies. The rapid commercial success of the Neo-Expressionists, combined with their thematic links to an established style, Pop art, was presumably a significant factor in the rapidity of their acceptance by these museums.

One indication that the museums were less in touch with the artists themselves was their failure to exhibit or to acquire younger artists in the seventies. There was a relationship between the age of the artist and having been acquired or exhibited by the major New York museums during this period. This relationship did not appear in the early acquisitions and exhibitions of Pop artists and Abstract Expressionists. The majority of the artists in both these styles, when first exhibited and purchased, were in an age group (25–40) that was later much less likely to be selected by these museums. This phenomenon begins to appear in Minimalism and is noticeable in Photorealism, Pattern painting, and particularly in Figurative painting (see table 7.5). Concomitantly a small number of artists became the subject of a great deal of attention from these museums: twenty-six artists (twenty-two of them Abstract Expressionists, Pop, or Minimalist) had had three or more exhibitions from at least two of the major New York museums. Two-

TABLE 7.5

Reception of Emerging Art Styles by New York Museums by Generation (1980)

Style	Before 1930	1930–39	After 1939
		% of Artists Purchased	
Figurative	63	41	11
N	(41)	(29)	(45)
Photorealism	14	48	29
N	(7)	(27)	(17)
Pattern	43	75	31
N	(7)	(12)	(36)
		% of Artists Exhibited	
Figurative	70	52	22
N	(41)	(29)	(45)
Photorealism	43	56	35
N	(7)	(27)	(17)
Pattern	71	83	58
N	(7)	(12)	(36)

thirds of this group were over forty in 1970. Albright (1980: 43) argues that more younger artists were actually shown in the seventies than before but mainly in the context of large group shows: "An artist could exhibit . . . repeatedly without ever being singled out for special notice. We are faced with the prospect of a future teeming with artists and would-be artists of every stripe and caliber who are perpetually 'emerging'—but never emerge."

In spite of increasing efforts to attract the public, the annual admissions of some of these museums actually declined during this period; only MOMA and the Whitney showed substantial increases (see Appendix table B.4).[8] During the same period, the category of corporate patrons was greatly enlarged. The number of corporate patrons of the Whitney Museum increased from 14 in 1967–68 to 159 in 1980–81 (*The Whitney Review,* 1967–68; *Bulletin of the Whitney Museum of American Art,* 1980–81). At the Museum of Modern Art, the number of corporate patrons increased from 90 in 1965–66 to 201 in 1981–82 (*Annual Report,* Museum of Modern Art, 1965–66 and 1981–82). As Allen (1974) points out, there were problems in seeking support from the general public and from corporations, in the former case because the artistic interests of the average museum visitor are superficial and in the latter because corporations are not likely to be entirely disinterested contributors.

While the number of artists was expanding unmanageably, museums were spending smaller proportions of their budgets in acquiring and exhibiting avant-garde art. Instead, money was being spent either on exhibitions that attempted to show the museum's interest in other issues or on activities that were peripheral to avant-garde art (e.g. education, publishing). In other words, by the early seventies, it was no longer possible for New York art institutions to assess and display effectively a valid selection of the artwork that was being produced in the United States.[9] Other art centers were emerging that were taking over some of the functions of the New York art world on a regional basis.

Alternatives to the New York Art Market

As we have seen, the number of regional museums and corporate collections substantially increased during the four decades when the artworks in our sample were being produced. As the New York museums became less receptive to new styles, is there any evidence that other organizations took over this role?

Regional Museums. There are two ways of assessing the role of regional museums in providing an alternative market for contemporary avant-garde art styles. First, one can examine the percentages of artists in each of these styles that had been purchased by New York and regional museums; and second, one can examine the percentages of artists in each style whose works had been purchased by regional museums but not by New York museums. Among the earlier styles— Abstract Expressionism, Pop, and Minimalism—the proportions of artists purchased by regional and New York museums were very similar; but among the later styles—Pattern painting, Photorealism, and Figurative art—the proportions of artists purchased by regional museums were substantially larger than the proportions purchased by New York museums (see Table 7.6). In each of the later styles, there was also a substantial proportion of artists who had been purchased only by the regional museums (see table 7.7).

Another indicator of the role of the regional museums in the art market is their selections of artists from different styles for exhibitions (see Appendix table B5). The proportions of artists who had been exhibited only at regional museums were not as great (see Appendix table B6). As we have seen, artists were more likely to be exhibited than purchased by New York museums. About one-third of the Figurative painters and one-quarter of the Pattern painters and Photorealists had been exhibited by regional museums but not by New York museums (see Appendix table B6). On the whole, the regional mu-

TABLE 7.6

Representation of Avant-Garde Art Styles in Museums and Corporate Collections (1980)

	% of Style Members with Works in					
Style	New York Museums	Regional Museums[a]	Major Reg. Mus.[a]	Corporate[a] Collections	No Inf.	N
Abstract						
Expressionism	100	100	100	62	0	21
Pop	75	89	71	43	11	28
Minimalism	71	71	58	29	11	80
Photorealism	41	78	45	47	18	51
Pattern	43	66	25	54	7	61
Figurative	35	56	30	34	13	126
Modern	38	56	26	51	18	39
Modern-Traditional	39	61	39	35	13	23
Traditional	47	71	45	18	11	38
Unclassified	8	31	8	31	8	26

[a]Data are derived from artists' biographies.

TABLE 7.7

Regional Museums as an Alternative Market: Purchases (1980)

| | % of Style Members with Works in | | | | | |
Style	Regional Museums Only	New York Museums Only	Both	Neither	No Information	N
Abstract						
Expressionism	0	0	100	0	0	21
Pop	14	0	75	0	11	28
Minimalism	8	10	64	8	9	80
Photorealism	41	2	37	2	18	51
Pattern	21	0	43	30	7	61
Figurative	21	1	36	29	13	126
Modern	15	0	41	26	18	39
Modern-Traditional	30	11	35	13	13	23
Traditional	21	0	50	18	11	38
Unclassified	23	0	8	62	8	26

seums were performing significant roles both in exhibiting and acquiring works by artists in styles that had not been generally accepted by New York museums.[10]

The Major Regional Museums. Eighteen of these museums (thirteen nonacademic and five academic) had purchased artworks by over twenty of the artists in our sample. Because of the size and importance of their collections, these museums, as a group, were comparable in prestige and influence to the New York museums. To what extent did they share the aesthetic tastes of the New York museums?[11]

All six styles were well represented in these museums with only one or two lacking a particular style. Pattern painting was absent in four out of the eighteen collections. Between ten and twelve of these museums had works by more than five Abstract Expressionists, Minimalists, and Figurative painters, but only six of these museums had over five Pop artists and only a couple had collections of more than five Photorealist and Pattern painters. In this respect, these museums showed the preference for Figurative art that was noticeable in the total population of regional museums.

Taking the seven museums in this group that had the largest collection of artists in our sample, I compared their acquisition patterns with those of the regional museums as a whole and of the New York museums (see table 7.6). Their acquisitions were more similar to those of the New York museums than to those of the total population of

regional museums, although these museums had substantially smaller proportions of Minimalist and Pattern painters than the New York museums. Like the New York museums and the regional museums, they had more Traditional Figurative than Modern Figurative painters. However, they had substantially fewer Figurative painters than the regional museums as a whole. It would appear that these prestigious regional museums took their cues for acquisitions from the New York museums. One interpretation of these patterns might be that the staffs of these museums were more professionalized than those of the majority of regional museums and thus their acquisition patterns resembled those of the New York museums where control by curators over acquisitions as opposed to control by trustees is more common (Zolberg, 1981).

The Corporation as Collector. Artworks by artists in our sample had been acquired by 183 corporations. These collections appeared to be small: 95 percent had five or less artists from the sample. Seventy-four percent of the collections were located east of the Mississippi, 31 percent in New York City.

The acquisition patterns of these collections diverged considerably from those of both the regional museums and the New York museums. From the distribution of styles in these collections, it is apparent that relatively few of them included works in styles other than Figurative and Pattern painting (see table 7.8). The more prestigious the corporate organization, the more likely it was to have Figurative and Abstract Expressionist painters in its collection.[12]

When the proportions of artists from each of these styles that were included in the corporate collections were examined, there were noticeable differences in comparison with the regional and New York

TABLE 7.8

Percentage of Regional Museums and Corporate Collections with Works in Designated Styles

Style	Nonacademic Museums	Academic Museums	Corporate Collections
Abstract Expressionism	39	29	13
Pop	37	29	7
Minimalist	46	37	15
Figurative	66	52	50
Photorealist	36	26	16
Pattern	36	33	37
N	147	165	183

museums (see table 7.6). The corporate collections had smaller pro-
portions of Abstract Expressionist, Pop, and Minimal artists than either
the regional or New York museums. Their representation of Mini-
malists was particularly low. Their representation of Pattern painters
was greater than that of the New York museums but slightly smaller
than that of the regional museums. They did not have a large propor-
tion of Figurative painters, apparently because many of their collec-
tions contained works by a small number of Figurative artists, primarily
modern. Their selection of Figurative artists was the reverse of that of
the New York museums. The latter chose primarily Traditional rather
than Modern Figurative artists. This is a curious finding since the
aesthetic interests of the Modern Figurative artists are more similar to
the aesthetic values the New York museums apparently espouse than
they are to those of the Traditional Figurative painters. By contrast,
one might have expected the corporations to prefer more traditional
types of Figurative painting, as expressing values that they would wish
to endorse. In fact, these data may simply reflect the timing of the
acquisitions. One would expect the corporate collections of Figurative
painting to have been acquired more recently than the museum col-
lections in the same style. The Modern group of Figurative painters
became visible in the art world during the seventies, when the New
York museums were cutting back on their acquisitions due to financial
difficulties while corporations were increasing their expenditures for
artworks.

There was some evidence that corporate collections served as alter-
natives to New York museums for some of these groups of painters.
However, their choices of particular painters tended to follow those
of either the New York or the regional museums. They appeared to
purchase painters who had been purchased by museums, either in New
York or outside New York.

Foreign Institutions and American Art. The six styles were unevenly
represented in foreign institutions.[13] Three-quarters of the Abstract
Expressionists, about half the Minimalist, Pop, and Photorealist art-
ists, but less than 20 percent of the Pattern painters and Figurative
painters were included in foreign institutional collections (see table
7.9).[14] Higher proportions of the artists in all six styles had been ex-
hibited in foreign institutions, suggesting that there was widespread
interest in these styles but that funds for their purchase were not avail-
able abroad. The one exception was Figurative painting, which had
not yet received international recognition. Only 23 percent of the Fig-

TABLE 7.9

Artists in Each Style Purchased and Exhibited by Foreign Institutions (1980)

Style	% Purchased	% Exhibited	N
Abstract Expressionism	76	90	21
Pop	54	70	28
Minimalism	48	85	80
Photorealism	47	59	51
Pattern	18	47	61
Figurative	12	23	126

NOTE: The category of foreign institution includes galleries and business corporations as well as museums.

urative painters had been exhibited abroad and only 12 percent purchased.[15]

Regional Museums, Corporate Collections, and the Auction Market

While both regional and corporate museums provided an alternative market for emerging art styles, purchases by these types of museums did not provide access to the auction market and commercial success in New York. Fifty-one percent of the artists in four styles (Pop, Minimalism, Photorealism, and Figurative painting) whose works had been purchased by New York museums had had auction sales as compared to only 10 percent of those whose works had been purchased only by regional museums.[16] This correlation was highest in the case of the Pop artists and lowest for the Figurative artists. In other words, in the latter style, a purchase by a New York museum was less likely to be associated with auction sales. As we have seen, both auction sales and purchases by New York museums were connected with the activities of certain galleries.

In the eighties, several of the major New York museums (including the Museum of Modern Art, the Whitney, the Guggenheim, and the Metropolitan) embarked on building programs, designed to expand their facilities (Glueck, 1985). At the same time, new museums of art were being created in other parts of the country (Glueck, 1985; Russell, 1984). However, while facilities for the acquisition and exhibition of contemporary art were clearly expanding, one critic (Russell, 1985) complained that "the same quite small band of living artists gets into virtually every museum of modern art." His list included Abstract

Expressionists, Pop artists, Minimalists, and Neo-Expressionists.[17] This suggests that the problem with the reception of new styles lay not in the availability of museum facilities but in the gatekeeping process itself whereby new artists were located and selected.

In some parts of the country, regional art markets were emerging, making it possible for artists to sell their work and to establish reputations in a particular area (Mangan, 1980: 78). However, prices in these markets were substantially lower than in New York, while success in these markets did not in itself lead to a national or international reputation. Acceptance by the New York art world alone provided this.

Conclusion

As we saw in Chapter 1, an enormous expansion of artistic institutions occurred between 1940 and 1985. Associated with these changes were greatly increased levels of funding from state and federal governments, foundations, and corporations, as well as changes in the salience of the arts in general in American society and the nature of the artist's social role. While the New York art market greatly expanded, alternative markets for art works emerged in regional museums and corporate collections.

As a result of this expansion, the various actors in the system gradually changed their functions. The New York art galleries and museums initially performed major gatekeeping roles in the evaluation and dissemination of avant-garde art. During this period, the major New York museums expanded their goals to include the presentation and dissemination of artworks to a larger and more heterogeneous public as well as the evaluation and endorsement of avant-garde artworks. While the New York museums were reducing their expenditures on the acquisition and exhibition of contemporary art, the number of artists all over the country was expanding enormously. By the early seventies, it was no longer possible for New York art institutions to assess and display effectively a representative selection of the artworks being produced in the United States. Although regional museums took over some of their gatekeeping functions, the New York art world retained its position at the center of the gatekeeping system. In spite of continual expansion in the numbers of galleries and exhibition spaces, the intensity of competition meant that only a small fraction of the artistic community was likely to receive either symbolic or material rewards.

Epilogue: The Evolution of the Avant-Garde

In comparison with what had existed in 1940, the organizational infrastructure for American avant-garde art was large, varied, and complex by 1985. Every aspect of it had increased substantially and broadened its functions. This period witnessed an enormous expansion of artistic institutions and personnel in American society, including the number of museums, the number of corporations collecting art, the number of collectors, the number of artists graduating from art schools, the number of galleries exhibiting avant-garde art, and the number of art centers providing artistic activities for the general public. Indicative of these trends was the fact that artworks by 367 artists in six of the styles in the study had been purchased by 771 institutions (331 museums, 183 corporations, 67 miscellaneous institutions, and 190 foreign institutions). These developments were due in part to the increasing emphasis being placed in American society on cultural activities of all kinds that was in turn an outcome of a period of increasing affluence and leisure. Another important factor was an increase in the proportion of the population attending college or university, as well as the numbers of individuals engaging in artistic pursuits of various kinds on an amateur basis.

As the number of artists working in New York increased, the character of the artistic milieu shifted from a tightly knit counterculture to a set of relatively transient, interlocking subcultures. Groups of artists were linked to groups of sponsors or "constituencies" whose members were able to obtain a sense of new developments and trends through their participation in this network and performed important roles in providing access to symbolic and material rewards. The enormous expansion in the number of artistic institutions affected the way these organizations functioned as gatekeepers for artistic innovation. During this period, the major New York museums became increasingly conservative in their selection of new artworks. Although some regional museums and corporate collections took over gatekeeping functions, the New York art world retained its status as the ultimate arbiter of

artistic success. A small number of New York galleries controlled access to the auction market and commercial success. Continual expansion in the numbers of galleries and exhibition spaces facilitated the display of artistic innovation, but the intensity of competition meant that only a small fraction of these innovations was likely to receive either symbolic or material rewards.

The dominant aesthetic tradition of modernism left an enduring imprint on the roles that American artists assumed in this period, leading to the virtual exclusion of humanistic values and sociopolitical commentary from the work of the majority of these artists. These tendencies were supported by the increasing integration of the artist into middle-class and particularly academic roles. As the influence of the modernist tradition waned, artists became increasingly receptive to themes and images from popular culture, with varying emphases depending upon the characteristics of the style with which they were associated. There was little evidence in the works of representational painters of the social tensions and conflicts of the period, in contrast to findings from a study of contemporary literature. These materials suggested that the choice and presentation of subject matter by these painters is constrained in part by the modernist aesthetic tradition and in part by the social-class background of their collectors and the conservative nature of the organizations that display and purchase these works—museums and corporations.

As a result of the changes documented in this study, the environment for contemporary art was very different from the prototypical situation of the avant-garde in which a minority perceived itself as being in opposition to a majority, in terms of aesthetic and social values. While the title of avant-garde is sometimes reserved for movements that define the artistic role as that of using attacks on art itself as a means of expressing rejection of the role that modern society assigns to the artist (Bürger, 1984), in fact, the conflicting conceptions of the artistic role at the present time have their origins in a wider range of artistic roles that emerged between the middle of the nineteenth century and the middle of the twentieth century. With the increasing ideological fragmentation of modern society, the artist was free to assume social attitudes that would not have been acceptable in earlier periods when the arts were patronized by a social elite whose values they reflected. Two artistic roles which emerged during this period were those of iconoclast and aesthetic innovator. The early iconoclasts saw art as a way of attacking bourgeois conventions, as in the case of Impressionist painters such as Manet (Clark, 1984). In the early years

of the twentieth century, artists turned their attacks on the institution of art itself because they believed it served only the interests of the middle class. Duchamp's experiments with "readymades," industrial objects reclassified as artworks, exemplified the rejection of social and aesthetic values that was typical of these movements. While mid-nineteenth-century artists had perceived themselves as belonging in one way or another to the middle class, these artists viewed themselves as classless outcasts from bourgeois society (Shapiro, 1976).

During the same period, artists adopted an attitude toward aesthetic innovation that was analogous to that of scientists exploring the area of visual perception. While painters in an earlier period had been concerned with expressing the meaning of a situation and showing how different elements in a painting related to that meaning, these painters analyzed visual reality in terms of its constituents and concentrated on particular dimensions of reality, such as color and form (Vitz and Glimcher, 1984).

In effect, painters at the turn of the century turned in two different and somewhat contradictory directions, both of which were identified with the avant-garde. In both cases the artworks demanded specialized knowledge of aesthetic issues in order to be understood by the viewer. This meant that artists tended to communicate with one another and a few knowledgeable critics, dealers, and collectors rather than with a larger public.

Still another view of the artist's role but one which is less often identified with the avant-garde is that of the social rebel, inspired by political loyalties, whose target is the economic and political institutions of his time. In the 1930s, the American Social Realists attempted not only to work within the art world and in what remained of the art market during the Depression years but to express their violent opposition to the social and political elite. Their work dealt with labor conflicts, poverty, greedy capitalists, and long-suffering workers in whose protests and strikes they actively participated. These artists viewed art as a weapon that could communicate and change social values and ideas ("Social Concern and Urban Realism," 1983). They were not concerned with their own careers or with aesthetic issues.

After World War II, social conditions were no longer conducive to work of this kind. Although the Abstract Expressionists envisaged the artist's role on a grand scale, as hero, seer, and visionary, they actually performed as aesthetic innovators. Their alienation was expressed in an esoteric, aesthetic language which reflected their unwillingness to confront the social realities of their time and their absorption in self-

discovery and their own psyches. To some extent, the Minimalists reintegrated the roles of aesthetic innovator and iconoclast. They continued the tradition of aesthetic experimentation on the nature of visual perception, but their motivation was less that of discovery and understanding than that of exploring the limits of aesthetic and social activity.

In subsequent decades, in response to a changing social and intellectual environment, these roles were gradually metamorphosized (see table 8.1). The increasing importance of all forms of culture, which was reflected in the expansion of public and corporate expenditures, the creation of new cultural institutions, and the increasing popular acceptance of high culture, meant that artists were less likely to perceive themselves as alienated. Instead, many artists identified with the middle class in terms of career goals and life-style. The aesthetic innovators became a moyen garde that continued to explore issues related to visual perception but presented them using personal iconographies that often reflected attitudes of passivity and withdrawal into private concerns rather than alienation or rebellion.

The social rebel who attacked the dominant social and political institutions was replaced by the democratic artist (Popper, 1975) who confined his efforts to the creation of wall murals in working class neighborhoods (Cockcroft et al., 1977) and had virtually no ties with the art world. The goal was not to change society but to communicate social and aesthetic ideas to a local audience. Artworks in this environment tended to have a transitory existence (many deteriorated or were demolished), reflecting their changing relevance for the local community.

Political art and a humanistically oriented representational art remained on the periphery of the art world (Kuspit, 1985), primarily being seen in alternative spaces and cooperative galleries. According to one of the proponents of the latter, artworks of this kind were meant to be viewed rather than owned (Van Devanter and Frankenstein, 1974: 208).

TABLE 8.1

Artistic Roles in Transition

Pre–World War II	Post–World War II	Subject Matter
Aesthetic innovator	Moyen garde	Visual perception
Iconoclast	Leisure specialist	Cultural institutions
Social rebel	Democratic artist	Social institutions

While the early twentieth-century iconoclast had attempted to elim-
inate the boundaries between artworks and other objects, their first
counterparts during this period were the Pop artists, whose activities
represented an attempt to bring the aesthetic tradition into contact with
visual imagery from commercial art and popular culture. With the
Neo-Expressionists, the conception that the artist's insights were su-
perior to those of other image-makers in American society disap-
peared. These artists saw themselves as entertainers, using visual
imagery to amuse and provoke the public, rather than as aesthetic
innovators contributing to an artistic tradition or as social rebels using
visual imagery to attack a political elite.

These shifts in the characteristics of artistic roles revealed certain
dilemmas inherent in the social and cultural bases for these roles. For
the aesthetic innovators, a major dilemma was the problem of the
exhaustion and renewal of the paradigms on which their innovations
were based. For example, there were indications that the issues un-
derlying modernism as an aesthetic tradition had been thoroughly ex-
plored. While the early twentieth-century aesthetic innovators had
maintained fruitful ties with scientists who had related interests, there
seemed to be less evidence of this kind of communication in the post-
war period. Sporadic attempts by artists to communicate with tech-
nologists were less successful perhaps because of the latter's
identification with corporate goals.[1] By contrast, postmodernism, a
highly eclectic approach, sought to renew the aesthetic tradition by
reincorporating elements from previous traditions and from popular
culture.

The democratic artist faced a social dilemma, specifically, the ab-
sence of institutional support structures that could sustain that type of
artistic activity and permit continuity and development. Since works
by democratic artists were not for sale, funds from philanthropic or-
ganizations were required to support these activities but were not al-
ways forthcoming. While Popper (1975: 280) claims that "the power
to identify one's own aesthetic needs, aspirations and destiny is the
only way in general terms to move towards an anti-kitsch, anti-
academic, and anti-elitist future," he does not indicate how this form
of art can be institutionalized in Western societies, where artworks are
generally perceived as commodities in an art market.

Finally, the leisure specialist faced the dilemma of differentiating his
activities from those of the popular artist, either in the entertainment
field or in advertising, whose symbols and images he often appropri-
ated. As the object of his irony turned from art and its relationship to

society to the role of mass-media symbols in society, there was a risk that the artist would become identified with his subject matter.

These developments coincide with a gradual decline in the control over art institutions that social elites had exercised since the mid-nineteenth century when the upper middle class began to use cultural events as a means of reinforcing their social status (DiMaggio, 1982). At the present time, as control over these institutions is shifting to new patrons—government agencies and corporations—that can better provide the ever-increasing resources needed to support these institutions, the barriers between high culture and popular culture are declining. Maintaining these barriers is less advantageous to the new patrons.

The present period is one of unprecedented cultural pluralism in which a wide variety of general and specialized worldviews coexist. The art world reflects in its pluralism the cultural fragmentation of its time and is criticized in some quarters for not providing a means of synthesizing these conflicting viewpoints. While in previous centuries different social and cultural institutions were identified with a particular worldview, in the present period a range of worldviews are to be found in each institution. Science and religion, as well as the arts, include a variety of orientations, both specific and general, whose implications for the nature of social and physical reality are inconsistent and contradictory. As we have seen, among artists who were engaged in contemporary American representational painting, there were fundamental disagreements about the nature of physical and social reality. Even among quantum physicists, there is apparently no consensus on these matters (Herbert, 1985). Some contemporary artists respond to this situation by creating works that are not intended to convey a specific idea; instead these works reverberate with inconsistent or contradictory images. Viewers are expected to create their own explanations of these works but no single interpretation can be devised (Olive, 1985).

Klapp (1982) has argued that the crisis of meaning in contemporary society arises from the fact that information is being produced more rapidly than meaning systems that could integrate and synthesize this information. He argues that the overload of random and disconnected pieces of information has the same psychological effect as noise, while the social institutions by means of which new interpretations of information are created are not able to respond effectively. It can also be argued that meaning systems are plentiful, but the fact that they are inconsistent and contradictory leads to the devaluation of meaning.

Meanings appear to be constructed in response to each social situation rather than to emerge from the integration of information and knowledge. In this cultural maelstrom, the public turns to art for insights into the nature and meaning of individual existence in contemporary society, while artistic movements in the aggregate reflect rather than resolve the cultural anarchy of our time. At the same time, art provides a setting in which cultural meanings can be redefined and in a sense "negotiated," although the extent to which this takes place varies in different art styles. In some styles, artists are largely concerned with aesthetic issues rather than with "meaning." Other artists are using themes from traditional art to make statements about the relevance of humanism to contemporary life. Finally, the increasing use of imagery from popular culture suggests that some artists are using their art to renegotiate the meanings of the visual imagery that pervades everyday life.

Unobtrusive Methods for Researching an Art Form

Because of the lengthy time span (forty-five years) covered by this study, I relied primarily on documentary materials, including interviews, reviews, statements and articles by artists, and biographical and organizational directories. Interviews with or surveys of artists conducted in the 1980s but dealing with events that had taken place years before were likely to be of questionable accuracy. Instead it seemed preferable to use interviews and reviews by art critics that had been published close to the time of the events in which I was interested. The abundance of documentary material about these artists made it possible to find out how they were thinking and reacting decades before. In addition, a number of the artists had written detailed statements about their work at the time it was being done. These too had advantages in comparison with a retrospective assessment years later. Alloway (1984: 7) makes a similar argument when he says: "Since artists are fairly accessible and their prestige high, critics frequently make a new interview in the preparation of a catalog or book rather than search the existing ones for complexities of intention, unnoticed details, and changes of opinion. The failure to interpret has left us with a backlog of unevaluated interviews. . . . there is a corresponding neglect of comparative and historical information." Information for biographical directories, being compiled for publication, is also likely to be more complete than information recalled during an interview. In other words, since artists are frequently being interviewed and written about, it was possible to reconstruct the development of an art style from its beginnings to its eventual decline, using published materials to a considerable extent. Only those materials which are actually cited in the text are listed in the bibliography. Many additional references were consulted.

There were however a number of difficulties in using this method of data collection. A major problem was that of defining the membership of the art styles. I attempted to obtain a complete list of artists working in each style. The sources of information used to obtain members of each style are listed in Appendix C. From these sources, I obtained names of artists who had been included in major group exhibitions that helped to define the style and in definitive publications on the style. In each case, there are presumably additional artists working in these styles whose work has not received this kind of attention. I am dealing with samples of the most prominent artists in a particular style, and with respect to the major artists in each style it seems

likely that my lists are complete. With respect to marginal and minor artists, the lists are less complete but samples of the most prominent artists are satisfactory for my purposes since I am concerned with the systems of cultural meanings underlying each style, to which the major artists have contributed most, as well as the nature of the reception accorded the style by art organizations. The reception received by the most prominent artists is the best indicator. Except for Minimalism and Photorealism, sculptors were excluded on the grounds that their aesthetic concerns appeared to be different from those of painters.

When the art style was sufficiently mature to have been the subject of definitive works, there was considerable consensus about the members of the style. This was the case for Abstract Expressionism, where I used the first generation only to avoid problems of definition that begin to occur with the second generation and subsequent fragmentation of the movement. Other movements such as Photorealism and Pattern painting can be defined with sufficient precision so that members can be readily identified. In the case of Photorealism, there has already been an attempt to compile a definitive listing of these artists (Meisel, 1981). In the case of the Minimal artists, there were some difficulties in distinguishing them from their close neighbors, the Conceptualists. In the case of Pop art, although the group itself was small, there seemed to be disagreements on the part of the critics who have written extensively about which artists actually belong to the style (Alloway, 1974; Lippard, 1966b). I defined the group as conservatively as possible, eliminating artists who were excluded by one or the other of these critics. Finally, in the case of Figurative painting, the group included only those painters who have been associated with the New York "school" of Figurative painting and included in exhibitions by members of this group. During the period covered by the study the number of Figurative painters working all over the United States greatly increased. By concentrating my attention on the New York "school," I have presumably located the "opinion leaders" of this group as well as the artists located in New York and to some extent elsewhere whom these opinion leaders perceive as being worthy of attention. This was the largest and most heterogeneous group in the study.

For the analyses of artistic careers and museum acquisitions, it was necessary to determine specific dates for the beginnings of art styles, generally a difficult task. The dates that were selected represent either the beginnings of a sense of "collective identity" among the painters themselves or the first instance of serious recognition of these painters as a group by a dealer or a museum curator, usually in terms of an exhibition. In each style, some paintings preceded the date that was chosen. Following Sandler (1976: 79), I selected 1943 as the beginning of Abstract Expressionism, since this was the period when these painters began to be aware of each other's work and to talk to one another about their work. Similarly, it is appropriate to locate the beginning of Pattern painting as a movement in 1975, when a group of these painters began meeting to discuss their work (Marincola, 1981: 32).

The beginning of Pop was set in 1958 with the appearance of the phrase "Pop Art" in England (Alloway, 1974: 1). The beginning of Minimalism as a movement was indicated by the first exhibition of works in this style, "Toward a New Abstraction," at the Jewish Museum (Alloway, 1968: 49) in 1963. The emergence of Photorealism was marked by an exhibition in 1972 for which Louis K. Meisel commissioned paintings from several of these painters. In order to organize the exhibition, Meisel defined the word—Photorealism— and developed criteria for membership in the style (Meisel, 1981: 12).

The beginning of Figurative painting was more difficult to specify. A group of these painters, including Charles Cajori, Paul Georges, Alex Katz, and Philip Pearlstein, began painting together from models in 1958 (Mainardi, 1976: 74). These painters and others who had moved out of Abstract Expressionism and into representational painting (Sandler, 1978) continued to paint in this way during the sixties. However, in 1968, the Alliance of Figurative Artists was founded and this seemed to be the most appropriate date to choose for the beginning of the movement (Kalish, 1979). Finally, Neo-Expressionism could be said to have coalesced as a movement in 1981 with the appearance of new galleries and an artistic community in the East Village (Kardon, 1984).

Having defined the members of these styles, I attempted to obtain information about their backgrounds and about their work, including reproductions of their work, whenever possible. Biographies for these artists were obtained from biographical directories (e.g. *Who's Who in American Art,* 1980, 1982, 1984; *Dictionary of Contemporary Artists,* 1977, 1982; *Contemporary Artists,* 1980) and, in some cases, from curriculum vitae. Since information in biographical directories was sometimes incomplete, I made a point of comparing biographies that had appeared in different directories.

Major American art journals (such as *Artforum, Art in America, Artnews,* and *Arts*) as well as a great variety of other sources (see Bibliography) were searched for reviews of these artists' exhibitions, articles about their work, and interviews with them. I also used interviews that had been conducted over the years for the *Archives of American Art.* From these materials, I obtained information about the characteristics of each artist's work, particularly the nature of the themes and problems the artist was attempting to explore, as well as relationships with other artists (close friendships, student-teacher ties, etc.). Such information made it possible to compare and contrast the meaning systems associated with different styles as well as the social networks surrounding them. Interviews with a small number of avant-garde artists (34), including some of the artists in these styles, during 1976–77 provided qualitative information about the art world and quantitative information on acquaintance networks among artists in the various styles.

Not surprisingly, the amount of information that I obtained varied for different artists. The most prominent artists had been the subject of numerous articles, sometimes even books, while the less prominent might have received no more than a single review. For some artists in each style it was not possible to obtain any information.

From the biographical information, I was able to reconstruct the organizational environment surrounding these artists, specifically the galleries that had represented them, the museums that had exhibited and purchased their works as well as the corporations that had purchased them and, to a lesser extent, the private collectors who had acquired these artworks. This information generated three additional samples, one of New York galleries, another of museums in New York and in the rest of the country (regional museums), and a third of corporate collections. These samples were used to examine the growth of the organizational infrastructure supporting avant-garde art during the period of the study. The data on museums and corporate collections were also used to compare the reception accorded the various styles. The data on galleries, supplemented by information on the auction sales of works by members of the sample, were used to examine the role of the avant-garde art gallery in promoting these artists and the characteristics of the art market.

In tracing the activities of art organizations, I was hampered by the absence of definitive directories of New York art galleries and of corporate collections, although a comprehensive listing of museums was available (*American Art Directory*, 1982). Information about individual collectors of these artworks was most difficult to obtain, in part because artists tend to list primarily institutional collectors in their biographies and in part because biographical information for all but the most prominent collectors was generally unavailable.

Systematic analysis of visual materials by social scientists has rarely been done and few guidelines exist for a sociological examination of aesthetic and expressive content in art objects. I based my analysis on two approaches: a content analysis of themes contained in representative works by these artists and analysis of statements concerning the content of these works that appeared in critical writings and in interviews with and statements by the artists themselves. The content analysis provided an indication of the subject matter with which these artists were concerned, while the documentary materials revealed the significance that these artists and their critics attached to it. In a sense I am using critics and artists as informants, but instead of obtaining information directly from them I used their published statements.

Finally, I am not dealing here with random samples but with populations of artists and organizations, some of which are quite small. Therefore the importance of my findings is not based on an elaborate statistical analysis but on an accumulation of many findings, based on groups of varying size and expressed in terms of percentage differences and sometimes ordinal correlation coefficients which in the aggregate provide a consistent interpretation of the workings of a cultural institution.

Supplemental Tables

TABLE B1

Percentages of Artists in Academic Positions, by Style

| | Timing of Academic Positions | | | | |
Style	Position within First 5 Yrs.[a]	Permanent Pos. within First 5 Yrs.	Position within First 10 Yrs.	Ever Taught in Univ.	N[b]
Abstract Expressionism	10	0	19	90	21
Pop	7	7	15	44	27
Minimalism	12	7	19	57	68
Figurative	27 (36)[c]	20	30 (38)	69	112
Photorealism	27	7	27	46	41
Pattern	15 (20)	8	15 (20)	46	52

NOTE: Only college or university positions at the assistant-professor level or above were included. Visiting positions were not included. Permanent positions were defined as associate or full professor. Positions in art schools are not included in this table.

[a]After style emerged. See Appendix A for discussion of dates when styles emerged.

[b]Cases for which information was not available were excluded.

[c]Percentages in brackets are for males only.

TABLE B2

Receipt of Grants by Style

Style	Grant within First 5 Years[a]	Grant after First 5 Years	N
Abstract Expressionism	5	38	21
Pop	25	43	23
Minimalism	31	56	68
Figurative	37	51	112
Photorealism	29	29	51
Pattern	50	50	52

[a]After style emerged. Includes federal, state, or private-foundation grants.

TABLE B3

Factors Associated with High Auction Prices

	Style			
	Pop	Minimalism	Photorealism	Figurative Painting
Number of New York shows[a]	.78	.84	.05	.92
Museum purchases[b]	.90	.83	.74	.94
Retrospective exhibitions	1.00	.55	.10	.93
Representation by gatekeeper galleries[c]	.87	.74	.69	.65[d]

NOTE: The price categories were: Pop: Over $20,000, $20,000 or less, and None; Minimalism, Photorealism and Figurative Painting: Over $5,000, $5,000 or less, and None. Gamma coefficients are shown.

[a]The categories were: Pop and Minimalism: Over 10, 10 or less; Photorealism and Figurative Painting: Over 5, 5 or less.

[b]The categories were: MOMA and Whitney; Either MOMA or Whitney; Neither.

[c]The categories were: Oligopoly-Gatekeeper; All other galleries.

[d]Female artists were excluded.

TABLE B4

Annual Admissions in New York Museums, 1969–80

Museum	1969	1980
Brooklyn	864,238	575,000
Guggenheim	500,000[a]	530,000
Jewish	165,000	85,000
Metropolitan	5,746,227[b]	3,800,000[b]
Museum of Modern Art	1,000,000[c]	1,300,000
Whitney	200,000	500,000 (1983)[d]

NOTE: The admission figures are from the *American Art Directory* (1970, 1981).

[a]In excess of one-half million annually.

[b]Includes the Cloisters.

[c]More than one million annually.

[d]Based on *American Art Directory* (1984).

TABLE B5

Exhibitions of Styles in New York Museums and Regional Museums

Style	New York Museums	Regional Museums	No Information	N
	% of Style Members Exhibited by			
Abstract				
Expressionism	100	90	0	21
Pop	86	93	7	28
Minimalism	74	81	10	80
Photorealism	47	69	18	51
Pattern	59	84	10	61
Figurative	44	81	13	126
Modern	54	82	13	39
Modern–Traditional	43	78	22	23
Traditional	55	84	8	38
Unclassified	15	77	15	26

TABLE B6

Regional Museums as an Alternative Market: Exhibitions

Style	Regional Museums Only	New York Museums Only	Both	Neither	No Information	Total	N
	% of Style Members with Works Exhibited in						
Abstract							
Expressionism	0	10	90	0	0	100	21
Pop	7	0	86	0	7	100	28
Minimalism	10	3	71	6	10	100	80
Photorealism	24	2	45	10	20	101	51
Pattern	28	3	56	3	10	100	61
Figurative	37	1	44	5	13	100	126
Modern	28	0	54	5	13	100	39
Modern–Traditional	35	0	43	0	22	100	23
Traditional	32	3	53	5	8	101	38
Unclassified	62	0	15	8	15	100	26

Appendix B

TABLE B7

Styles Represented, by Geographical Location of Museums

Style	% of Museums Owning Works in Designated Styles			
	East Coast	Interior	West Coast	N
	Nonacademic			
Abstract Expressionism	37	38	56	21
Pop	32	37	56	28
Minimalism	55	38	50	80
Figurative	66	72	44	126
Photorealism	31	35	63	51
Pattern	35	37	38	61
No. of Museums	(62)	(68)	(16)	
	Academic			
Abstract Expressionism	29	35	14	21
Pop	26	27	36	28
Minimalism	43	35	18	80
Figurative	58	50	32	126
Photorealism	24	24	41	51
Pattern	39	32	14	61
No. of Museums	(76)	(66)	(22)	

Lists of Artists by Style

Abstract Expressionism (First Generation)

Baziotes, William
Brooks, James
de Kooning, Willem
Ferren, John
Gorky, Arshile
Gottlieb, Adolph
Guston, Philip
Hofmann, Hans
Kline, Franz
McNeil, George
Motherwell, Robert
Newman, Barnett
Pollock, Jackson
Pousette-Dart, Richard
Reinhardt, Ad
Rothko, Mark
Stamos, Theodoros
Still, Clifford
Tomlin, Bradley Walker
Tworkov, Jack
Vincente, Esteban

Figurative Painting

Modern
Baen, Noah
Bell, Temma
Berkeley, Pamela
Berlind, Robert
Blaine, Nell
Burckhardt, Rudy
Cajori, Charles
Campbell, Gretna
Chupack, Jeannette
Cohen, Arthur

Day, Lucien
DeManuelle, Stephanie
Dodd, Lois
Finkelstein, Louis
Fish, Janet
Freilicher, Jane
Groell, Theophil
Haney, William L.
Howrigan, Roger
Jacquette, Yvonne
Katz, Alex
Kurz, Diane
Levine, Marion L.
Lund, David
Mainardi, Pat
Middleman, Raoul
Naar, Harry
Pearlstein, Philip
Porter, Fairfield
Rand, Archie
Resika, Paul
Shorr, Harriet
Thiebaud, Wayne
Townsend, Diane
Turner, Norman
Welliver, Neil G.
Wilson, Jane
Wilson, Helen
Wynn, Donald

Modern-Traditional
Bailey, William
Beckman, William
Bell, Leland
Bishop, Isabel
Button, John
Chiriani, Richard

153

Ciarrochi, Ray
Downes, Rackstraw
Elias, Arthur
Finnegan, Sharyn
Godfrey, Robert
Kaldis, Aristodemis
Laderman, Gabriel
Matthias-Dottir, Louisa
Moore, John
Murch, Walter
Murphy, Catherine
Portnow, Marjorie
Santuoso, Anthony
Sultan, Altoon
Valerio, James
Wexler, George
Wiesenfeld, Paul

Traditional
Anderson, Lennart
Andrejevic, Milet
Arcilesi, Vincent
Beal, Jack
Beck, Rosemarie
Berg, Michael
Carson, Ronnie
Cornell, Thomas
Davidson, Thyra
Daykin, Susan
Dean, Peter
Dickinson, Edwin
Edelheit, Martha
Georges, Paul
Gillespie, Gregory
Goodman, Sidney
Grillo, Stephen
Grooms, Red
Heise, Myron
Johnson, Lester
Krag, Gillian P.
Lerman, Ora
Leslie, Alfred
McGarrell, James
McNeely, Juanita
Mazur, Michael

Midgette, Willard
Neel, Alice
Opie, John
Perlis, Donald
Sklarski, Bonnie
Sleigh, Sylvia
Soyer, Raphael
Sperakis, Nicholas
Sullivan, Bill
Tillim, Sidney
Uhlich, Richard
Wilson, Jim

Unclassified
Beal, Nancy L.
Bishop, Benjamin
Buszko, Irene
Campbell, Lawrence
Clark, Marcia
Crespo, Michael
Dufresne, Leonard
Ecker, Kenneth
Eisenmann, Michael
Faden, Lawrence
Gelber, Samuel
Giordano, Joe
Goldman, Lester
Grubb, David
Hall, Richard
Holtzman, Eric
Kramer, Marjorie Anne
Lanyon, Ellen
Levine, Tomar
Marcus, Andrew
Pitcher, Hank
Rose, Herman
Schneider, Janet
Severson, Sue
Sigel, Barry
Steig, Susan

Minimalism

Andre, Carl
Annesley, David

Artschwager, Richard
Baer, Jo
Barry, Robert
Bell, Larry S.
Bladen, Ronald
Bolus, Michael
Brunelle, Al
Caro, Anthony
Delap, Tony
De Maria, Walter
Downing, Thomas
Doyle, Tom
Feeley, Paul
Flavin, Dan
Fleming, Dean
Fleminger, Irwin
Forakis, Peter
Frazier, Paul D.
Gerowitz, Judy
Gorski, Daniel
Gourfain, Pete
Gray, David
Grosvenor, Robert
Hall, David
Held, Al
Hinman, Charles
Huebler, Douglas
Humphrey, Ralph
Huot, Robert
Insley, Will
Irwin, Robert
Judd, Donald
Kelly, Ellsworth
King, Philip
Kipp, Lyman
Kirby, Michael
Krushenick, Nicholas
Kuwayama, Tadaaki
Laing, Gerald
Lee, David
LeWitt, Sol
Lukin, Sven
McCracken, John
Mangold, Robert
Martin, Agnes

Matkovic, Tina
Mehring, Howard
Meyer, Ursula
Morris, Robert
Myers, Forrest W.
Noland, Kenneth
Novros, David
O'Doherty, Brian
Phillips, Peter
Pinchbeck, Peter
Poons, Larry
Romano, Salvatore M.
Ross, Charles
Ruda, Edwin
Ryman, Robert
Scott, Tim
Smith, Leon Polk
Smith, Tony
Smithson, Robert
Steiner, Michael
Stella, Frank
Todd, Michael C.
Tucker, William C.
Valledor, Leo
Van Buren, Richard
Von Schlegall, David
Williams, Neil
Wilmarth, Christopher
Witkin, Isaac
Woodham, Derrick
Youngerman, Jack
Zox, Larry

Neo-Expressionism

Basquiat, Jean-Michel
Bonk, Keiko
Bosman, Richard
Braithwaite, Frederick
Chase, Louise
Clough, Charles
De Monte, Claudia
Ferrer, Rafael
Fischl, Eric
Frangella, Luis

Futura
Garet, Jedd
Glier, Mike
Goldstein, Jack
Golub, Leon
Hambledon, Richard
Haring, Keith
Holzer, Jenny
Jensen, Bill
Kruger, Barbara
Lack, Stephen
Laemmle, Cheryl
Levine, Sherrie
Longo, Robert
Morley, Malcolm
Pfaff, Judith
Porter, Katherine
Rifka, Judy
Rothenberg, Susan
Salle, David
Scharf, Kenny
Schnabel, Julian
Sherman, Cindy
Snyder, Joan
Steir, Pat
Young, Frank
Zwillinger, Rhonda

Pattern Painting

Andrews, Jonathan
Bengston, Billy Al
Benson, Robert
Carlson, Cynthia
Cibula, Ellen
Clapsaddle, Jerry
Cole, Joyce
Conlon, William
Davis, Brad
Dries, Danny
Faulkner, Frank
Febland, Harriet
Fortgang, Susan
Girouard, Tina

Grigoriadis, Mary
Guitzeit, Fred
Hammond, Harmony
Heilmann, Mary
Hodgkins, Rosalind
Iskowitz, Gershow
Janson, Agnes
Jaudon, Valerie
Kalina, Richard
Kaufman, Jane
Knowles, Christopher
Koursaros, Harry
Kozloff, Jane
Kushner, Robert
Lanigan-Schmidt, Thomas
Lehrer, Robin
MacConnel, Kim
Mauldin, David
Michod, Susan
Miller, Robert L.
Natkin, Robert
Nonn, Tom
Okimoto, Jerry
Pindell, Howardena
Reich, Murray
Ripps, Rodney
Robbin, Tony
Samaras, Lucas
Schapiro, Miriam
Schwartz, Barbara
Schwedler, William
Shapiro, Dee
Shaw, Kendall
Shields, Alan
Slavin, Arlene
Stella, Frank
Sugarman, George
Thomas, Alma W.
Torreano, John
Tseng, Marlene
Walker, Joy
Weintraub, Annette
Woodman, George
Young, Peter

Yrisarry, Mario
Zakanitch, Robert
Zucker, Joe

Photorealism

Baeder, John
Bechtle, Robert A.
Bell, Charles
Besser, Arne
Blackwell, Tom
Bond, Douglas
Bull, Fran
Chen, Hilo
Clarke, John Clem
Close, Chuck
Cottingham, Robert
de Andrea, John
Douke, Dan
Eddy, Don
Estes, Richard
Everett, Bruce
Flack, Audrey
Gasiarowski, Gerard
Gertsch, Franz
Goings, Ralph
Gregor, Harold
Hanson, Duane
Hucleux, Jean-Olivier
Johnson, Guy
Kacere, John
Kessler, Alan
Kessler, David
Kleeman, Ron
Leonard, Michael
Levine, Marilyn
Ligare, David
McLean, Richard
Mahaffey, Noel
Mangold, Sylvia
Mendenhall, Jack
Miller, Mariann
Morley, Malcolm
Neiland, Brendan

Ott, Jerry
Parrish, David
Raffael, Joseph
Rummelhoff, John
Salt, John
Sandler, Barbara
Schonzeit, Ben
Semmel, Joan
Staiger, Paul L.
Weber, Idelle
Woodburn, Stephen
Yao, Ching-Jang
Yoshimura, Fumio

Pop Art

Antonakos, Stephen
Bengston, Billy A.
Berlant, Tony
D'Arcangelo, Allen
Dine, Jim
Gill, James
Goode, Joe
Hay, Alex
Hefferton, Phillip C.
Indiana, Robert
Jensen, Leo
Johns, Jasper
Kuntz, Roger
Lichtenstein, Roy
Moscowitz, Robert
Nice, Don
Oldenburg, Claes
Pettibone, Richard
Ramos, Mel
Rauschenberg, Robert
Rosenquist, James
Ruscha, Ed
Strider, Marjorie
Thiebaud, Wayne
Warhol, Andy
Watts, Robert M.
Wesley, John
Wesselmann, Tom

The names of the artists were selected from the following sources:

Abstract Expressionism

Sandler (1978)

Figurative Painting

"Artists' Choice: Figurative Art in New York," New York, December 11, 1976, through January 5, 1977.

"Figurative/Realist Art," Artists' Choice Museum, New York, September 8–22, 1979.

"Younger Artists: Figurative/Representational Art," Artists' Choice Museum, New York, September 6–18, 1980.

Minimalism

Battcock (1968)

Haskell (1976)

Lippard (1965, 1966a)

"Primary Structures: Younger American and British Sculptors," The Jewish Museum, New York, April 27 through June 12, 1966.

"Schemata 7," Finch College Museum of Art, New York, 1967.

"Systemic Painting," The Solomon R. Guggenheim Museum, New York, 1966.

"Ten Sculptors," The Dwan Gallery, New York, 1966.

Neo-Expressionism

"The East Village Scene," Institute of Contemporary Art, University of Pennsylvania, October 12–December 2, 1984.

Nilson (1983)

Ratcliff et al. (1982)

Pattern Painting

"Ten Approaches to the Decorative," Alessandra Gallery, New York, 1976.

"Pattern Painting at P.S. 1," The Institute of Art and Urban Resources, Project Studios One, Queens, New York, 1977.

"Patterning and Decoration," The Museum of the American Foundation for the Arts, Miami, Florida, and Gallery Alexandra Monett, Brussels, Belgium, 1977.

"23rd Annual Exhibition, Contemporary American Painting: Pattern, Grid and System Art," Ralph Wilson Gallery, Lehigh University, Bethlehem, Pennsylvania, 1977.

"Arabesque," The Contemporary Arts Center, Cincinnati, Ohio, 1978.

"Pattern on Paper," Gladstone/Villani Inc., New York, 1978.

"Patterning Painting," Palais des Beaux-Arts de Bruxelles, Brussels, Belgium, 1979.

"Persistent Patterns," Andre Zarre Gallery, New York, 1979.

"The Decorative Impulse," Institute of Contemporary Art, University of Pennsylvania, 1979.

Photorealism

Battcock (1975)

Chase (1976)

Lindey (1980)

Meisel (1981)

Pop Art

Alloway (1974)

Lippard (1966b)

Notes

Chapter One

1. A French art critic (Seuphor, 1951: 118) commented in 1951: "It is only in the past five or six years that modern painting has begun to live. I mean it has entered the ranks of society, it is talked about. Formerly everything was imported, at least all the art in the galleries and museums. Nearly all the original conceptions came from Paris. Today Paris maintains a very great prestige in the eyes of most Americans but the opinion is that their young painters equal ours."

2. I restricted my attention to styles that used the traditional equipment of the plastic arts, thereby excluding Earth art, Performance art, and Video art. My analysis of Neo-Expressionism was confined largely to its content, since the kinds of biographical materials necessary for examining the reception of these artists by the support structure were not yet available for many members of the group. See Appendix A for a discussion of the design of the study and of the difficulties in using this type of approach.

3. Fifty-three percent of the galleries that represented artists in the study (col. 1, table 1.2) represented only one of the artists. The analysis in Chapter 6 is based on a subsample of galleries that represented two or more artists in the study (col. 2, table 1.2).

4. In the late seventies, galleries were said to have twice as many collectors as the number of years they had been in business (Kuhn, 1977: 113). If this rule of thumb is accurate, New York avant-garde galleries had a total of 2,550 collectors in 1980. This information was obtained by taking the galleries that had shown artists from the sample and that were in business in 1977, dividing them into categories based on date of origin, and multiplying each group by the number of collectors expected for that age level. The mid-point of each decade (e.g., 1975, 1965) was arbitrarily taken as the date of origin for all galleries in the decade. Age was calculated from each midpoint to 1980. However, the number of buyers of contemporary American art on the auction market is said to be very small (Patterson, n.d.: 28).

5. Two of these painters, Willem de Kooning and Jackson Pollock, obtained prices of over one million dollars. A painting by de Kooning was auctioned for $1.21 million in 1983, then the highest price ever paid for a work by a living artist (De Kooning painting fetches $1.21 million, 1983). A painting by Pollock was sold by a collector to a museum for $2 million in 1973 (Shirey, 1974: 75). See also table 6.3. However, in 1986, a painting by Jasper Johns, a Pop artist, was auctioned for $3.63 million (Reif, 1986).

6. Many of these individuals are artists by avocation rather than by vocation. Since many active artists cannot support themselves entirely by sales of their work, one can reasonably define an artist as an individual who exhibits his work in a recognized gallery or exhibition space with a fair degree of regularity (at least once every five years). This would rule out maverick artists (Becker, 1982), many of whom never exhibit their work through regular channels.

In 1975, a survey of a cross-section of American adults (National Research Center of the Arts, 1975) found a substantial interest in artistic activity among members of the general public. Forty-three percent (representing 63 million people) reported that they frequently engaged in activities such as photography, painting or sketching, woodworking and weaving. Forty-eight percent (representing 70 million people) had visited an art museum in the previous year. Forty-one percent approved of government support for art museums while 33 percent favored corporate support for these organizations.

7. Based on listings in *American Art Directory,* 1982.

8. Information about date of establishment was available for only 18 of the 183 corporate collections in which artists in our sample were represented, but in every case it was after 1940. Martorella (1986) in a study of 170 corporate collections found that 91 percent had been founded after 1940. *The 1986 Artnews Directory of Corporate Art Collections* listed about 600 corporate collections.

9. Support from the New York State Council on the Arts increased from $772,000 to $35.7 million between 1966 and 1976, while twenty-two other states were contributing over $1 million per year by the late seventies (Helms, 1979: 22).

10. In the early seventies, museums received 76 percent of the funds allocated to the visual arts by the NEA (Netzer, 1978: 66). According to Berman (1979), the NEA has typically given no more than 3 percent of its annual budget to individual artists. Almost one-half (41 percent) of the corporate funds for the arts were allocated to the visual arts, as support for museums, art exhibitions, art and cultural centers, and art funds or councils. Museums received the largest share of these funds (19 percent or $82 million) (*Guide to Corporate Giving in the Arts, 2,* 1981: 4), possibly because they are perceived as viable, stable, and uncontroversial institutions (Sloane, 1980: 113). In the early seventies, 25 percent of the funds allocated by the New York State's Council on the Arts went to the visual arts and museums; museums received 81 percent of these funds (Netzer, 1978: 83). Again, grants to individuals represented a small proportion of the total funds: 11 percent (Netzer, 1978: 82).

11. The percentage of the population aged eighteen to twenty-four years that was enrolled in institutions of higher education was 12.5 percent in 1946 and 32 percent in 1970 (U.S. Bureau of the Census, 1975: 383).

12. Useem and DiMaggio (1977: 30) state that "educational attainment appears to be the individual characteristic most closely related to attendance at museums and live performing arts events."

13. Performance art in which the artwork becomes synonymous with its production is the most radical example in the category (Battcock and Nickas, 1984).

14. For example, in the Street Murals Movement (Cockcroft et al., 1977), artists worked directly with members of working-class or minority neighborhoods to create wall murals dealing with issues of concern to these communities. This kind of art does not meet the aesthetic standards of the avant-garde art community. Avant-garde art critics either ignored the phenomenon or reacted to it negatively or with patronizing praise. The muralists themselves argued that their work could not be adequately evaluated in terms of contemporary art criticism (Cockcroft et al., 1977: 268), since the standards for evaluating the purpose and relevance of an artwork were very different in these settings than in the avant-garde art world.

Chapter Two

1. For a discussion of art worlds from a symbolic interactionist perspective, see Becker (1982). For a description of the art world in Paris, see Moulin (1967).

2. In my study, approximately 15 percent of the artists had worked in more than one style.

3. Traditional Western styles of painting were defined as those that existed before the Impressionist period in France. Modern styles included the Impressionists and subsequent European styles through the middle of the twentieth century. Contemporary American styles were those that had appeared since World War II. I was unable to classify 21 percent of the Figurative painters due to insufficient information about the nature of their work.

4. The social relationships among these artists were observed and documented at the time by Irving Sandler, an art critic, whose volumes *The Triumph of American Painting* (1976) and *The New York School* (1978) are invaluable sources of information about these artists. Members of the first generation of the Abstract Expressionists were a face-to-face group. If one examines the ties that are mentioned in biographies and reviews of their work and that consequently were among their most meaningful and lasting relationships, one finds that each member was linked by a personal tie to at least two other members of the group so that the entire group was linked by direct and indirect ties.

5. For an analogous situation, see White and White (1965) on the Post-Impressionists in France in the nineteenth century.

6. They were Donald Judd, Ellsworth Kelly, Kenneth Noland, and Frank Stella.

7. As was not the case in the previous styles, a substantial proportion (35 percent) of these artists were women.

8. Seventeen members of the group were not included on the list of names presented to informants. Informants who were interviewed in 1977 were presented with a list of names of Figurative artists who had exhibited

in "Artists' Choice: Figurative Art in New York," 1976–77. Additional members of the group were included in later exhibitions by the Artists' Choice Museum.

9. Some indication of this is seen by the fact that informants in other styles, when presented with lists of Minimalists and Photorealists, were acquainted with over half of those named. Out of a list of 45 Minimalists, informants in other styles were acquainted with 67 percent. Out of a list of 41 Photorealists, informants in other styles were acquainted with 56 percent. The 34 informants, each of whom belonged either to one of the styles in our sample or to one of several other styles were interviewed in 1976–77. Members of different styles were linked to other styles in various ways: the Figurative, Pattern, and Abstract Expressionist painters primarily by teacher-student relationships, the Photorealists and the Minimalists by the influence of members of other styles on their work and the Pop artists by personal communication. Thirty-seven percent of the sample of 367 artists (excluding Neo-Expressionists) were linked to one another in at least one of these ways.

10. Kadushin says (1976: 109): "The circle is viable even if most members do not relate directly to most other members. In this respect, it is quite different from a group."

11. For example, Claes Oldenburg, Jim Dine, Robert Rauschenberg, and Robert Morris.

12. Jim Dine (Abstract Expressionism, Happenings), Robert Indiana (Minimalism), Roy Lichtenstein (Happenings), Claes Oldenburg (Happenings).

13. Minimalists who wrote about their work included: Carl Andre, Donald Judd, Robert Morris, and Robert Smithson.

14. The collectors in question were Richard Brown Baker, Leon Kraushar, Leo Manuchin, Count Giuseppe Panza di Biumo, and Robert C. Scull. Other important early collectors of Pop art included Philip Johnson, Peter Ludwig, and Mr. and Mrs. Burton Tremaine.

15. A culture class is a group of consumers of a cultural product that is characterized by similar attitudes and values (a worldview) rather than by similar social attributes such as social class.

16. Certain types of museums tended to acquire Figurative paintings; specifically, the newer academic museums, nonacademic museums with low attendance rates, and both academic and nonacademic museums that had purchased few artists from the study.

Chapter Three

1. The word "modernism" is often associated with the writings of the critic Clement Greenberg (see, for example, Greenberg, 1961a). However, I am using the word in a broader sense to include modernist art that began in the mid-nineteenth century (see Vitz and Glimcher, 1984: 2) and that was characterized by abstraction or by a tendency to incorporate an abstract approach in representational painting.

2. It seems more likely that the acceptance of this art by the "establishment" can be understood as a consequence of their success in the art world in the early fifties. During the same period, other groups of artists working in very different styles were equally depoliticized, including the Social Realists, many of whom were still producing artworks during the postwar period. However, the Social Realists were not chosen to represent America abroad, although as exemplars of American political freedom they would actually have been more appropriate since their works were explicit commentaries on the American political and social scene. Significantly, the modernist critics who championed Abstract Expressionism despised these works as being entirely incongruent with modernist aesthetic values (Shapiro, 1973).

3. Gablik (1977) saw a parallel in sciences such as atomic physics where the relationships between the units, not the units themselves, are significant.

4. According to Pincus-Witten (1970: 67), "Many figures associated with Minimalism—in fact its chief figures—have recently undergone periods of intense reexamination of Minimalist precepts (which is to say, their own psychic structures) and have emerged from what can only have been a harrowing self-immersion . . . with radical shifts of sensibility."

5. Abstract Expressionism has been called "the dominant force behind contemporary realism" ("Realism, Photorealism," 1980: 13). This was particularly true of Figurative painting in the modernist tradition. Many of the older artists in the Modern Figurative group had begun their careers when Abstract Expressionism was the dominant style and had received their training from those artists. These older artists in turn taught some of the younger members of the Modern Figurative group.

6. The Traditional Figurative painters were attempting to create paintings using the same techniques and modes of composition that traditional painters had used (see, for example, Mangan, 1974; Smith, 1979). See Chapter 2, n. 3.

7. Forty-one percent of these artists were women. For a discussion of the role of women in the New York art world during this period, see Alloway (1984). He shows that women had been largely peripheral to previous art movements and that during the early seventies their work received considerably more attention than had been the case previously.

8. An indication of the extent to which these artists were synthesizing divergent styles can be seen in the fact that 42 percent were influenced both by Western and non-Western traditions, 22 percent by Western traditions only, 24 percent by non-Western traditions only, and 11 percent by neither tradition.

9. During the sixties and seventies, political and social concerns were expressed in sit-ins and strikes rather than in artworks. These activities were directed on the one hand against American policies toward Vietnam and, on the other hand, against art institutions, primarily museums (Siegel, 1985).

Chapter Four

1. Many but not all Neo-Expressionists began their careers in the East Village.

2. Another technique that was frequently used was that of making outrageous or provocative artistic statements (see Ridgeway, 1977).

3. "Superstars" such as David Salle and Julian Schnabel emerged very rapidly in the Neo-Expressionist movement. By the mid-eighties, 19 percent of these artists had entered the auction market (see Chapter 6). A work by Schnabel was auctioned for $85,000 in 1984 (*Auction Prices of American Artists*, 1982–84).

Chapter Five

1. The content of other forms of culture also shifted significantly in the mid-fifties. See Peterson and Berger (1975) and Wright (1976).

2. See Appendix A for a discussion of the mode of analysis of visual materials used in this chapter. For a discussion of aesthetic aspects of these styles, see Chapters 3 and 4.

3. John Salt's paintings of derelict automobiles were an exception.

4. Jacques Louis David, a French painter (1748–1825). For a sociological discussion of his work, see Hadjinicolaou (1978).

5. Duane Hanson's exceedingly realistic sculptures of Vietnam war scenes and Bowery bums are exceptions to this generalization, as are Myron Heise's scenes of New York's Forty-Second Street (Heise, 1978).

6. For a survey of American representational painting that includes numerous reproductions, see Goodyear (1981). For a survey of French Impressionism, see Blatt (1984) and "The Jeu de Paume Museum" (1983). According to Blatt, Impressionism is "typified by the works of Manet, Monet, Degas, and Renoir, and culminated in the work of the Post-Impressionists, including Van Gogh, Seurat, and Cézanne" (Blatt, 1984: 291).

7. Goodyear's (1981) survey of contemporary American representational painting contains 143 reproductions. Not one of them depicts a bar, restaurant, theater, or dance. Only one of these paintings shows a party: Alfred Leslie's *A Birthday for Ethel Moore,* which he presents as a somber affair. Alex Katz's treatment of a cocktail party in SoHo (not in Goodyear, 1981) shows an equally joyless occasion.

8. For another interpretation of these paintings, see Clark (1984).

9. Alice Neel's portraits contained elements of biting satire, but her attacks were focused on her individual subjects rather than on a social class.

10. The Photorealists were predominantly male (85 percent), the best-selling authors 75 percent male, and the Figurative painters 65 percent male. The best-selling authors were most likely to have attended Ivy League colleges (50 percent as compared to 42 percent of the Figurative artists and 31 percent of the Photorealists).

11. One might argue that the museum- and gallery-going public is drawn from a broader social background. This may be true of the museum-going public (see O'Hare, 1974) but Haacke (1976) found that the majority of gallery visitors were artists or art students. In any case, museum and gallery publics probably influence the artist's work less than do peers, dealers, and collectors.

Chapter Six

1. The gamma coefficients were, respectively, .74, .93, and .68.

2. Five of these galleries represented over five artists in two or more of the styles in the sample. Six of them had made such a commitment to only one style but also represented up to five artists in more than two of the other styles.

3. This association did not occur among the Abstract Expressionists and the Pattern Painters. All but two Abstract Expressionists had participated in the auction market, while only six Pattern Painters had participated in it.

4. Since only six of the Pattern Painters and seven of the Neo-Expressionists had had auction sales, these styles were not included in table 6.2. Distinct price strata were also observable in these styles however. The Neo-Expressionists moved into the auction market more rapidly and obtained higher prices in a shorter period of time than members of the other recent styles. In the auction season 1982–84, the top prices in two of the styles had increased substantially (Abstract Expressionism: $1,650,000; Pop art: $420,000), reflecting the escalation of prices of a few leading artists (*Auction Prices of American Artists,* 1982–84).

5. This effect was also seen in the rapid increase in value on the auction market of works by the Modern Figurative painter Fairfield Porter, who died in 1976. In the early eighties, his works were auctioned for less than $28,000. In 1984, one of his paintings was auctioned for $154,000 (Walker, 1984), the highest auction price for a painter in the Figurative group.

6. For gamma coefficients by style, see Appendix table B3. Ninety-five percent of the artists whose works had obtained high auction prices had been associated with one of the galleries in the entire group of gatekeeper galleries. High auction prices were also correlated with (a) purchases by prestigious museums (MOMA and Whitney); (b) having had retrospective exhibitions; (c) number of gallery exhibitions in New York City (see Appendix table B3). As we saw, type of gallery representation correlated with (a) and (b).

7. All the galleries in the oligopoly were established before the 1970s. Ninety-one percent of them were still in existence in 1977. Among the other 123 galleries, 75 were established before 1970, of which 37 percent were still in existence in 1977.

8. This conclusion is supported by the discussion of the art market contained in Patterson (n.d.).

9. For purposes of the following analysis, prices were standardized according to 1972 values, using information contained in the *Economic Report of the President* 1983: 166). Since paintings vary in size and since price is correlated with size, prices were calculated in terms of square inches.

Chapter Seven

1. The Brooklyn Museum and the Metropolitan Museum were founded in 1823 and 1870, respectively, and the Jewish Museum in 1904 (*American Art Directory,* 1982).

2. In order to conduct an analysis of this kind, it was necessary to set specific dates for the beginnings of art styles. See Appendix A for a discussion of this issue.

3. Statistics concerning purchases by MOMA are based on Barr (1977), Legg (1977), annual and biennial reports of the Museum, and artists' biographies. Statistics concerning exhibitions are based on artists' biographies and annual and biennial reports of the Museum. Barr's account is in the form of a chronicle, a detailed account of events, month by month, based on documents and reports that he compiled as the first director of the Museum (1929–43) as well as its curator of painting and sculpture and later as the director of museum collections (1943–67). Acquisitions include both gifts to the museum and purchases by the museum staff from funds allocated for this purpose. It is presumed that these museums only accept gifts which meet standards set by their curators.

4. For example, between September 1969 and March 1975, the museum held about 140 exhibitions (Alloway, 1975a: 32).

5. "Toward a New Abstraction," The Jewish Museum, 1963; "Black and White," The Jewish Museum, 1963; "Primary Structures: Younger American and British Sculptors," The Jewish Museum, 1966; "Systemic Painting," The Solomon R. Guggenheim Museum, 1966.

6. Jasper Johns at the age of thirty-four and Robert Rauschenberg at thirty-eight.

7. For example, the Whitney Museum held exhibitions on "The American Frontier: Images and Myths" (June 26–September 9, 1973); "Two Hundred Years of American Indian Art" (November 16, 1971–January 9, 1972); "Another Chance for Cities" (September 15–October 4, 1970) (*The Whitney Review,* 1970–73).

8. According to McGill (1984), museum attendance nationwide increased significantly in the late sixties and early seventies but remained stable during the late seventies and early eighties.

9. In the mid-eighties, the Museum of Modern Art acknowledged that it had slighted artists working in styles that had succeeded Pop and Minimalism and announced the appointment of a curator of contemporary art to rectify that omission (McGill, 1985).

10. Location of the museum (East or West) was related to stylistic preferences in both categories of museums. Nonacademic West Coast museums were less likely than nonacademic East Coast museums and museums in the interior to have purchased Figurative and more likely to have purchased Abstract Expressionist, Pop, and Photorealist works (see Appendix table B7). Academic West Coast museums were more likely than the others to have purchased Photorealist and Pop art paintings and less likely to have purchased works in other styles. The majority of these museums, both academic and nonacademic,

were located east of the Mississippi (66 percent and 61 percent respectively). Almost half (46 percent and 42 percent respectively) were located in states on the East Coast.

11. These museums were older than the total population of regional museums. Fifty percent were founded before 1900 (as compared to 19 percent of the total population of museums) and 61 percent were located on the East Coast (see n. 10 for comparison with the total sample). Eighty-nine percent had attendance rates of over 100,000 visitors per year (as compared to 32 percent of the total population of museums).

12. I.e., organizations that were listed in *Fortune* magazine's lists of the top 500 industrial corporations and the top 50 banks, insurance companies, etc. (The *Fortune* directory of the largest U.S. industrial corporations: the 500, 1982; the *Fortune* directory of the largest non-industrial companies: the 50's, 1980).

13. The category of foreign institutional collector included both galleries and corporations, as well as museums.

14. These institutions had purchased and exhibited higher proportions of the Photorealists than had the New York museums.

15. In addition to corporate and foreign collectors, there were 67 miscellaneous institutional collectors, including foundations (17), government organizations (17), both state and federal libraries (6), religious organizations (6), hospitals (5), schools (3), and unions (2). Only one of these collections included more than 5 artists in our sample. The paucity of these figures suggests that, among other social institutions, avant-garde art has most relevance for educational and business institutions. Its relevance for religious institutions appears to be minimal.

16. The Abstract Expressionists were excluded from these calculations because all of these artists were included in the collections of New York museums. Pattern painters were excluded because only a few of these artists had entered the auction market.

17. These Neo-Expressionists were associated with the leading galleries (see Chapter 6).

Chapter Eight

1. Burnham (1971: 68) said of a large project that was sponsored by the Los Angeles County Museum in the late sixties and that provided funds for a number of artists each of whom was to spend a year in residence at a major industrial firm: "There was never any real symbiosis between the two groups— except for the occasional development of a personal friendship. Corporations do not find artists sufficiently valuable either to buy off or to subvert. Nevertheless a decisive ideological schism between the artist and the corporate technocrat is obvious in many of the artists' attitudes."

Bibliography

References are listed in three categories: books and articles, directories, and catalogues of exhibitions. Books and articles are indicated in the text by author and date. Titles of directories are italicized in the text; titles of exhibitions appear with quotation marks.

Books and Articles

Albrecht, Milton C. 1968. Art as an institution. *American Sociological Review,* 33 (June), 383–97.

Albright, Thomas. 1980. The contemporary art museum: "irresponsibility has become widespread." *Artnews,* 79 (January), 42–47.

Allen, Barbara J. 1974. Organization and Administration in Formal Organization: The Art Museum. Ph.D. dissertation, Department of Sociology, New York University.

Alloway, Lawrence. 1968. Systemic painting. In Gregory Battcock, ed., *Minimal Art: A Critical Anthology.* New York: E. P. Dutton, 37–60.

———. 1972. Network: the art world described as a system. *Artforum* 11 (September), 28–32.

———. 1974. *American Pop Art.* New York: Collier Books, Macmillan.

———. 1975a. The great curatorial dim-out. *Artforum,* 13 (May), 32–34.

———. 1975b. *Topics in American Art Since 1945.* New York: W. W. Norton.

———. 1977a. Art. *The Nation,* 225 (February 5, 1977), 156.

———. 1977b. The artist count: in praise of plenty. *Art in America,* 65 (September–October), 105–9.

———. 1981. The renewal of realist criticism. *Art in America,* 69 (September), 108–11.

———. 1984. *Network: Art and the Complex Present.* Ann Arbor, Michigan: UMI Research Press.

Amaya, Mario. 1971. American Pop Art. In J. P. Hodin et al., *Figurative Art Since 1945.* London: Thames and Hudson, 217–41.

Anderson, Dennis. 1977. Peter Dean. *Arts,* 51 (April), 21.

Apple, Jacki. 1981. Introduction. "Alternatives in Retrospect: An Historical Overview, 1969–1975." The New Museum, New York, May 9–July 16, pp. 5–7.

Archives of American Art. Smithsonian Institution, Washington, D.C.

Armstrong, Richard. 1964. Abstract Expressionism was an American revolution. *Canadian Art,* 21 (September–October), 262–65.

Arthur, John. 1980. Realism. "Realism, Photorealism," Philbrook Art Center, Tulsa, Oklahoma, October 5–November 23, pp. 13–17.

Ashton, Dore. 1973. *The New York School: A Cultural Reckoning.* New York: Viking.

Baker, Elizabeth C. 1971. Is there a new academy? In Thomas B. Hess and John Ashbery, eds., *Academic Art.* New York: Collier Books, Macmillan, 139–58.

Baldwin, Carl R. 1974. On the nature of Pop. *Artforum,* 12 (June), 34–38.

Banfield, Edward C. 1984. *The Democratic Muse: Visual Arts and the Public Interest.* New York: Basic Books.

Bannard, Darby. 1966. Present-day art and ready-made styles. *Artforum,* 5 (December), 30–35.

Bard, Joellen. 1977. Tenth Street days: an interview with Charles Cajori and Lois Dodd. *Arts,* 52 (December): 98–103.

Barr, Alfred H., Jr. 1977. *Painting and Sculpture in the Museum of Modern Art, 1929–1967.* New York: Museum of Modern Art.

Battcock, Gregory, ed. 1968. *Minimal Art: A Critical Anthology.* New York: E. P. Dutton.

———. 1969–70. Reevaluating Abstract Expressionism. *Arts,* 44 (December, 1969–January), 46, 48.

———, ed. 1975. *Super Realism: A Critical Anthology.* New York: E. P. Dutton.

———, and Nickas, Robert, eds. 1984. *The Art of Performance: A Critical Anthology.* New York: E. P. Dutton.

Baxandall, Michael. 1972. *Painting and Experience in 15th Century Italy.* Oxford: Oxford University Press.

Beardsall, Judy. 1978. Susan Pear Meisel. *Arts,* 52 (May), 11.

Becker, Howard S. 1982. *Art Worlds.* Berkeley: University of California Press.

Bell, Daniel. 1976. *The Cultural Contradictions of Capitalism.* New York: Basic Books.

Bellah, Robert N., et al. 1985. *Habits of the Heart: Individualism and Commitment in American Life.* Berkeley: University of California Press.

Benjamin, Walter. 1973. The author as producer. In *Understanding Brecht.* London: New Left Books.

Bensman, Joseph, and Gerver, Israel. 1958. Art and mass society. *Social Problems,* 6, pp. 4–10.

Bérard, Michele. 1971. *Encyclopedia of Modern Art Auction Prices.* New York: Arco.

Berger, John. 1972. *Ways of Seeing.* New York: Penguin.

Bergesen, Albert, and Warr, Mark. 1979. A crisis in the moral order: the effects of Watergate upon confidence in social institutions. In Robert Wuthnow, ed., *The Religious Dimension.* New York: Academic Press, 277–95.

Berlind, Robert. 1981. Harriet Shorr at Fischbach. *Art in America,* 69 (May), 145.

Berman, Ronald. 1979. Art vs. the arts. *Commentary,* 68 (November), 46–52.

Blatt, Sidney J. 1984. *Continuity and Change in Art: The Development of Modes of Representation.* Hillsdale, N.J.: Lawrence Erlbaum Associates.

Bourdieu, Pierre. 1980. The aristocracy of culture. *Media, Culture and Society,* 2, pp. 225–54.

Bourdon, David. 1975. Andy Warhol and the society icon. *Art in America,* 63 (January–February), 42–45.

———. 1977. A critic's diary: The New York art year. *Art in America,* 65 (July–August), 67–78.

———. 1985. Sitting pretty: a new cast of art stars comes into focus. *Vogue,* 175 (November), 108, 116.

Brooklyn Museum. 1979. *American Painting: A Complete Illustrated Listing of Works in the Museum's Collection.* Brooklyn, New York: The Brooklyn Museum.

Buettner, Stewart. 1981. *American Art Theory, 1945–1970.* Ann Arbor: University Microfilms International Research Press.

Bürger, Peter. 1984. *Theory of the Avant-Garde.* Minneapolis: University of Minnesota Press (translated by Michael Shaw).

Burnham, Jack. 1971. Corporate art. *Artforum,* 9 (October), 66–71.

Butterfield, J. 1976. On the periphery of knowing. *Arts,* 50 (February), 72–77.

Bystryn, Marcia. 1978. Art galleries as gatekeepers: the case of the Abstract Expressionists. *Social Research,* 45 (Summer), 390–408.

Calas, Nicolas. 1968. *Art in the Age of Risk and Other Essays.* New York: E. P. Dutton.

Campbell, Lawrence. 1982. Lucien Day at Blue Mountain. *Art in America,* 70 (November), 121–22.

Carter, Malcolm W. 1976. The magnificent obsession: art collecting in the seventies. *Artnews,* 75 (May), 39–45.

Cavaliere, Barbara. 1981. Barnett Newman's "Vir Heroicus Sublimis": building the "idea complex." *Arts,* 55 (January), 144–51.

Cawelti, J. G. 1976. *Adventure, Mystery, and Romance: Formula Stories as Art and Popular Culture.* Chicago: University of Chicago Press.

Chamberlain, Betty. 1980. Professional page: alternative spaces. *American Artist,* 44 (September), 14, 99–100.

Chase, Linda. 1975a. Existential vs. humanist realism. In Gregory Battcock, ed., *Super Realism: A Critical Anthology.* New York: E. P. Dutton, 81–95.

———. 1975b. *Les hyperréalistes américains.* Paris: Filipacchi, EPI Editions.

———. 1976. Photo Realism: post-modernist illusionism. *Art International,* 20 (March–April), 14–27.

———. 1980. Tom Blackwell, 1970–1980. *Arts,* 55 (December), 154–55.

Clark, Timothy. 1984. *The Painting of Modern Life: Paris in the Art of Manet and His Followers.* New York: Knopf.

Cochrane, Diana. 1974a. The teachings of Hans Hofmann: push and pull. *American Artist,* 38 (March), 26–35, 63–65.

————. 1974b. Paul Georges: the object is the subject. *American Artist,* 38 (September), 58–63, 76–79.

Cockcroft, Eva. 1974. Abstract Expressionism, weapon of the cold war. *Artforum,* 12 (June), 39–41.

Cockcroft, E.; Weber, J.; and Cockcroft, J. 1977. *Toward a People's Art: The Contemporary Mural Movement.* New York: E. P. Dutton.

Collins, Randall. 1975. *Conflict Sociology.* New York: Academic Press.

Cotter, Holland. 1984. Robert Longo. *Arts,* 59 (September), 7.

Cottingham, Jane. 1980. For real: paintings by Jack Beal. *American Artist* (November), 58–63.

Cox, Annette. 1982. *Art-as-Politics: The Abstract Expressionist Avant-Garde and Society.* Ann Arbor, Michigan: University Microfilms International Research Press.

Crane, Diana. 1976. Reward systems in art, science and religion. In Richard A. Peterson, ed., *The Production of Culture.* Beverly Hills: Sage, 57–72.

————. 1982. Cultural differentiation, cultural integration, and social control. In Jack P. Gibbs, ed., *Social Control: Views from the Social Sciences.* Beverly Hills: Sage, 229–44.

Crary, Jonathan. 1976. Paul Wiesenfeld. *Arts,* 51 (October), 4.

Crow, Thomas. 1983. Modernism and mass culture in the visual arts. In Benjamin H. D. Buchloh et al., *Modernism and Modernity.* Halifax, Nova Scotia: The Press of the Nova Scotia College of Art and Design, 215–64.

Cummings, Paul. 1979. *Artists in Their Own Words.* New York: St. Martin's Press.

Davies, Hugh M., and Yard, Sally E. 1977. Gregory Gillespie: the timeless mystery of art. *Arts,* 52 (December), 116–20.

Davis, Douglas. 1977. *Artculture: Essays on the Post-Modern.* New York: Harper and Row.

————. 1982. The avant-garde is dead! Long live the avant-garde! *Art in America,* 70 (April), 11–19.

De Kooning painting fetches $1.21 million. 1983. *International Herald Tribune,* May 12.

Deitch, Jeffrey. 1980. The Warhol product. *Art in America,* 68 (May), 9–13.

Diamonstein, Barbaralee. 1979. *Inside New York's Art World.* New York: Rizzoli.

————. 1980. Chuck Close: I'm some kind of slow-motion cornball. *Artnews,* 79 (Summer), 113–16.

DiMaggio, Paul. 1977. Market structure, the creative process, and popular culture. *Journal of Popular Culture,* 11, pp. 436–52.

————. 1982. Cultural entrepreneurship in nineteenth-century Boston: the creation of an organizational base for high culture in America. *Media, Culture, and Society,* 4 (1982), 33–50.

Doherty, M. Stephen. 1979. Robert Cottingham: an unabashed realist. *American Artist,* 43 (July), 48–53, 110–12.

Doty, Robert M. 1982. The imagery of Neil Welliver. *Art International,* 25 (September–October), 34–41.

Douglas, Mary, and Isherwood, Baron. 1979. *The World of Goods: Towards an Anthropology of Consumption*. London: Allen Lane.

Dowd, Maureen. 1985. Youth-art-hype: a different bohemia. *New York Times Magazine*, November 17, pp. 26–31, 33–34, 36, 38, 40, 42, 87–88, 100.

Downes, Rackstraw. 1976. Postmodernist painting. *Tracks*, 2 (Fall), 70–73.

Economic Report of the President. 1983. Washington, D.C.: U.S. Government Printing Office.

Elkins, Charles. 1977. An approach to the social functions of American science fiction. *Science Fiction Studies*, 4, pp. 228–32.

Ellenzweig, Allen. 1975a. Catherine Murphy. *Arts*, 49 (February), 21.

———. 1975b. John Button and romantic reality. *Arts*, 50 (November), 92–94.

———. 1975c. Rackstraw Downes. *Arts*, 50 (December), 18.

Escarpit, Robert. 1977. The concept of 'mass'. *Journal of Communication*, 27 (Spring), 44–47.

FitzGibbon, Heather M. 1985. From prints to posters: the production of artistic value in an alternative art world. Paper presented at the 11th Annual Conference on Social Theory, Politics and the Arts, Adelphi University and New School for Social Research, October 25–27.

Flack, Audrey. 1981. *Audrey Flack on Painting*. New York: Harry N. Abrams.

Foote, Nancy. 1976. The apotheosis of crummy space. *Artforum*, 15 (October), 28–36.

Fort, Ilena Susan. 1981. Paul Wiesenfeld. *Arts*, 56 (September), 28.

The *Fortune* directory of the largest non-industrial companies: the 50's. 1980 *Fortune*, 102 (July 14), 146–61.

The *Fortune* directory of the largest U.S. industrial corporations: the 500. 1982. *Fortune*, 105 (May 3), 258–86.

Foster, Hal. ed. 1983. *The Anti-Aesthetic: Essays on Postmodern Culture*. Port Townsend, Wash.: Bay Press.

Frank, Elizabeth. 1982. Miriam Schapiro: formal sentiments. *Art in America*, 70 (May), 106–12.

Friedman, Jon R. 1982. Kim MacConnel. *Arts*, 56 (June), 21.

Fröhlich, Fanchon. 1968. Aesthetic paradoxes of Abstract Expressionism and Pop art. In Lee A. Jacobus, ed., *Aesthetics and the Arts*. New York: McGraw-Hill, 236–44.

Gablik, Suzi. 1977. *Progress in Art*. New York: Rizzoli.

———. 1982. Report from New York: the graffiti question. *Art in America*, 70 (October), 33–39.

———. 1984. *Has Modernism Failed?* New York: Thames and Hudson.

Gallati, Barbara. 1981. Alex Katz. *Arts*, 55 (April), 33.

Gans, Herbert. 1974. *Popular Culture and High Culture*. New York: Basic Books.

———. 1985. American popular culture and high culture in a changing class structure. In Judith H. Balfe and Margaret Jane Wyszomirski, eds., *Art, Ideology, and Politics*. New York: Praeger.

Gardner, Paul. 1980. Gee, what's happened to Andy Warhol? *Artnews*, 79 (November), 72–77.

———. 1982. The Stable wasn't 'just another gallery'. *Artnews*, 81 (May), 108–13.

Geldzahler, Henry. 1969. *New York Painting and Sculpture, 1940–70*. New York: E. P. Dutton.

———. 1974. Pop Art: two views. *Artnews*, 73 (May), 30–32.

Gendel, Milton. 1979. If one hasn't visited Count Panza's villa, one doesn't know what collecting is all about. *Artnews*, 78 (December), 44–49.

Genova, Judith. 1979. The significance of style. *Journal of Aesthetics and Art Criticism*, 37 (Spring), 315–24.

Glaser, Bruce. 1966. If it was just a satirical thing, there wouldn't be any problem. *Artforum*, 4 (February), 21–24.

———. 1968. Questions to Stella and Judd. In Gregory Battcock, ed., *Minimal Art: A Critical Anthology*. New York: E. P. Dutton, 148–64.

———. 1970–71. Modern art and the critics: a panel discussion. *Art Journal*, 30 (Winter), 154–59.

Glaser, David. 1983. Neo-Pop strategy. *Arts*, 57 (November), 126–27.

Glueck, Grace. 1971. Power and aesthetics: the trustee. *Art in America*, 59 (July–August), 82.

———. 1981. How emerging artists really emerge: putting the biennials together. *Artnews*, 80 (May), 95–99.

———. 1985. The art boom sets off a museum building spree. *International Herald Tribune*, July 5, p. 7.

Godfrey, Robert. 1979. Have museums slighted certain types of art, particularly figurative art? *American Artist*, 43 (October), 14, 117.

Goldberger, Paul. 1984. The new MOMA. *The New York Times Magazine*, April 15, Section 6, pp. 36–46, 68–72.

Goldin, Amy. 1966. Requiem for a gallery. *Arts*, 40 (January), 25–29.

———. 1975. Patterns, grids and painting. *Artforum*, 14 (September), 50–54.

Goldin, Amy, and Smith, Roberta. 1977. Present tense: new art and the New York museum. *Art in America*, 65 (September–October), 92–104.

Golub, Leon. 1973. 16 Whitney Museum Annuals, percentages 1950–72. *Artforum*, 11 (March), 36–39.

Goodrich, Lloyd, and Baur, John. 1961. *American Art of Our Century*. New York: Praeger.

Goody, Kenneth. 1984. Arts funding: growth and change between 1963 and 1983. *Annals of the American Academy of Political and Social Science*, 471 (January), 144–57.

Goodyear, Frank H., Jr. 1981. *Contemporary American Realism Since 1960*. Boston: New York Graphic Society.

Gottdiener, M. 1985. A semiotic approach to mass culture. *American Journal of Sociology*, 90 (March), 979–1001.

Gottlieb, Adolf. 1967. Statement. Jackson Pollock, an artist's symposium. *Artnews*, 66 (April), 29–33.

Grana, Cesar. 1971. *Fact and Symbol: Essays in the Sociology of Art and Literature*. New York: Oxford University Press.

Greenberg, Clement. 1961a. Modernist painting. *Arts Yearbook,* 4, pp. 101–8.

———. 1961b. *Art and Culture: Critical Essays.* Boston: Beacon Press.

Grote, David. 1983. *The End of Comedy: The Sit-Com and the Comedic Tradition.* Hamdon, Conn.: Archon Books.

Guilbaut, Serge. 1983. *How New York Stole the Idea of Modern Art: Abstract Expressionism, Freedom, and the Cold War.* Chicago: University of Chicago Press, 1983.

Gussow, Alan. 1972. *A Sense of Place: The Artist and the American Land,* vol. 1. San Francisco: Friends of the Earth.

Haacke, Hans. 1976. *Framing and Being Framed: 7 Works, 1970–75.* New York: New York University Press.

———. 1981. Working conditions. *Artforum,* 19 (Summer), 56–61.

Hadjinicolaou, Nicos. 1978. *Art and Class Struggle.* London: Pluto Press.

Hall, Stuart. 1979. Culture, media and the ideological effect. In James Curran, et al., *Mass Communication and Society.* Beverly Hills, Calif.: Sage.

Hall, Stuart, and Jefferson, T., eds., 1976. *Resistance Through Rituals.* London: Hutchinson.

Halley, Peter. 1981. Beat, Minimalism, New Wave, and Robert Smithson. *Arts,* 55 (May), 120–21.

———. 1983. A note on the 'new expressionism' phenomenon. *Arts,* 57 (March), 88–89.

Haney, William L. 1981. Our place in time. *ACM Newsletter,* 1 (January–February), 6–7.

Hanson, Duane. 1970. Presenting Duane Hanson. *Art in America,* 58 (September), 86–89.

Harshman, Barbara. 1978. An interview with Chuck Close. *Arts,* 52 (June), 142–45.

Hart, Kitty C. 1984. Changing public attitudes toward funding the arts. *Annals of the American Academy of Political and Social Science,* 471 (January), 45–56.

Haskell, Barbara. 1976. Two decades of American sculpture: a survey. In *Two Hundred Years of American Sculpture,* Catalogue. New York: Whitney Museum of Modern Art.

Haskell, Barbara. 1984. *Blam! The Explosion of Pop, Minimalism, and Performance, 1958–1964.* New York: Whitney Museum of American Art in association with W. W. Norton.

Heise, Myron. 1978. Street painter Myron Heise. *American Art Review,* 4 (November), 100–103.

Helms, Roy. 1979. State funds are zooming: 23 states top $1 million for the arts. *American Arts,* 10 (December), 22–23.

Henry, Gerrit. 1975. The artist and the face: a modern sampling. *Art in America,* 63 (January–February), 34–41.

———. 1981a. Jane Freilicher (Fischbach). *Artnews,* (March), 220.

———. 1981b. Milet Andrejevic at Robert Schoelkopf. *Art in America,* 69 (April), 141.

———. 1981c. Painterly realism and the modern landscape. *Art in America*, 69 (September), 112–19.

Herbert, Nick. 1985. *Quantum Reality: Beyond the New Physics*. Garden City, New York: Anchor Press, Doubleday.

Hightower, John B. 1970. From class art to mass art. *Art in America*, 58, (September–October), 25.

Hills, Patricia. 1980. Painting, 1941–80. In Patricia Hills and Roberta K. Tarbell, *The Figurative Tradition and the Whitney Museum of American Art*. Newark: University of Delaware Press, 109–51.

Hirsch, Paul M. 1972. Processing fads and fashions: an organization set analysis of cultural industry systems. *American Journal of Sociology*, 77 (January), 639–59.

Hobbs, Robert C. 1978. Early Abstract Expressionism: a concern with the unknown within. In Robert C. Hobbs and Gail Levin, *Abstract Expressionism: The Formative Years*. New York: Whitney Museum of American Art, 8–26.

Hopkins, Budd. 1976. Frank Stella's new work: a personal note. *Artforum*, 15 (December), 58–59.

Hopps, Walter. 1965. An interview with Jasper Johns. *Artforum*, 3, pp. 32–36.

Hughes, Robert. 1982. The rise of Andy Warhol. *New York Review*, 29 (February 18), 6–10.

Humphrey, Ralph. 1975. Statement and critique. *Arts*, 49 (February), 56–59.

Hunter, Sam. 1959. Into the forties: the crisis in painting. In *Modern Painting and Sculpture*. New York: Dell, 131–61.

———. 1979. *Art in Business: The Philip Morris Story*. New York: Harry N. Abrams.

Hutton, Jon. 1982. Jack Goldstein. *Arts*, 56 (January), 17.

Huyssen, Andreas. 1975. The cultural politics of Pop: reception and critique of US Pop art in the Federal Republic of Germany. *New German Critique*, 2, pp. 77–97.

———. 1980. The hidden dialectic: the avant-garde—technology—mass culture. In Kathleen Woodward, ed., *The Myths of Information: Technology and Postindustrial Culture*. Madison, Wis.: Coda Press, 151–64.

Jeffri, Joan. 1980. *The Emerging Arts*. New York: Praeger.

Johnson, Ellen H. 1965. Jim Dine and Jasper Johns: art about art. *Art and Literature*, 6 (Autumn), 128–40.

Jowitt, Deborah. 1971. Post-Judson dance. *Art in America*, 59 (September–October), 81–87.

Kadushin, Charles. 1976. Networks and circles in the production of culture. *American Behavioral Scientist*, 19 (July–August), 769–84.

Kagan, Andrew. 1978. Most wanted men: Andy Warhol and the anti-culture of punk. *Arts*, 53 (September), 119–21.

Kahn, W. 1979. The subject matter of new realism. *American Artist*, 49 (November), 50–55.

Kalish, Howard. 1979. Toward the Artists' Choice Museum. In "Figurative/Realist Art." Artists' Choice Museum, New York, September 8–22, pp. 5–7.

————. 1980. Figurative, representational, realist art. *ACM* [Artists' Choice Museum] *Newsletter,* 1 (April), 3–5.

Kardon, Janet. 1984. The East Village Scene. In "The East Village Scene," Institute of Contemporary Art, University of Pennsylvania, October 12- December 2, pp. 6–8.

Karp, Ivan. 1975. Rent is the only reality, or the hotel instead of the hymns. In Gregory Battcock, ed., *Superrealism: A Critical Anthology.* New York: E. P. Dutton, 21–35.

Keen, Geraldine. 1971. *The Sale of Works of Art: A Study Based on the Times-Sotheby Index.* London: Nelson.

Kelly, William. 1980. Robert Godfrey. *Arts,* 54 (March), 12.

Kent, Norman. 1959. Some sales talk. *American Artist,* 23 (May), 3, 62.

Kirby, Michael, and Richard Schechner. 1965. Interview with John Cage. *Tulane Drama Review,* 10 (Winter), 50–72.

Klapp, Orrin E. 1982. Meaning lag in the information society. *Jouurnal of Communication,* 32 (Spring), 56–66.

Koslow, Susan. 1982. Empirical realism and poetic form in the paintings of Lennart Anderson. *Arts,* 57 (December), 90–99.

Kozloff, Max. 1964. The honest elusiveness of Jim Dine. *Artforum,* 3, pp. 36–40.

————. 1965. The critical reception of Abstract Expressionism. *Arts,* 40 (December), 27–33.

Kramer, Hilton. 1973. *The Age of the Avant Garde: An Art Chronicle of 1956–1972.* New York: Farrar, Straus and Giroux.

————. 1974. Realism: the painting is fiction enough! *New York Times,* April 28, D19.

————. 1976. SoHo: figures at an exhibition. *New York Times,* December 10, C14.

————. 1977. Why figurative art confounds our museums. *New York Times,* January 2, D19.

Kuh, Katherine. 1971. Of, by and for artists. *Saturday Review,* 54 (January 23), 88–89.

————. 1973. The new art and its collectors. *Saturday Review/World,* 56 (December 4), 38–40.

Kuhn, Annette. 1977. Post-war collecting: the emergence of phase III. *Art in America,* 65 (September), 110–13.

Kuhn, Thomas S. 1970. *The Structure of Scientific Revolutions.* 2d ed. Chicago: University of Chicago Press.

Kuspit, Donald B. 1976. Regionalism reconsidered. *Art in America,* 64 (July-August), 64–69.

————. 1977. Art criticism: where's the depth? *Artforum,* 16 (September), 38–41.

————. 1978. Symbolic pregnance in Mark Rothko and Clyfford Still. *Arts,* 52 (March), 120–25.

————. 1979a. Modern art's failure of critical nerve. *Arts,* 53 (February), 113–17.

———. 1979b. *Clement Greenberg: Art Critic.* Madison, Wis.: University of Wisconsin Press.

———. 1981. What's real in realism? *Art in America,* 69 (September), 84–95.

———. 1982. David Salle at Boone and Castelli. *Art in America,* 70 (Summer), 142.

———. 1985. *Leon Golub: Existential/Activist Painter.* New Brunswick, N.J.: Rutgers University Press.

Kuwayama, Tadaaki. 1964. Statement. *Art in America,* 52, no. 4, p. 100.

Laderman, Gabriel. 1967. Unconventional realists. *Artforum,* 6 (November), 42–46.

———. 1968. The future of landscape painting. *Artforum,* 6 (November), 57–60.

Landau, Ellen G. 1976. The French sources for Hans Hofmann's ideas on the dynamics of color-created space. *Arts,* 51 (October), 76–81.

Lanes, Jerrold. 1972. Problems of representation—are we asking the right questions? *Artforum,* 10 (January), 60–62.

Lawson, Thomas. 1981. Last exit: painting. *Artforum,* 20 (October), 40–45.

Lee, S. E., ed. 1975. *On Understanding Art Museums.* Englewood Cliffs, N.J.: Prentice-Hall.

Leepa, Allen. 1968. Minimal art and primary meanings. In Gregory Battcock, ed., *Minimal Art.* New York: E. P. Dutton, 200–208.

Legg, Alicia, ed. 1977. *Painting and Sculpture in the Museum of Modern Art: Catalogue of the Collection, January 1, 1977.* New York: The Museum of Modern Art.

Levin, Kim. 1978. Chuck Close: decoding the image. *Arts,* 52 (June), 146–49.

———. 1979a. Frank Stella. *Arts,* 53 (March), 22.

———. 1979b. Farewell to modernism. *Arts,* 54 (October), 90–92.

———. 1980. Alex Katz. *Arts,* 54 (May), 5.

Levine, Edward. 1976. Robert Irwin: world without frame. *Arts,* 50 (February), 72–77.

Levine, Les. 1973. A portrait of Sidney Janis on the occasion of his 25th anniversary as an art dealer. *Arts,* 48 (November), 51–54.

Lichtenstein, Grace. 1979. Betty Parsons: still trying to find the creative world in everything. *Artnews,* 78 (March), 52–56.

Lindey, Christine. 1980. *Superrealist Painting and Sculpture.* New York: William Morrow.

Lipman, Jean, ed. 1970. *The Collector in America.* New York: Viking.

Lippard, Lucy. 1965. The third stream: constructed images and painted structures. *Art Voices,* 4 (Spring), 45–49.

———. 1966a. Recent sculpture as escape. *Art International,* 10 (February), 48–58.

———. 1966b. *Pop Art.* New York: Praeger.

Long, Elizabeth. 1981. Affluence and after: themes of success in American best-selling novels, 1945–1975. *Knowledge and Society: Studies in the Sociology of Culture Past and Present,* 3 pp. 257–301.

———. 1985. *The American Dream and the Popular Novel.* Boston: Routledge and Kegan Paul.

Loucheim, Aline B. 1944. Who buys what in the picture boom? *Art News* (July 1–31), 12–14, 23, 24.

———. 1945. Second season of the picture boom: private buying of contemporaries continues to climb. *Art News,* (August 1–31), 8–11, 26.

Lubell, Ellen. 1977. Idelle Weber. *Arts,* 52 (September), 8.

Mackie, Alwynne. 1978. New realism and the photographic look. *American Art Review,* 4 (November), 72–79, 132–34.

———. 1979. Ben Schonzeit and the changing faces of realism. *Art International,* 22 (January), 24–32.

Mainardi, Patricia. 1976. Philip Pearlstein: old master of the new realists. *Artnews,* 75 (November), 72–75.

———. 1978. Louis Finkelstein. *Arts,* 52 (February), 10.

———. 1979. Gretna Campbell. *Arts,* 53 (May), 7.

Mangan, Doreen. 1974. Paul Wiesenfeld redefines the still life. *American Artist,* 38 (August), 20–25, 58–62.

———. 1980. How New York galleries operate: do you need one? *American Artist,* (June), 78–80.

Marincola, Paula Chronology. 1981. "Robert S. Zakanitch," Institute of Contemporary Art, University of Pennsylvania, June 12 to August 9.

Marter, Joan. 1978. Joan Semmel. *Arts,* 53 (November), 12.

———. 1982. Narrative painting, language, and Ora Lerman's trilogies. *Arts,* 56 (May), 90–94.

Martorella, Rosanne. 1986. Beauty and the boardroom: a sociological analysis of the artistic styles of corporate art collections. Paper presented at the Annual Meeting of the American Sociological Association, New York City, September 3.

Mathews, Margaret. 1981. Duane Hanson: Super Realism. *American Artist,* 45 (November), 58–62, 95–97, 102.

McCormick, Carlo. 1984. The periphery of pluralism. In "The East Village Scene." Institute of Contemporary Art, University of Pennsylvania, Philadelphia, Pa., October 12–December 2, pp. 20–55.

McGill, Douglas C. 1984. More Americans attend the arts. *New York Times,* December 4.

———. 1985. Rubin of Modern Museum to stress new works. *New York Times,* February 20, C15.

———. 1986. Probing society's taboos—on canvas. *New York Times,* March 2, Section 2, p. H1.

McQuarie, Donald. 1980. Utopia and transcendence: an analysis of their decline in contemporary science fiction. *Journal of Popular Culture,* 14 (Fall), 242–50.

McTwigan, Michael. 1982. What is contemporary American realism? An interview with Frank Goodyear. *American Artist,* 46 (March), 12, 14, 16, 67, 70–71.

Meisel, Louis K. 1981. *Photorealism.* New York: Harry N. Abrams.

Metz, Robert. 1979. The corporation as art patron: a growth stock. *Artnews,* 78 (May), 40–47.

Meyer, Leonard B. 1963. The end of the Renaissance? *The Hudson Review,* 16, pp. 169–86.

Meyer, Ursula. 1972. *Conceptual Art.* New York: E. P. Dutton.

Moffett, Kenneth. 1974. Pop Art: two views. *Artnews,* 73 (May), 30–32.

Monaco, James. 1978. *Media Culture.* New York: Delta.

Motherwell, Robert, and Reinhardt, Ad, eds. 1951. *Modern Artists in America.* Ser. 1. New York.

Moufarrege, Nicolas A. 1982. Another wave, still more savagely than the first: Lower East Side, 1982. *Arts,* 57 (September), 69–73.

Moulin, Raymonde. 1967. *Le Marché de la Peinture en France.* Paris: Les Editions de Minuit.

Mulkay, Michael, and Chaplin, Elizabeth. 1982. Aesthetics and the artistic career: a study of anomie in fine-art painting. *The Sociological Quarterly,* 23 (Winter), 117–38.

Murry, Jesse. 1980. William Conlon. *Arts,* 54 (February), 14.

Naifeh, Steven W. 1976. *Culture Making: Money, Success and the New York Art World.* Princeton University: Undergraduate Studies in History, The History Department of Princeton University.

National Endowment for the Arts. 1975. *Museums USA: A Survey Report.* Washington, D.C.: United States Government Printing Office.

National Research Center of the Arts. 1975. *Americans and the Arts: A Survey of Public Opinion.* New York: Associated Councils of the Arts.

———. 1976. *Americans and the Arts: A Survey of the Attitudes Toward and Participation in the Arts and Culture of the U.S. Public.* New York: Associated Councils of the Arts.

Nemser, Cindy. 1971–72. Representational painting in 1971: a new synthesis. *Arts,* 46 (December–January), 41–46.

Netzer, Dick. 1978. *The Subsidized Muse: Public Support for the Arts in the United States.* New York: Cambridge University Press.

Nilson, Lisbet. 1983. Making it in Neo. *Artnews,* 82 (September), 62–70.

Nochlin, Linda. 1967. The invention of the avant-garde: France, 1830–80. In Thomas B. Hess and John Ashbery, eds., *Avant-Garde Art.* London: Collier-Macmillan, pp. 1–24.

———. 1981. The flowering of American realism. In "Real, Really Real, Super Real," San Antonio Museum Association, San Antonio, Texas, March 1–April 26, pp. 25–36.

Nora, Françoise. 1967. The neo-impressionist avant-garde. In Thomas B. Hess and John Ashbery, eds., *Avant-Garde Art.* New York: Macmillan, 25–50.

O'Doherty, Brian. 1967. *Object and Idea: An Art Critic's Journal, 1961–67.* New York: Simon and Schuster.

————. Minus Plato. 1968. In Gregory Battcock, ed., *Minimal Art: A Critical Anthology*. New York: E. P. Dutton, 251–55.

————. 1976a. Inside the white cube: notes on the gallery space. Part I. *Artforum*, 14 (March), 24–30.

————. 1976b. Inside the white cube. Part III: Context as content. *Artforum*, 15 (November), 38–44.

O'Hare, Michael. 1974. The audience for the museum of fine arts. *Curator*, 17, 126–59.

Ohmann, Richard. 1983. The shaping of a canon: U.S. fiction, 1960–1975. *Critical Inquiry*, 10 (September), 199–223.

Olive, Kristin. 1985. David Salle's deconstructive strategy. *Arts*, 60 (November), 82–85.

Oresman, Janice G. 1982. Still life today. *Arts*, 57 (December), 111–15.

Orton, Fred, and Pollock, Griselda. 1981. Avant-gardes and partisans reviewed. *Art History*, 4 (September), 305–27.

Owens, Craig. 1981. The critic as realist [book review]. *Art in America*, 69 (September), 9.

Passlof, P. 1976. Gretna Campbell's 'new paintings'. *Arts*, 50 (April), 100–102.

Patterson, Jerry. 1973. Facts, figures, questions about the Scull sale. *Artnews*, 72 (December), 78–80.

————. N.d. Review of American art at auction, 1970–78. In Richard Hislop, ed., *Auction Prices of American Artists*. Pond House, Weybridge, Surrey: Art Sales Index, n.d.

Perl, Jed. 1977. Gabriel Laderman. *Arts*, 51 (May), 5.

Perreault, John. 1967. Union-made: report on a phenomenon. *Arts*, 41 (March), 26–31.

————. 1968. Minimal abstracts. In Gregory Battcock, ed., *Minimal Art: A Critical Anthology*. New York: E. P. Dutton, 256–62.

————. 1974. "Classic" Pop revisited. *Art in America*, 62 (March–April), 64–68.

————. 1977. Issues in pattern painting. *Artforum*, 16 (November), 32–36.

————. 1978. Photo-realist principles. *American Art Review*, 4 (November), 108–11, 141.

Perrone, Jeff. 1984. The fresh and the not-so-fresh. *Arts* 59 (December), 104–7.

Peterson, Richard. 1979. Revitalizing the culture concept. *Annual Review of Sociology*, 5, pp. 137–66.

Peterson, Richard A., and Berger, David. 1975. Cycles in symbol production: the case of popular music. *American Sociological Review*, 40, pp. 158–73.

Peterson, Richard, and DiMaggio, Paul. 1975. From region to class: the changing locus of country music: a test of the massification hypothesis. *Social Forces*, 53 (March), 497–506.

Pincus-Witten, Robert. 1970. [Review of Edwin Ruda] *Artforum*, 8 (January), 67–68.

Plagens, Peter. 1974. *Sunshine Muse: Contemporary Art on the West Coast*. New York: Praeger.

———. 1981. The academy of the bad. *Art in America,* 69 (November), 11–17.

Poggioli, Renato. 1971. *The Theory of the Avant-Garde.* New York: Harper and Row.

Pollock, Duncan. 1972. The verist sculptors: two interviews. *Art in America,* 60 (November), 98–99.

Pollock, Jackson. 1947–48. My painting. *Possibilities* 1 (Winter), 78–83.

Popper, Frank. 1975. *Art—Action and Participation.* London: Studio Vista.

Porter, Fairfield. 1981. Speaking likeness. *ACM Newsletter,* 2 (November-December), 1–2.

Price, Derek J. de Solla. 1965. Networks of scientific papers. *Science,* 149, pp. 510–15.

———. 1970. Citation measures of hard science, soft science, technology, and non-science. In C. Nelson and D. Pollock, eds., *Communication among Scientists and Engineers.* Lexington, Mass.: D. C. Heath, 3–22.

Ratcliff, Carter. 1978. In the manifold present—the paintings of Tony Robbin. *Arts,* 52 (March), 100–101.

———. 1982. Art and resentment. *Art in America,* 70 (Summer), 11.

Ratcliff, Carter, et al. 1982. Expressionism today: an artists' symposium. *Art in America* 70 (December), 58–75, 139–41.

Raymond, H. D. 1974. Beyond freedom, dignity and ridicule. *Arts,* 48 (February), 25–26.

Reif, Rita. 1986. Jasper Johns painting sets an auction record. *New York Times,* November 12.

Reise, Barbara M. 1968a. Greenberg and the group: a retrospective view: Part 1. *Studio International,* 175 (May), 254–57.

———. 1968b. Greenberg and the group: a retrospective view: Part 2. *Studio International,* 175 (June), 314–15.

Ridgeway, Sally. 1977. The social dynamics of an avant-garde movement. Paper presented at the Meetings of The American Sociological Association, Chicago, September.

Robins, Corinne. 1973. Mary Grigoriadis. *Arts,* 53 (September), 3.

———. 1978. Willard Midgette. *Arts,* 52 (April), 2.

———. 1980. Late decorative art: art, artifact, and ersatz. *Arts,* 55 (September), 150–51.

Robinson, Walter, and McCormick, Carlo. 1982. Slouching toward Avenue D. *Art in America,* 72 (Summer), 134–61.

Robbin, Tony. 1976. Visual paradox and four-dimensional geometry. *Tracks,* 2 (Winter), 11–19.

Rosand, David. 1971. Portrait of the artist as a portrait of the artist. *Artnews,* 70 (March), 32–34, 74.

Rose, Barbara. 1968. ABC art. In Gregory Battcock, ed., *Minimal Art: A Critical Anthology.* New York: E. P. Dutton, 274–97.

———. 1975a. *American Art Since 1900.* New York: Praeger.

———, ed. 1975b. *Readings in American Art, 1900–1975.* New York: Praeger.

———. 1978. Hans Hofmann: From expressionism to abstraction. *Arts,* 53 (November), 110–14.

———. 1983. Letter to a young artist. *ACM Journal,* 1 (Fall), 16–18.

Rosenberg, Bernard, and Fliegel, N. E. 1965. *The Vanguard Artist.* Chicago: Quadrangle Books.

Rosenberg, Harold. 1964. Rosenberg on criticism. *Artforum,* 2, no. 8, pp. 28–29.

———. 1965. *The Tradition of the New.* New York: McGraw-Hill.

Rosenblum, Robert. 1981. How about a show of the ten highest-priced artists whom no right-thinking museum would ever consider exhibiting? *Artnews,* 80 (January), 133.

Rubin, David S. 1978. Andy Warhol. *Arts,* 53 (December), 10.

Rublowsky, John. 1965. *Pop Art.* New York: Basic Books.

Ruda, Ed. 1967. Park Place, 1963–1967: some informal notes in retrospect. *Arts,* 42 (November), 30–33.

Russell, John. 1982. Thomas Eakins' moral dimension. *International Herald Tribune,* June 10, p. 8.

———. 1984. Modern museums are on every city's list. *New York Times,* April 29, H31.

———. 1985. Modern art museums: too much of the same thing. *International Herald Tribune,* August 9, p. 7.

Sandler, Irving. 1965. The Club: How the artists of the New York school found their first audience—themselves. *Artforum,* 4 (September), 27–30.

———. 1976. *The Triumph of American Painting: A History of Abstract Expressionism.* New York: Harper and Row.

———. 1978. *The New York School: The Painters and Sculptors of the Fifties.* New York: Harper and Row.

———. 1984. Tenth Street then and now. In "The East Village Scene," Institute of Contemporary Art, University of Pennsylvania, Philadelphia, Pa., October 12–December 2, pp. 10–19.

Sawin, Martica. 1976. Abstract roots of contemporary representation. *Arts,* 50 (June), 106–9.

———. 1977. Kendall Shaw. *Arts,* 51 (January), 8.

Schjeldahl, Peter. 1980. Warhol and class content. *Art in America,* 68 (May), 112–19.

Schwartz, Barry. 1974. *The New Humanism: Art in a Time of Change.* New York: Praeger.

Seitz, William C. 1972. The real and the artificial: painting of the new environment. *Art in America,* 60 (November–December), 58–72.

Selz, Peter. 1963. A symposium on Pop art. *Arts,* 37 (April), 36–45.

Seuphor, Michel, 1951. Paris New York 1951. In Robert Motherwell and Ad Reinhardt, eds. *Modern Artists in America,* ser. 1. New York: Wittenborn Schultz, 118–22.

Shaman, Sanford, S. 1981. An interview with Philip Pearlstein. *Art in America,* 69 (September), 120–26, 213–15.

Shapiro, David, ed. 1973. *Social Realism: Art as a Weapon*. New York: Frederick Ungar.

Shapiro, Theda. 1976. *Painters and Politics: The European Avant-Garde and Society, 1900–1925*. New York: Elsevier.

Shirey, David. 1974. Arts market. *Arts*, 48 (June), 75.

Shore, Michael. 1980. Punk rocks the art world: how does it look? *Artnews*, 79 (November), 78–85.

Siegel, Jeanne. 1973. Adolf Gottlieb at 70: "I would like to get rid of the idea that art is for everybody." *Artnews*, 72 (December), 57–59.

———. 1983. Richard Bosman: stories of violence. *Arts*, 57 (April), 126–28.

———. 1985. *Artwords: Discourse on the 60s and 70s*. Ann Arbor: UMI Research Press.

Simpson, Charles R. 1981. *SoHo: The Artist in the City*. Chicago: University of Chicago Press.

Sloane, Leonard. 1980. Is big business a bonanza for the arts? *Artnews*, 79 (October), 8, 111–15.

Smith, Corinna. 1979. Alfred Leslie. *Arts*, 53 (January), 14.

Smith, Corinna, and Brian Wallis. 1979. The big still life. *Arts*, 53 (May), 15.

Smith, Philip. 1981. Jedd Garet and the atomic age. *Arts*, 55 (June), 158–60.

Smith, Paul. 1982. Lois Dodd. *Arts*, 57 (December), 7.

Snow, Robert P. 1983. *Creating Media Culture*. Beverly Hills: Sage.

Spencer, John R. 1971. The university museum: accidental past, purposeful future? *Art in America*, 59 (July–August), 84–90.

Storr, Robert. 1982. Keith Haring and Frank Young at Hal Bromm. *Art in America*, 70 (March), 144.

———. 1984. Rackstraw Downes: painter as geographer. *Art in America*, 72 (October), 154–61.

Strand, Mark. 1983. *The Art of the Real: Nine American Figurative Painters*. New York: Crown Publishers.

Sullivan, Ellen. 1981. Sharyn Finnegan. *Arts*, 55 (April), 23.

Tannenbaum, Judith. 1977. Sidney Goodman. *Arts*, 51 (May), 37–38.

———. 1978. Dee Shapiro. *Arts*, 52 (April), 10.

Thomas, Helen. 1979. Tomar Levine. *Arts*, 53 (June), 39.

Tillim, Sidney. 1965. Further observations on the Pop phenomenon. *Artforum*, 4 (November), 17–19.

———. 1966. The Katz cocktail: grand and cozy. *Artnews*, 64 (December), 46–49, 67–69.

———. 1969. A variety of realisms. *Artforum*, 7 (Summer), 42–48.

———. 1977. Notes on narrative and history painting. *Artforum*, 15 (May), 41–43.

Tomkins, Calvin. 1971. Moving with the flow. *New Yorker*, 47 (November 6), 58–113.

———. 1975. Profile on Betty Parsons. *New Yorker*, 51 (June 9), 44–48, 51–52, 54, 59–60, 62, 64.

————. 1980a. Matisse's armchair. *New Yorker,* 56 (February 25), 108–13.

————. 1980b. A good eye and a good ear. *New Yorker* 56 (May 26), 40–72.

Trini, Tommaso. 1970. At home with art: the villa of Count Giuseppe Panza di Biumo. *Art in America,* 58 (September–October), 107–9.

Trucco, Terry. 1981. Insider's guide to the art market. *Artnews,* 80 (April), 78–82.

Truewoman, Honey. 1975. Realism in drag. In Gregory Battcock, ed., *Superrealism: A Critical Anthology.* New York: E. P. Dutton, 223–29.

Tuchman, Maurice. 1970. *New York School: The First Generation.* Greenwich, Conn.: New York Graphic Society.

Tuchman, Phyllis. 1970. American art in Germany: the history of a phenomenon. *Artforum,* 9 (November 9), 58–69.

————. 1971. Interview with Jack Tworkov. *Artforum,* 9 (January), 62–68.

————. 1976. Peter Ludwig: an obligation to inform. *Artnews,* 75 (October): 60–63.

————. 1977. Minimalism and critical response. *Artforum,* 15 (May), 26–31.

Turner, Norman. 1981. Charles Cajori. *Arts,* 55 (April), 21.

————. 1982. Painterly landscape. *Arts,* 56 (March), 115–19.

Tworkov, Jack. 1973. Notes on my painting. *Art in America,* 61 (September), 66–69.

United States Bureau of the Census. 1975. *Historical Statistics of the United States: Colonial Times to 1970, Part 1.* Washington, D.C.: U.S. Department of Commerce, Bureau of the Census.

————. 1951; 1982–83. *Statistical Abstracts of the United States.* Washington, D.C.: U.S. Bureau of the Census.

Useem, Michael, and DiMaggio, Paul. 1977. A critical review of the content, quality and use of audience studies. In David Cwi, ed., *Research in the Arts,* Proceedings of the Conference on Policy Related Studies of the National Endowment for the Arts. The Walters Art Gallery, Baltimore, Maryland, December 7–9.

Varian, Elayne H. Schemata 7. In Gregory Battcock (ed.) *Minimal Art: A Critical Anthology.* New York: E. P. Dutton, 1968, 359–80.

————. 1970. New dealing. *Art in America,* 58 (January–February), 68–73.

Van Devanter, Anne C., and Frankenstein, Alfred V. 1974. *American Self-Portraits, 1670–1973.* Washington, D.C.: International Exhibitions Foundation.

Vitz, Paul C., and Glimcher, Arnold B. 1984. *Modern Art and Modern Science: The Parallel Analysis of Vision.* New York: Praeger Publishers.

Walker, John A. 1983. *Art in the Age of the Mass Media.* London: Pluto Press.

Walker, Richard W. 1984. Record price for Fairfield Porter. *Artnews,* 83 (December), 22.

Wallach, Alan. 1980. Thomas Cornell. *Arts,* 54 (February), 7.

Wallen, Burr. 1980. William Schwedler in orbit, or, pattern is more than you think it is. *Arts,* 54 (March), 172–76.

Welish, Marjorie. 1981. James McGarrell at Frumkin. *Art in America,* 69 (Summer), 132.

Weschler, Lawrence. 1982. Lines of inquiry. *Art in America,* 70 (March), 102–9.

White, Harrison, and White, Cynthia. 1965. *Canvases and Careers.* New York: Wiley.

Whitney Museum of American Art. 1975. *Catalogue of the Collection.* New York: Whitney Museum of American Art.

———. 1986. *Painting and Sculpture Acquisitions, 1973–1986.* New York: Whitney Museum of American Art. 1986.

Williamson, Judith. 1978. *Decoding Advertisements: Ideology and Meaning in Advertising.* Salem, N.H.: Marion Boyars.

Wilson, Janet. 1978. What makes MOMA run? Richard Oldenburg. *Artnews,* 78 (October), 141.

Wolff, Janet. 1981. *The Social Production of Art.* New York: St. Martin's Press.

———. 1983. *Aesthetics and the Sociology of Art.* London: George Allen and Unwin.

Wollheim, Richard. 1968. Minimal art. In Gregory Battcock, ed., *Minimal Art: A Critical Anthology.* New York: E. P. Dutton, 387–99.

Wright, Will. 1976. *Six-Guns and Society.* Berkeley, Calif.: University of California Press.

Wuthnow, Robert, et al., 1984. *Cultural Analysis: The Work of Peter L. Berger, Mary Douglas, Michel Foucault, and Jurgen Habermas.* Boston: Routledge and Kegan Paul.

Yau, John. 1978. Sidney Tillim. *Arts,* 52 (February), 7.

———. 1981. Robert Berlind at Milliken. *Art in America,* 69 (Summer), 134–35.

Yourgrau, Barry. 1980. Janet Fish: new paintings. *Arts,* 55 (December), 96–97.

Zimmer, William. 1976. William Schwedler. *Arts,* 50 (April), 5.

———. 1976. Frank Faulkner. *Arts,* 51 (September), 5.

Zolberg, Vera L. 1981. Conflicting visions in American art museums. *Theory and Society,* 10, pp. 103–25.

———. 1983. Changing patterns of patronage in the arts. In Jack B. Kamerman and Rosanne Martorella, eds., *Performers and Performances: The Social Organization of Artistic Work.* New York: Praeger, 251–68.

Zukin, Sharon. 1982. *Loft Living.* Baltimore: The Johns Hopkins University Press.

Directories

American Art Directory. 1970, 1981, 1982, 1984. Edited by Jaques Cattell Press. New York: R. R. Bowker.

The Art Collector's Almanac, No. 1, 1965. 1965. Edited by Marshall Matusow. New York: Art Collector's Almanac.

Arts Yearbook 6. 1962. Edited by James R. Mellow. New York: Art Digest.

Arts Yearbook. 1959. Edited Hilton Kramer. New York: Art Digest.

Auction Prices of American Artists. 1970–84 Volume 1: *1970–78;* 2: *1978–80;* 3: *1980–82;* 4: *1982–84.* Edited by Richard Hislop. Pond House, Weybridge, Surrey: Art Sales Index.

Contemporary Artists. 1981. Edited by Colin Naylor and G. P-Orridge, New York: St. Martin's Press.

Dictionary of Contemporary Artists. 1977, 1982. Edited by Paul Cummings. New York: St. Martin's Press.

Fine Arts Marketplace, 1977–78. 1977. Edited by Paul Cummings. New York: R. R. Bowker.

"Gallery Guide." 1977. *Art Now,* 8 (December), 1–36.

Guide to Corporate Giving in the Arts 2. 1981. Edited by Robert A. Porter. New York: American Council for the Arts.

New York Art Yearbook, 1975–76. 1976. Volume 1. Edited by Judith Tannenbaum. New York: Noyes Art Books.

The 1986 Artnews Directory of Corporate Art Collections. 1986. New York: Artnews.

Who's Who in American Art. 1980, 1982, 1984. Edited by Jaques Cattell Press. New York: R. R. Bowker.

Catalogues of Exhibitions

"Alternatives in Retrospect: An Historical Overview, 1969–1975." 1981. The New Museum, New York, May 9–July 16.

"Artists' Choice: Figurative Art in New York," 1977. Bowery Gallery, First Street Gallery, Green Mountain Gallery, Prince Street Gallery, SoHo Center for Visual Arts, New York, December 11, 1976 through January 5.

"Eight Contemporary American Realists." 1977. Curator: Frank H. Goodyear, Jr. Pennsylvania Academy of the Fine Arts, Philadelphia, September 16–October 30.

"Figurative/Realist Art." 1979. Artists' Choice Museum, New York, September 8–22.

"The Great Decade of American Abstraction: Modernist Art, 1960 to 1970." 1974. Curator: E. A. Carmean. The Museum of Fine Arts, Houston, Texas, January 15–March 10.

"The Jeu de Paume Museum." 1983. Paris: Ministry of Culture, Editions of the Association of National Museums.

"New York Realists." 1980. Thorpe Intermedia Gallery, Sparkill, New York, March 30–April 27.

"Primary Structures: Younger American and British Sculptors." 1966. The Jewish Museum, New York, April 27–June 12.

"Real, Really Real, Super Real: Directions in Contemporary American Realism." 1981. San Antonio Museum Association, San Antonio, Texas, March 1–April 26.

"Realism, Photorealism." 1980. Philbrook Art Center. Tulsa, Oklahoma, October 5–November 23.

"Seven on the Figure: Jack Beal, William Beckman, Joan Brown, John De Andrea, Willem de Kooning, Stephen Destaebler, Ben Kamihira." 1979. Curator: Frank H. Goodyear, Jr. Pennsylvania Academy of the Fine Arts, Philadelphia, Pa., September 20–December 19.

"Social Concern and Urban Realism: American Painting of the 1930's." 1983. Curator: Patricia Hills. Boston University Art Gallery, Boston, Mass.

"Systemic Painting." 1966. Guggenheim Museum, New York.

"Ten Approaches to the Decorative." 1976. Alessandra Gallery, New York, September 25–October 19.

"The Decorative Impulse." 1979. Institute of Contemporary Art, University of Pennsylvania, Philadelphia, Pa., June 13–July 21.

"The East Village Scene." 1984. Institute of Contemporary Art, University of Pennsylvania, Philadelphia, Pa., October 12–December 2.

"Toward a New Abstraction." 1963. The Jewish Museum, New York, May 19–September 15.

"Twenty-two Realists." 1970. Curator: James Monte. Whitney Museum of American Art, New York, February.

"Younger Artists: Figurative/Representational Art." 1980. Artists' Choice Museum, New York, September 6–8.

Index

Abstract art, 61, 119
Abstract Expressionism, 1, 2, 3, 4, 23, 25, 31, 39, 40, 41, 45, 55, 57, 61, 62, 66, 99, 112, 114, 124, 125, 131, 146, 163, 167; and contemporary realism, 163; criticism of, 51; demise of, 21
Abstract Expressionists, 2, 3, 4, 11, 25, 26, 27, 28, 30, 32, 36, 37, 42, 44, 47, 49, 52, 62, 64, 83, 113, 115, 121, 123, 129, 132, 133, 134, 139, 161, 162, 165; face-to-face network of, 29; prices of, 4; second- and third-generation, 30
Abstraction, 162
Academic roles, 138
Acquaintance network, 31, 33
Advertising, 141; and Pop art, 70, 78
Aesthetic innovator, 138, 140, 141
Aesthetic tradition, 44, 45, 66, 71, 73, 141; and Neo-Expressionism, 75; and pastiche, 67; Photorealists' attitude toward, 71; Pop artists' ambivalence toward, 66; rejection of, 75. *See also* Modernist aesthetic tradition
Albright, Thomas, 130
Allen, Barbara J., 120, 127
Alliance of Figurative Artists, 28, 29, 147
Alloway, Lawrence, 31, 32, 40, 66, 69, 145
Alternative spaces, 15, 34, 111, 118, 140; definition of, 59
American Abstract Artists, 26, 119
American society, interpretations of in the arts, 85
Anderson, Lennart, 94, 96
Andre, Carl, 30, 54, 162
Andrejevic, Milet, 24, 96
Apple, Jacki, 16
Archives of American Art, 147
Art: increasing importance of, 84; social content of, 84
Art centers, 9, 137
Art history, 74
Art journals, 28, 37, 40
Art market, 28, 39, 41, 47, 59, 63, 110, 112, 117, 131, 141, 165; competition

in, 112; growth of, 5; prices in regional, 136
Art movements, 1, 14, 15, 28, 41, 143; and the avant-garde, 14; and bureaucracy, 120
Art of This Century Gallery, 2
Art organizations, growth in numbers of, 6
Art schools, 29, 33, 137
Art styles, 2, 19, 131; dates of origin, 146; defining membership of, 145; leading members of, 23; marginal members of, 23; traditional, 23; variation among, 21; variation in auction prices of, 115–16
Art traditions, 13
Art world, 12, 15, 34, 42, 59, 79; New York, 34, 64, 130, 137, 161
Artist: definition of, 160; popular image of, 19; role of avant-garde, 11; as social critic, 52⁻
Artistic communities, 34, 46, 63; as counterculture, 27
Artistic role, 15, 33, 42, 44, 45, 138, 139, 140, 141; Abstract Expressionists' conception of, 48; analogous to scientist's, 54; changes in, 9; nature of, 18; social, 81; types of, 14
Artists: amateur, 137; changes in number of, 1, 4, 130, 136; and the middle class, 140; as participants, 20; perceptions of social role, 59; as teachers, 58
Artists Union, 26
Arts: benefits of support for, 7; changes in support for, 6; lobbying for, 7
Arts programs, enrollments in, 8
Ashton, Dore, 5, 77
Auction houses, 1
Auction market, 40, 116, 117, 135, 138; emergence of, 3; stratification of, 115; women artists in, 116
Auction prices, 28, 38, 39, 117, 165; changes in, 3; factors associated with, 15, 115–16, 150

189